# *Tibetan Journey*

By
## GEORGE N. PATTERSON

## PILGRIMS PUBLISHING
◆ Varanasi ◆

TIBETAN JOURNEY
George N. Patterson

*Published by:*
PILGRIMS PUBLISHING

*An imprint of:*
PILGRIMS BOOK HOUSE
*(Distributors in India)*
B 27/98 A-8, Nawabganj Road
Durga Kund, Varanasi-221010, India
Tel: 91-542- 2314060, 2312456
E-mail: pilgrims@satyam.net.in
Website: www.pilgrimsbooks.com

PILGRIMS BOOK HOUSE (New Delhi)
9 Netaji Subhash Marg, 2nd Floor
Near Neeru Hotel, Daryaganj
New Delhi 110002
Tel: 91-11-23285081 Fax: 91-11-23285722
E-mail: pilgrim@del2.vsnl.net.in

*Distributed in Nepal by:*
PILGRIMS BOOK HOUSE
P O Box 3872, Thamel,
Kathmandu, Nepal
Tel: 977-1-4700942
Off: 977-1-4700919
Fax: 977-1-4700943
E-mail: pilgrims@wlink.com.np

*Cover design by* Asha Mishra

ISBN: 81-7769-291-7

*Printed in India at Pilgrim Press Pvt. Ltd. Lalpur Varanasi*

# Preface to the new edition

The memory will never fade, that of the young porter whose right shoulder I held down while he lay on what passed for an operating table in the dirty shack in Manang. The sirdar held his left shoulder and the local nurse held his feet, while the Canadian doctor lanced a massive boil on his stomach. He squirmed, or rather attempted to do so despite our heavy hands upon him, for an instant, but a second later a mass of gruesome yellow pus squirted violently out of the hole made by the surgeon's deft handling of the scalpel, and a look of peace came over his weather-beaten face. The pressure was off. He would live again. He smiled at me, and that look forgave me for subjecting him to such, albeit temporary, agony. But what next? "You must take these antibiotics, three a day for the next week, and *you must keep clean.*" Now how was he to do that? I went with him to the place he called home, at least until he was well enough to move on. It was a cowshed, where he lay in the straw on an old sack. Next to his stable were the animals; all around him lay dung. The air was filled with a thick choking dust. "*Keep clean!*" had an empty ring about it.

George Patterson's book begins with just such a tale, of a young woman who will die if he does not perform surgery. But how will she keep the wound clean afterwards? He has to leave soon after the surgery and leaves an anxious friend behind to pick up the pieces if anything goes wrong. I also had to leave with my trekking group, though the surgery involved was nowhere near as serious. This tale of Tibet in 1950 is little different from my tale of Nepal in 1989, and probably neither has changed much in the intervening years.

George Patterson was a missionary doctor in Tibet in 1950, and this book tells the tale of his journey through Tibet to India, at a time when *only two month's journey away to the east, the Chinese Communist armies were already sweeping forward towards to the borders of Tibet with their threat of blood and bondage. Soon the people of this country of unutterable beauty would have to face the decision of fighting or submitting to that, which would mean the ultimate destruction of that which they held most dear. We had decided to remain whatever happened.*

A devout Christian, he *was faced with the problem of my generation and of all time – Christ's 'Submit and be saved' or Marx's 'Defy and be damned.'* Later he writes perceptively, *organised religion has been re-*

sponsible for more evil than good, and has a terrible judgement awaiting. But I suspect he was not referring to his own beloved Christianity.

A remarkable man, he is also a remarkable writer, and brings his journey to life with sometimes excruciating detail, but always full of local colour and a vivid sense of humour.

Talking of a local bandit chief who was a good friend, he writes…"*Certainly," I replied, "but how do I get there? Your valley is very difficult to find" – I grinned, "and is several days' journey away." "But of course! My valley is the most difficult to approach in all Tibet," he boasted, laughing. "How do you expect me to live as a bandit unless I have a safe retreat and fast horses to get me there? No, when you return from India, send me a letter and I will send you an escort to bring you to my valley, otherwise you will be killed long before you ever reach there."*

*"Thank you," I replied mockingly. "Do you rob me of my medicines after I arrive, then?"*

*He lay back and roared with laughter, delighted at the thrust: "No that would not profit me at all as I do not know how to use your medicines. I will treat you royally until all your medicines are finished and then I will rob you—of your horse. You will then have to remain as my guest and I shall have obtained your horse"—he finished triumphantly.*

What is it that draws one away from the comfortable routine of a western way of life? As an enthusiastic traveller myself, I have often been asked or wondered why myself.

*What did I want with the pursuits and trappings of civilisation? None of them provided me with the patent, sustained excitement, the satisfying pleasure, the fascinating suspense of travel in unknown places, with no shaving, no washing, no bathing, no dressing, into the bargain!*

Oh, the joys of camping! Tied up in knots in a mummy-shaped sleeping bag, unable to move or breathe; ice-cold air outside, or choking smoke inside. What a choice!

*Here it comes, I thought, the right atmosphere for the enthusiastic writer. A man may gaze unflinchingly at certain death, but I defy him to do it in yak-dung smoke! Just how bad it was could be gathered from the fact that I'd rather zip myself into my own sleeping bag and asphyxiate in the unwashed, unbathed atmosphere there than face the descending menace. I fought the usual losing battle in that space and finally lifted my head out to face the music…*

*Geoff had awakened at the noise of preparations and was undulating convulsively within his sleeping bag, so I assumed he was about to erupt from his chrysalis and get up. He had always been much more definite about this process than I.*

Tea is often thought of as a peculiarly British beverage, for everywhere in the world the 'Britisher' (as we are still referred to on the subcontinent even in 2004) traditionally takes tea when arriving anywhere. But it would appear that the Tibetans got there first, though their beverage made with salt and rancid butter is not perhaps everyone's cup of tea (pun intended!)

*It is am unwritten law in Tibet that everyone high and low takes tea on making camp before there is any attempt to prepare food for the official or master, since no matter how tired a Tibetan may be, after he has taken several bowls of the strong, salted, butter tea, he is again ready for anything.*

In the west we are perpetually washing; at least once, perhaps twice or more per day we will linger under the shower or soak in a hot bath, in an attempt to clean the surface of our bodies and the soles of our feet, if not our souls. Clearly a certain degree of cleanliness is necessary for our survival, but also a certain degree of dirt is necessary for our bodies to build up some immunity. Even as a medical practitioner, Patterson was totally thrilled at the feeling of not having washed for a while; in Tibet water is a scarce commodity and perhaps bugs also find it harder to survive in this harsh environment?

*Superficially speaking, I was dirty. If I had not had a wash for days I certainly had not had a bath for months. Not that this condition gave me any perturbation or was allowed to upset the equanimity of my existence, for if the truth be told in all its appalling clarity I could not remember when I had even washed my hands last—and I couldn't care less. I felt a warm glow of satisfaction at my reckless daring in defying the hygienic principles of civilisation and thus suffering in consequence only an unalloyed pleasure.*

He may have enjoyed not washing for a while, but the thought and sight of cockroaches was quite another matter. There's something about these foul creatures which makes most people squirm in disgust, and which are associated throughout the world with dirt and squalor. His Tibetan fellow travellers felt much the same.

*The floor swarmed with them, from the very small quarter-inch to the large three-inch kind they ran hither and yon with their loathsome lurch, and I fervently wished that they might smash into each other two by two and so eliminate themselves by concussion... As George Orwell said, "All animals are equal, but some are more equal than others."*

*...Their comments on the nightlife of the cockroaches were an education in the extent and use of abuse in the Tibetan language. My faith in Oriental imperturbability faded.*

Food is always a major topic of conversation on any expedition, however long. Each person has their own dreams, and many is the time an after dinner conversation has turned to chocolate or cheesecake, ice cream or strawberry pavlova. Eggs are nearly always easily available, and many things can be done with eggs, but if it's all you've had for months or even years, then maybe…

*I watched Loshay prepare breakfast. Six eggs lay cosily side-by-side on the rim of the brazier. For several minutes I had been devoting all my mental energies to trying to think of a new recipe for eggs. My trail was strewn with broken eggshells. Where the hen squatted, there hawked I. The ubiquitous domestic fowl spoiled by the equally ubiquitous foul domestic. For years now I seemed to have lived my gastronomical life in a cycle of eggs fried, eggs boiled, eggs scrambled. If I did not break out of this cycle soon, I should build up a complex and end up by seeing eggs rolling down mountains, flowing down rivers, falling as snowflakes, turning as wheels, growing as grass—and believing that I was Humpty Dumpty.*

So his unbounded elation on receiving a gift of some simple sugar lumps is entirely understandable.

*I could have yelped for joy when I saw several lumps of solid brown sugar…it was from Yunnan in West China that these sugar cones were obtained. They were lumps of solidified molasses and contained all sorts of matter, animate and inanimate, but I hugged them to my bosom. They even made the eggs (scrambled)—which I had for supper—tolerable.*

Nowadays when trekking, there are still some rather hair-raising bridges to cross, but they are in the minority. Most of the suspension bridges in Nepal have been rebuilt by the Swiss and Austrians with their world-renowned technology. But at the time of this book, it was not so easy to cross a river and the author naturally became somewhat obsessed with these precarious structures. One, indeed, was just a rope with a couple of pieces of wood strung below it, on which the passenger had to sit, hurl themselves into the abyss and hope they reached the other side intact.

*Bridges always seem to be cropping up at disconcertingly disproportionate intervals in this journey, but I submit that they loomed equally disconcertingly and disproportionately on the author's horizon, and if this record is to remain true to experience so must they remain. Some day I might be able to write a bridgeless record but so long as my destiny confines me to Tibet, the greatest watershed in the world, the possibility seems remote.*

We return again to food, and of course eggs. I remember once on trek long ago when our sirdar had sent half our food supplies round to the

other side of the Annapurna Circuit, and we had run out of food before we reached the Thorong La pass, which we had to cross in order to regain the other supplies. All that remained were eggs, flour and potatoes. So we had pancakes, chips, saute potatoes, mashed potatoes, potato fritters, fried eggs, omelettes, potato momos etc etc. I can entirely feel his pain as he writes:

*Shall I write a paragraph on eggs as I did on bridges? No, if any reader wishes to know how I felt at having to face eggs in the morning, eggs at noon and eggs at night, I suggest that he try it for some time in circumstances where the only other variety of food offered is raw meat—dried for one and two years at zero temperatures. It is a profound experience.*

Chocolate, now that's another matter. Almost everyone dreams of chocolate even when it's readily available, don't they? It's a luxury, but we love it, especially when we are told that it's good for us, because dark chocolate contains flavonoids, which are good for the heart. So to be deprived of one of life's essential luxuries for so long and then to see it before one's eyes must have been an almost indescribable occasion. After his long journey, across Tibet, he arrives in India and meets Kingdon Ward, the famous botanist and his wife.

*"Well, John the Baptist, I presume?" she exploded in astonishment. We roared with laughter. It was certainly apposite, for my hair lay on my shoulders, my beard was long and untrimmed and I was tanned deeply by sun, wind and snow...(as he left) Mrs Kingdon Ward threw in several blocks of Cadbury's chocolate which delighted me more than all the other food put together...*

Many people when on holiday today want to escape from the realities of daily life—indeed there are so many horrors which perhaps we would rather not know about. But personally (since we are always on holiday according to some of our nearest and dearest!) I prefer to keep up with what is happening around the world. The news may not be good, but it won't go away just because we don't know about it. That is not to say that I can understand at all the apparent public desire to see the news in all its gory detail on video. But I can entirely understand the author's thrill at reading the first current newspaper he had seen for years. *While lying back in a chair on the veranda in the cool of the evening I read my first up-to-date newspaper for years...I read that once again the Labour Government had gained power, but by a very small majority this time. It was strange to read of that and other world events after the months of silence and peaceful remoteness in the mountains of Tibet. I was in a new world and already Tibet seemed far away and mysterious in its lofty solitude...I had almost arrived...*

So now he was 'home', among other people of his own type of civilisation. But what is civilisation? How long would he have to wait to return to his friend left behind on the roof of the world, where civilisation has another meaning altogether... You'll have to read the rest of the book to find out...

*This was civilisation. This seething, aimless mass of humanity, purposeful only in its quest for food and pleasure, was about to swallow me up again for a little while...*

*Some lines from John Masefield rose up before me...*

*Therefore go forth, companion: when you find*
*No highway more, no track, all being blind,*
*The way to go shall glimmer in the mind...*

Siân Pritchard-Jones
Bob Gibbons
Kathmandu 2004

# *Contents*

# Illustrations

The author did not take photographs on the journey itself: to have done so would have meant incurring the risk of attack by bandits, who are attracted by any form of modern gadget such as a camera, and the possible hostility of local officials who might have delayed him. A selection of his photographs taken in Tibet, which have a bearing on the narrative, is however given at the end of the book.

# *Maps*

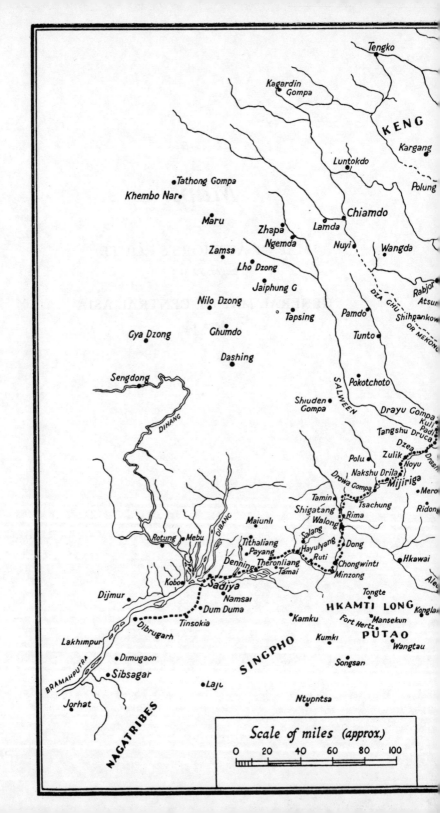

Scale of miles (approx.)

0    20    40    60    80    100

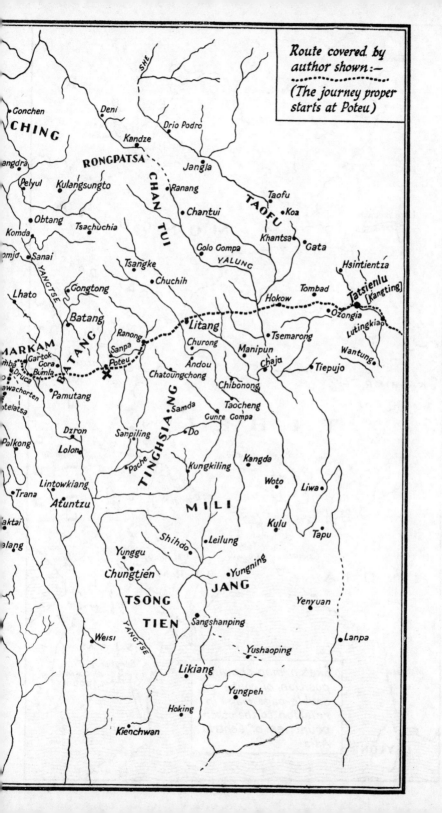

Route covered by
author shown :—
••••••••••••••••••
(The journey proper
starts at Poteu)

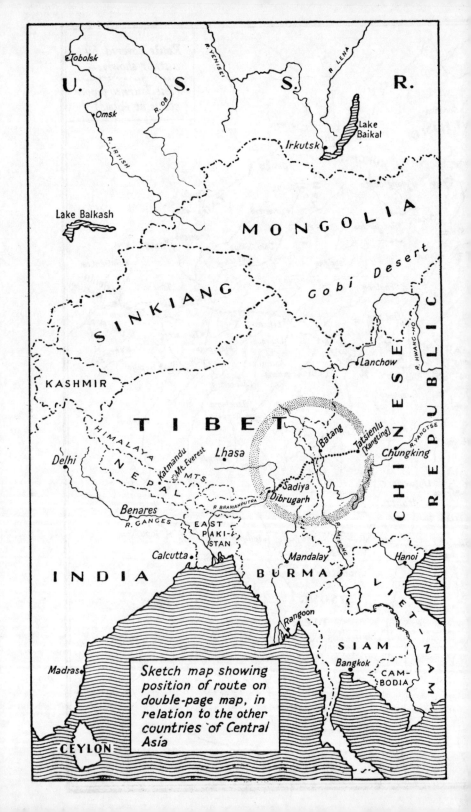

Sketch map showing position of route on double-page map, in relation to the other countries of Central Asia

# Author's Preface

I wanted a cause for which I might die.

My search for such a cause brought me into touch with two persons who offered me all that my youth demanded—Jesus Christ and Karl Marx. I was faced with the problem of my generation and of all time—Christ's "Submit and be saved" or Marx's "Defy and be damned". I chose the former. Not the impotent Christ of a vitiated Christendom but the conquering Christ who triumphs in men and in nations, in life and in death. Not with the desolate triumph, either, of Swinburne's:

> *Thou hast conquered, O pale Galilaean; the world*
> *Has grown grey from thy breath,*

but with the sublime victory, beyond the accepted values of a materialistic world, in W. H. Hamilton's:

> *O, what tame worship could such a Rebel brook?*
> *Claims He not some defiance for His meed*
> *Of things held fixt and legal and secured,* ·
> *Passionate avowals that none else dare approve*
> *And hearts that cannot deign to be victorious?*

It was in this cause that I went to Tibet.

The spiritual environment and training necessary for such a task I could only find amongst those known as Plymouth Brethren, who, with all their weaknesses, are still the most potent exponents of fundamental Scriptural truth in its early Christian and apostolic character; the physical environment and training I found in the mountains of Scotland and the Missionary School of Medicine in London. Hearing through a

# Author's Preface

mutual friend of another young man of my own age and convictions, Geoffrey Bull of London, I corresponded with him and, finding that our experiences and desires were similar in many ways, we decided to go to Tibet via China in March 1947. We arrived on the Tibetan border at the end of that year and proceeded to make a concentrated study of the Kham dialect of the Tibetan language, spoken in Kham Province of East Tibet, throughout which we travelled in the next few years. The advance of the Chinese Communists, as well as other factors, eventually led us away from the borders deep into the mountains of Tibet and it is from a remote valley there, in January 1950, that the journey to India with which this book is concerned begins.

The following is a record of only one of many journeys more dangerous and only a few of many experiences more interesting, but the notes of such not being available at present and the time for such not being suitable I submit this as my initial challenge to my generation.

G.N.P.

*Kalimpong*
*India, 1952*

# *Prologue*

"But if you operate who will attend to her when you leave for India?" protested Geoff. "You know I have only a little knowledge of first aid."

"If I do not operate she will die," I replied grimly, "and if she dies, with or without operation, we shall still be held responsible, with the priests after our blood and making the most of it."

"If you decide to operate, where will you do it? You cannot possibly attempt it in here."

"No", I answered slowly, looking round our cramped temporary quarters which were nearly all taken up by our stacked boxes and a huge open Tibetan fireplace, with a small opening in the roof serving as a hypothetical escape for smoke, "but, on the other hand, the room in which the woman is living is much worse."

The woman had come to me several days before, complaining of a pain in her breast, and on opening her blouse I was appalled at the sight. Her left breast was swollen to almost twice the size of the other and gleamed redly as the taut skin reflected the light of the fire. The inflammation had closed the milk ducts and the milk had accumulated in her breast with no escape. There was no flow from her right breast either, as some weeks before, when her baby was born, she had had a mammary abscess there which had resolved itself but left the breast useless for feeding purposes. She was almost crazy with pain and fear for herself and her baby, which was wasting away in her arms. I had drawn off what milk I could with a breast pump and applied fomentations to reduce inflammation and swelling, but her condition was too far advanced to be cured by this

method. I had tried homoeopathy to hasten the process of bringing it to a head, hoping that the abscess might burst of itself, relieving the woman of her pain and enabling her to feed and save her baby. I did not want to attempt any surgical or medical work on a large scale just yet as I had no instruments or anaesthetics with me and also I had no suitable place in which to work.

Now, with my departure for India across Tibet only a few days away, and the woman tossing and moaning in her room in agony, I had to decide. If I operated and she died on my hands my life would be in jeopardy. If I operated and left, and she died on Geoff's hands, his life would be in jeopardy.

"I will operate right away," I decided; "that will give me a few days to watch her over the danger period before I leave, then you will have to take over."

I was not afraid of the operation itself as it was quite simple, but the conditions under which I had to operate were almost certain to produce complications. The woman was frantic with pain and screamed when anyone tried to move her or touch her. She was lying on a filthy Tibetan sheepskin in a dirty little wood-and-mud-built room about 12 feet by 8 feet. A fire had to be kept going all the time because of the intense cold and also for the butter tea which was her sole food, and, as in all Tibetan houses there is only a small hole in the roof as a chimney, smoke and soot lay thickly everywhere. The blouse and gown which she wore were stiff with grease and dirt and she probably had not been bathed since birth.

It was into those surroundings that Geoff and I went, about two hours later, with our two servants, Loshay and Gaga, carrying all that I would require. Her husband and two other men, who might also have been her husbands as this was an area in which polyandry was widely practised, were already there. I had sent word ahead of me to stoke up the fire and then let it die down to a comparatively smokeless red ash so that I might have plenty of hot water and as little smoke as possible. I gave orders for two boxes to be brought and up-ended in the middle of the room and to be covered with two clean towels,

one to be spread with my instruments as a surgical "trolley" and the other to be spread with basins, soap, brushes, etc., for scrubbing up. The woman was to be lifted and laid on her back on the middle of the floor between the fire and boxes. I required the fire for light as it was now getting dark outside and the small spluttering butter lamps were of no use whatsoever.

With a vigorous "scrubbing up" of ourselves and the woman completed, I gave her a local anaesthetic with some novocaine around the area to be incised, and we were ready. Four hefty Tibetans held the woman down on the floor by an arm or a leg each, Loshay stood by to replenish the basins with boiling water, and Geoff as "assistant" was ready to pass swabs, scalpel, forceps and scissors when required, while I knelt on the floor beside the woman to operate. I offered up a brief prayer for help and for the woman's life, and then with a nod to the Tibetans to be ready, I made a deep incision in the underside of her breast. A spurt of pus shot out over my shoulder and then flowed in a thick stream from the wound, rapidly filling the bowl which I had hastily placed under the breast. The woman had given a loud scream and rolled her head in a frenzy to escape from the iron grip of the Tibetans and then settled down to whimpering, "My breast, my baby." Three bowls of pus had flowed out of the wound without any compressure of the breast and then Geoff was passing me forceps and swabs to clean it out, at the same time driving off cockroaches which were running over the floor and the woman's body. When I lifted her up to pass the bandage over her shoulder little rivulets of sweat from her face and body splashed on to my hand.

As soon as Loshay and Gaga had cleaned and put away the instruments and we had "scrubbed up" once more, I sat down gratefully to drink several bowls of the hot milk which the woman's husband had prepared for us. She lay in the corner on her filthy sheepskin, moaning softly now, the bandages showing plainly in the surrounding murk. With a few words of assurance to her and the worried husband that she would be all right now and that I would call again in the morning, we left.

Outside, the full moon hung above the snow-topped moun-

tains, towering high above us, throwing the large expanses of
pine forest into dark relief in the silvery light. The river, flowing
through the valley from north to south, accepted the silver
benison and transformed it into a new beauty of patterned
radiance. The stars sparkled their differing glories against a
background of black velvet, and the world breathed peace.

At this time, only two months' journey away to the east, the
Chinese Communist armies were already sweeping forward to-
wards the borders of Tibet with their threat of blood and bond-
age. Soon the people of this country of unutterable beauty
would have to face the decision of fighting or submitting to that
which would mean the ultimate destruction of all that they held
most dear. We had decided to remain whatever happened. If
there was fighting, we were an absolute necessity in a country
whose only medicines were mud, manure, and muttered incan-
tations; if there was no fighting, there was still a great work to be
done. But our stocks of food and medicine had become danger-
ously low. We had become accustomed to living on the spare
diet of the Tibetans, but new supplies of both food and medicine
would be needed in the future, since we were now completely
cut off from our source of supply in China. Thus we had decided
that one of us must go to India and make arrangements for
supplies to reach us from that country across Tibet, at whose
eastern borders we were now. At first it was suggested that
Geoff take the trip as I was required in the area because of
some knowledge of medicine, but after weighing all the pros
and cons of such a journey and its demands it was finally
decided that I should go. Hence the significance of our dis-
cussion before the operation which has just been described.

We had foreseen that the Chinese would stop at the borders
of Tibet because the high ranges of mountains presented great
problems of transport and movement, and also that there
would be a period of negotiation. Any journey contemplated,
therefore, would have to be completed there and back, before
the decisions following on the negotiations had been taken. Con-
sequently, the long northern route taken by the Tibetan caravans,

# Prologue

through Chamdo and Lhasa, was out of the question, as even with permits this would require a year to accomplish, six months to and from India. A new and quicker way had to be found.

Two ways lay before me: one was from Kham, or Sikang as the Chinese called the eastern province of Tibet, down into Yunnan and across north Burma into India; the other was in the almost direct south-westerly direction across Tibet into India at Upper Assam. The former route, while presenting many difficulties from bandits and warring tribesmen, had been travelled by a Lieut.-Colonel Baillie some years before, but the latter route had never been travelled at all. As a matter of fact, very few Tibetans had ever done the complete journey, and Pangdatshang, our Tibetan friend, of whom I shall have much to say, had been able to find only one man amongst all his soldiers who had gone right through from India to Kham; and as he had done it on foot five years before he was now very hazy as to distances and conditions. The goods which were transported by the trade route from Sadiya in Upper Assam to Tibet were usually carried by relays of Tibetans, hired from different places en route, who returned to their villages when each stage was completed.

With all its difficulties this was the route which attracted me most, and so we sent to Chamdo to wire the Tibetan Government in Lhasa for permission to use this route. We asked for a permit for Geoff as well in case the situation should collapse before I could return and he wanted to leave suddenly. If I obtained permission to make the journey through Tibet I hoped to do the journey, there and back, in six months. To accomplish this would mean pushing forward from dawn to dusk every day to arrive in India in two months, then with two months in India to attend to everything I could be back in Kham before anything of note had happened. In this country of vast distances and no post the negotiations could easily drag on for another six months. The only obstacle to my returning according to schedule would be an unexpected delay in India which would mean that, the monsoons, breaking the rivers would rise and I should be stranded in India for a further six

months. While I was away Geoff would go ahead with the building of a house, and this would serve as our base from which we could travel in the future.

In the meantime we were living in a log hut on the flat roof-top of a Tibetan house. It stood in a beautiful valley, which Pangdatshang, the leader of the Khambas, had made his temporary headquarters. All the rooms in Pangdatshang's house were at present occupied so we could not live with him as had been planned, but we ate with him and his family and slept in our log cabin until such time as our own house should be built. It was, as I have said, because of all these difficulties and considerations that I had refrained from any large-scale medical and surgical work.

To this log cabin we now made our way. Loshay and Gaga had heaped the fire with logs to boil water for sterilizing the instruments and a heavy pall of smoke caught at our eyes and throats as we entered. Years beside camp-fires of wood and yak dung had inured us to this, however, and after a few sputtering coughs we were able to move about in the enshrouding gloom. As Pangdatshang would be waiting to hear an account of the operation, we remained only to gulp down a few bowls of tea and went down and across to his house.

This was a huge, square, fort-like building, broad at the base and narrowing towards the battlemented, flat roof. A few narrow slits for windows were all that disturbed the smooth white face of the building from bottom to top. Multi-coloured prayer-flags, fluttering from the battlements, were the only sign of decoration and colour. In the eastern wall of the house, facing the large courtyard with rows of stables along the whole of one side, was a large, two-leaved, heavy wooden door.

Instead of the ground floor being used to house the livestock as was usual in other Tibetan houses, Pangdatshang had used it to store guns, ammunition, and some valuable merchandise. A broad wooden staircase led upwards to the first floor where the huge kitchen and servants' quarters were, and then to the second floor, where Pangdatshang and his family lived.

# Prologue

They were all in the main living-room when we entered, a large room occupying almost the whole of the second floor, with the smaller bedrooms leading off it to the north. Along the whole of the south side, detachable windows had been built to face out on a narrow sheltered balcony which caught the sun throughout the day. Now of course the windows were tightly closed to keep out the bitter cold, and keep in the heat generated by a metal barrel, cut to our design to make a very efficient stove, which was now red and roaring. Underneath the windows, and along the far side of the room, ran a dais with deep-piled, highly-coloured Tibetan rugs, on which the various members of the family were sitting.

Pangdatshang, as befitted his position as head of the house, sat on the slightly higher dais at the far side of the room with his brother beside him, then their sons, and lastly the women-folk further down. Pangdatshang was really the family name, and belonged properly to the eldest brother, now in Lhasa, the capital of Tibet, but, because of his long absence, and the wide influence of this rebel young brother, who was admired and respected by all the fight-loving Khambas, he had been given the family name. His name was really Pangda Topgyay and Topgyay I shall call him. The second brother sitting beside him was Pangda Rapga, and the one in Lhasa Pangda Yang-pel—"Pangdatshang" meaning "House of Pangda" or "Family of Pangda". On Topgyay's other side sat a visitor to the valley, the colourful bandit-leader, Linka Gyabon, who had come to have a dispute settled concerning his alleged rustling of hundreds of yak and horses from a neighbouring chief.

They formed an interesting group as they waited to hear an account of the operation, the flickering light from the butter lamps high-lighting their faces. Topgyay—who had already fought in two wars, once against the Tibetan government and once against the Chinese government—short, fat, and like an Oriental version of a feudal baron as he lounged at his ease, wrapped in a loose, lamb's-wool-lined gown; Rapga, pale and scholarly, exiled because of his political machinations, and inscrutable as always as he sat cross-legged on the dais with his

hands tucked in the sleeves of a fur-lined, maroon-coloured silk gown; Linka Gyabon, burly, laughing young chieftain of the wildest crowd of bandits amongst all the warlike Khambas, waiting with rapt attention like any innocent schoolboy, huddled in his carelessly tied, maroon silk-faced sheepskin. The others were outside the circle of light thrown from the butter lamps on the table and were only vague figures in the shadows.

When I had finished Topgyay asked, "Will she live?"

"If there are no complications she will certainly live," I replied confidently, "but it is the possibility of the wound becoming infected now which worries me. As soon as she feels the pain easing she will be up and working, and then the bandage will be forgotten."

"I'll see to it that she doesn't have to work," promised Topgyay. "I will give orders to her husband and some of the women to help her in every way. What age is she?"

"Twenty-three."

"She is very young to die, but she would have if you had not been here with your medicine. Does she need anything that I can supply?"

This was typical of Topgyay. Unlike most Tibetan officials, he was interested in these Khambas, the fiercest and most populous of all the Tibetan peoples, as individuals and not as mere tools to serve his purpose. They loved him for it, as much as they respected him for his fighting record.

"A-roks!"[1] interrupted Linka Gyabon in his impulsive way. "There are many sick people in my country: will you come and give them medicine as well?"

"Certainly," I replied, "but how do I get there? Your valley is very difficult to find"—I grinned—"and is several days' journey away."

"But, of course! My valley is the most difficult to approach in all Tibet," he boasted, laughing. "How do you expect me to live as a bandit unless I have a safe retreat and fast horses to get me there? No, when you return from India send me a letter and

[1] Friend.

# Prologue

I will send you an escort to bring you to my valley, otherwise you will be killed long before you ever reach there."

"Thank you," I replied mockingly. "Do you rob me of my medicines *after* I arrive, then?"

He lay back and roared with laughter, delighted at the thrust: "No, that would not profit me at all as I do not know how to use your medicines. I will treat you royally until all your medicines are finished and then I will rob you—of your horse. You will then have to remain as my guest and I shall have obtained your horse"—he finished triumphantly.

My horse had been a source of argument between us since he had arrived and heard of its great reputation. It had been reckoned a killer and unrideable, and since I had bought it several times almost justified its reputation with me.

In this country where one's life depended on a good horse I had been gripped by the appearance of this one, and after the worst two hours' punishment in all my life had managed to ride it. I had bought it cheaply as the owner was unable to ride it and was glad to get rid of it before it killed someone and he was held responsible. Since then it had defeated over two hundred horses in races of speed and stamina until it had become something of a legend. I had already come across two stories, which had been recounted as camp-fire gossip, to account for its phenomenal speed; one, that I gave it injections of some of my medicines, and the other, that I whispered a Christian prayer in its ear as I started a race! Linka Gyabon had scarcely arrived in our valley before he was negotiating for the sale of the horse. "I need it", he had protested, "in my work. What is the use of being a bandit leader if other people have faster horses?" He had spent the rest of his stay in threatening to bribe my servant, steal it when he left, or waylay me on some of my travels.

"Why don't you race your horses and find out just how good or how bad they really are?" suggested Rapga, who had been a mad rider in his youth, and gambled recklessly on horses during his stay in India. "Your own horse has a good reputation and it would make a good race," he added to Linka Gyabon.

Linka Gyabon gazed at him in blank amazement. "You are

not suggesting that his horse is as good as mine?" he gasped, wide-eyed. "I only wanted it because I heard it was very fast, not because I ever thought it had a chance against my horse."

Topgyay grinned lazily at Linka Gyabon's thunderstruck countenance. "That sounds as if you might be afraid of the result," he commented innocently.

Linka Gyabon still could not believe that they were serious. "Do you *really* want to race?" he asked me disbelievingly.

"Saddled or bare-back?" I queried laconically, according to the Kham custom of the champion's giving the contender the choice.

It was the last straw. Linka Gyabon swore a terrific oath and exclaimed: "All right! You've asked for it. Saddles. Tomorrow morning."

Linka Gyabon had come in with twenty men armed to the teeth and mounted on swift ponies. The official who had lodged the complaint against him had also come in with some of his men, armed and well-mounted. And many others had come in from the surrounding mountains and valleys when they had heard of visitors to the valley, knowing that there would be shooting and horse-racing, pastimes dear to the heart of a Khamba. They had been gathering since sunrise along the mountainside above the level floor of the valley over which the race was to be run. Not a man, woman, or child amongst them but had heard of the famous red horse of Linka Gyabon and there was a raging controversy as to the possible outcome. Many had seen my grey terror race and swore themselves deep into debt on its merits, but the majority had only heard of it by reputation and had not seen it in action against a really first-class animal as Linka Gyabon's was known to be. Loshay had been up since dawn grooming it, and as he led it forward to where we were standing there was an admiring gasp from the crowd. Small, even for a Tibetan horse, it was built like a song and moved like a melody. A deep, powerful chest tapering to compact, beautifully proportioned hindquarters, carried on legs which lifted like steel springs, it looked the champion it was:

26

but the rolling eye and tossing head showed a dangerous impatience and kept the crowd at a distance. When Linka Gyabon's horse was led forward there was another murmur from the crowd as the tall, rakish animal with the gleaming red coat pulled the two attendants from their feet with its rearing and prancing. Two other horses, one belonging to a soldier of Topgyay's, were to run as pacemakers, and the soldier's horse, a deceptively nondescript sorrel, looked as if it might be capable of anything.

As we walked towards the starting-point a thought suddenly struck me for I noticed that Linka Gyabon was still wearing his heavy lamb's-wool-lined gown, and I asked him: "Aren't you riding?"

"No," he said, surprised. "Why? Are you?"—looking at my riding-breeches and boots with new comprehension—"I am too heavy a weight for my horse to carry in a mile race with saddle, and I have given him to one of my men to ride. Is that all right?" he added anxiously. "It is one of our customs."

"Of course!" I replied quickly, grinning. "Only I wanted to beat you as well as your horse. No one can ride my horse saddled except myself, and no one can ride him bare-back except my servant, so if you'd rather ride bare-back I'll tell my servant."

"No, ride as we agreed. It will make no difference anyway," he said confidently.

It took me several minutes to mount because the grey reared high in the air as soon as I put my foot near the stirrup, and even when I had swung into the saddle he pawed the air, dragging Loshay off his feet as he tried to hold him. The other horses were milling around as well, keyed up with the excitement, and there was great danger of those who were holding the bridles and trying to give a level start being mangled under the flailing hooves. Finally, the starter called to the holders to get away and he would try to give a fair start when we were all facing up the course, but his flashing white cloth on the downstroke of the start startled my horse into another pitching battle, and when I had straightened out the others were already

a good hundred yards away and bunched close together. I hurled the grey after them with loose reins, giving him his head for the first time since I had bought him. The other races I had won comfortably from the start and had had no need to extend him; though to tell the truth, I had been afraid to really turn him loose. Now he was bulleting forward, gathering speed with every stride, until the wind of his going drove the breath back in my throat and his whipping mane stung me like a thousand needles. He devoured the distance between the other horses, and the riders threw startled glances over their shoulders as I thundered alongside. They were already using their whips, and with a wild yell I drove in my heels and lifted the grey into a hammering lead. The watching Tibetans were yelling like dervishes, and so to give them something to really shout about I lay along the grey's neck and drummed a mad tattoo on its flanks, streaking past them in a flying hurricane of dust.

When I finally managed to pull up I was several hundred yards past the winning-post and a good bit up the mountain, and still the grey was pawing and pulling savagely at the bit. I circled back to where Linka Gyabon was standing beside Topgyay and Rapga with an expression of blank amazement still on his face as he gazed wonderingly at the horse.

"I wouldn't have believed it possible," he admitted ruefully, "if I hadn't seen it with my own eyes. What a horse!"

The last horse had come in and Geoff, who had been acting as timekeeper, walked towards us watch in hand.

"One minute twenty-seven seconds," he announced, "with the sorrel second at one minute thirty-four, Linka Gyabon's horse third at one minute forty-two, and the other also ran."

"Beaten by fifteen seconds over a mile?" queried Linka Gyabon incredulously, as he gazed gloomily at his horse which was being paraded backwards and forwards in front of us.

"Never mind," I consoled him, "it was not really a mile—a little under it—and rough at that."

He ignored my levity, and then, as we walked back to the house together, he suddenly announced: "I must have that

28

# Prologue

horse! How much do you want for it? I will pay you double what you gave for it."

"Sorry. No sale." I answered promptly and definitely.

"All right! I steal him," he replied equally promptly and definitely.

I loved him like a brother for he was a charming rogue, I told him, but if he tried to steal my horse after all that I had gone through to break him and train him then his blood be on his own head.

I grew more and more indignant but he remained serenely confident, until Topgyay, who had been listening to our argument with amusement, interjected, "I will decide."

As he was the acknowledged leader of all Khambas and a friend of both of us besides, we had to agree to let the decision rest with him.

"Loshay, bring the horse here," he commanded. "Now," he said turning to Linka Gyabon, "if you can ride him you can pay double the price, and he is yours. If you cannot ride him you will acknowledge your defeat and say no more about it."

For a moment I was dismayed as I saw Linka Gyabon walk forward confidently to swing into the saddle, for the horse had been ridden at a gruelling pace in that race and it must have taken a lot of the fire from him. But I need not have worried. As Linka Gyabon gathered the reins in his hands and shuffled to a surer seat in the saddle, he hesitated before telling Loshay to turn him loose. Instead, he commanded him to pace the grey forward and then let him loose on a longer rein before letting him go altogether. As the horse bunched his powerful muscles to go into his celebrated warming-up dance he signed to Loshay to take control, dismounted, and walked towards us with his boyish grin.

"All right! I'll let you keep him," he said shamelessly.

When we had drunk several bowls of butter tea and exhausted the subject of the race just run, Geoff and I excused ourselves and went off to see our patient. She had slept all night and only just wakened before we came in; her breast was still painful but nothing to compare with the agony of the past

few days, and when could she feed her baby? I warned her against being over-optimistic as that was the very thing to lead her into being careless, with dire consequences, and said it would be some time before she would be able to feed her baby. She had to be held again when I withdrew the soaked packing from the wound and inserted fresh dressings. I had nothing to use as a drain and had to pack gauze into the incision to keep the wound open until all the pus had been drained off. I explained everything to Geoff as I went along so that he would know what to do when I had gone. If the woman's breast healed with the remarkable rapidity usual amongst these superbly virile people then I should be able to make my preparations for departure with an easy mind, knowing that nothing could go wrong so long as she kept obeying Geoff as she had obeyed me.

A few days later, news arrived from the Tibetan Military Governor at Gartok, the border garrison town in east Tibet, to say that I had been given permission to travel through Tibet to India and that he would give me the permit when I arrived there.

# The Journey

I stretched myself, opened my eyes sleepily and became irritatingly conscious of the uncomfortable wet feeling about my beard and neck due to the condensation of vapour in my sleeping-bag. I wakened to the same feeling every morning but it never ceased to annoy me as it raised a mental picture of a child dribbling on his bib, instead of the bearded intrepid explorer which I liked to imagine. I closed my eyes again when I saw that it was still dark, shifted within the strict limits of my mummified sleeping-bag to a more comfortable position—and then came awake suddenly and completely. I was leaving today. The slow seductive satisfaction which could never be defined and whose sensation heralded the unwinding ribbon of the trail beneath my feet, began to well up slowly within me. I stretched myself contentedly, with a vague suggestion of restlessness, like a man awaiting the arrival of his beloved. I grinned at my own feeling of pleasure. What did I want with the pursuits and trappings of civilization? None of them provided me with the latent, sustained excitement, the satisfying pleasure, the fascinating suspense of travel in unknown places, with no shaving, no washing, no bathing, no dressing, into the bargain! Well! Well! My languid musings were intensified by the sudden gloomy thought, Ay-hay, it's cold outside. The temperature is probably eighteen below and everything frozen solid. My teeth will be chattering, my fingers frozen and fumbling trying to close buttons and zips long before I get into my outer furs. "Give to me the life I love," I thought cynically, looking back on my previous thoughts.

In order to experience the joys of travelling, I continued to myself, especially when the mercury is thumbing its nose at zero and trying to break out of the bulb, it is advisable that one

## The Journey

should first master the art of Houdini in order that one might be able to dress completely to outer furs while still within the confines of a sleeping-bag with straitjacket capacity. Then one ought to have a servant (one at least) with the abilities of a Jeeves and a Man Friday combined. This servant would then proceed to build a fire without matches, without paper, without wood, and without yak-dung smoke—if possible. This last being impossible it is suggested that the intending traveller have his taste buds, his lachrymal ducts and his nasal mucosa—or whatever it is that is irritated to sneezing by smoke—removed before taking to the trail. Finally, any operation or condition which will enlarge his capacity for consuming unlimited quantities of beverage (designated as tea merely for want of a better term) without the discomfort entailed by the subsequent drainage, would be of great help. Having all these things he would then be able to get up.

"Loshay," I said into the darkness.

"Uhnhnhmhh" (at least it sounded like that).

"Ya la lang. Meh tri bar. Cha bong" (which being interpreted is—"Get up. Kindle the fire. Make tea").

"Uhnhnhmhh."

There were sounds of Loshay stirring in the darkness of the room and soon the energetic puffing amongst the seemingly dead ashes of fire produced a red glow, a ridiculous amount of smoke, and, finally, a burst of flame. I watched the smoke rise thickly, then, unable to find sufficient outlet, begin to spread out beneath the roof like a huge mushroom, and descend towards me. Here it comes, I thought, the right atmosphere for the enthusiastic writer. A man may gaze unflinchingly at certain death, but I defy him to do it in yak-dung smoke! Just how bad it was could be gathered from the fact that I'd rather zip myself into my own sleeping-bag and asphyxiate in the unwashed, unbathed atmosphere there than face the descending menace. I fought the usual losing battle in that space and finally lifted my head out to face the music. Loshay had used some precious pieces of wood in order to try to get rid of the worst of the smoke by flame, and breathing became more or less toler-

32

# The Journey

able. Soon the water was bubbling merrily, a handful of tea and twigs thrown in, the liquid poured into the wooden churn through a wooden strainer, a lump of butter and a pinch of salt added, and life took on a rosier hue. After several bowls of this I was sufficiently fortified to face the prospect of getting up.

Geoff had awakened at the noise of preparations and was undulating convulsively within his sleeping-bag, so I assumed he was about to erupt from his chrysalis and get up. He had always been much more definite about this process than I.

Outside it was bitterly cold and we kept the door closed as much as possible during my preparations to leave in order to retain the warmth within the room.

I carefully checked all supplies once again, and all loads, as we had no means of ascertaining how long we should be delayed on the journey or the prospects of replenishing supplies en route. Geoff was busy writing letters by the red light of the fire and the grey light of the dawn. Loshay and Gaga were part of the cacophony of sound associated with breakfast preparations.

Gaga was breaking eggs, trying to find some that weren't as bad as others, while Loshay battered energetically at two or three pieces of yak meat on the Irishman-and-his-wife principle of "the-harderer-you-beat-it-the-tenderer-it-becomes".

Having negotiated safely the digestive obstacles of breakfast in Tibet I decided to wander over to the White House (Top-gyay's) and see how things were progressing there. I still wasn't sure about leaving, because any one of a thousand reasons can be given for not leaving then—the "mañana" of the Spaniard has nothing on the "Sang nyin" of the Tibetan for ambiguity!

As I crossed the compound the piercing wind swept the breath back in my throat and chilled me to the marrow, even beneath my furs. Servants were hurrying around leading horses and mules out of the stables and saddling them, so I thought the signs were at least hopeful. In the main room of the White House I reverted to a more cautious optimism, for here no one seemed to be considering anything abnormal in the way of departure. My entrance, as always, was taken as if I were one of the family and I could see that they had not even eaten yet.

# The Journey

Topgyay asked casually if I intended leaving today, as though I were contemplating a cup of coffee at Lyons round the corner. However, Rapga showed more hopeful signs by his intense activity in writing letters for me to take with me.

While breakfast was being brought in and eaten, we discussed final arrangements, the messages to be delivered en route, the messages to friends in India. I was to be given a royal send-off with full escort part of the way, and each one was talking enthusiastically and at length of the horse he was going to ride. The excitement had spread to the servants and the meal was constantly interrupted by some other servant or soldier coming to enquire for permission to ride such and such an animal. Last-minute bedlam as Mrs. Topgyay and Mrs. Rapga asked me to bring things from India: the family clamouring about the same and also about whether I was going to ride my grey horse; Topgyay giving advice on how to conduct myself on the road with servants, bandits and officials, and Rapga giving instructions about messages to friends in Kalimpong—and then we were outside.

The compound was a milling mass of men and animals. The Khamba loves an occasion, and any opportunity to sling his gun over his shoulder, saddle his horse and ride is snatched eagerly. Some men were leading their horses and some horses were leading their men; some children were on the horses and some were underneath them; some women were laughing, some giggling and all indulging in badinage which it would be polite, but untrue, to call suggestive—it left nothing to the imagination. Geoff appeared, pushing his way through the crowd to the door where we were standing, with a more preoccupied expression than usual on his face. It appeared that all Pangdatshang's horses had been taken by the soldiers and servants and that left him without an animal to ride except for my grey horse, as I had decided to leave that behind and take Geoff's easy-going and less expensive bay with me. To appreciate Geoff's perturbation you must understand that Geoff's idea of a horse is a necessary species of motivation to cover the distance between two points in the most comfortable manner

34

possible. He was still in genuine doubt as to the spiritual wisdom
of my riding the grey which he considered gave great occasion
to the flesh and even greater occasion to the devil, so that he
himself would not ride the grey on the ground of either spiritual
conviction or physical necessity! The only occasion that would
see Geoff on that horse would be one of physical necessity
which would supply the spiritual conviction. A quick dis-
cussion determined that I would ride the grey until the parting
of the ways when I would change over to the bay, and Geoff
could then either walk back leading the horse or else perhaps
someone could be found to ride it and give his horse to Geoff!

To horse! Jogar, Topgyay's head groom, brought up his
master's famous pacing mule and he was up, settling himself in
the saddle as the mule swayed forward on the slack bit and was
brought to a stop by the other milling horses as riders swung to
the saddle now that their chief was up. Tsering Dorje, Rapga's
personal servant, brought forward Rapga's mule and he was
up, serene and unmoved by all the excitement. Gaga brought
forward the bay and Geoff was up, still looking a bit flustered
and probably wondering if I had forgotten anything in my
preparations. Loshay brought forward my grey and I was up
and a blank ten minutes later I was able to see that there were
other horses around and that my horse was not all of them, as it
had appeared. The sight of my horse ready to give one of its
celebrated performances was the automatic signal for departure
and the calvacade began to break up and wind downhill in a
colourful pattern of weaving, pirouetting horses and riders over
the wooden bridge in the centre of the village. I saw Loshay
mount the second wildest horse in Pangdatshang's string, and
gathered from the angle of his fur hat, the grin on his face and
his handling of the horse that he had managed successfully to
drown his sorrows at parting from his friends in "chang".[1] The
fact that the servant who had held the horse to help him mount
was thrown off his balance and trodden on by the horse was
only a minor detail to be remembered and laughed over later.
I managed to lift my hand in a more or less respectable salute

[1] "Chang" is Tibetan for beer.

to the ladies, then grabbed wildly for the reins again as the grey prepared to take off. There was only one bridge over the stream allowing one animal to cross at a time, but the grey showed at all times a contemptuous disregard for such human pigheadedness. I let out a Khamba whoop to clear the way, hoping fervently that the other riders would not consider it a challenge to race to the bridge, and an eternity and two hundred yards later I had managed to slow down and greet the others who had been waiting for me to join the leader. After a mile or two I managed to calm the brute sufficiently to be able to talk to various friends as we rode down the valley.

A few miles further on, where the valley widened slightly in a small basin, we dismounted for the final goodbyes. These were accomplished with a true Scot's eloquence and expressiveness. To Topgyay: "Thank you. Goodbye." To Rapga: "Thank you. Goodbye." To Geoff: "God bless you, Geoff. Goodbye."

It had begun to snow, and I muffled myself in my furs as I slouched down in the saddle of Geoff's plodding bay at the pace we would maintain across Tibet. Loshay, Tsering Dorje and Bajay, my companions for the journey, after a few desultory remarks had lapsed into silence except for an occasional shout at a recalcitrant horse or mule. Our caravan had been trimmed down to the absolute minimum as its smallness would both serve as a deterrent to bandits, and be useful in case we should have to carry the loads, in the event of animals not being able to proceed as had been reported. Two small pack mules, one pack horse, and five riding horses with saddle-bags completed our outfit. Tsering Dorje carried his rifle, Bajay his revolver, and all carried swords and knives.

The trail started winding up out of the valley on the right, or west side, and became rougher as we ascended. Soon the ascent became so steep we had to pile off the horses and lead them over, up and around the huge boulders. I was sweating profusely under my furs but it was so bitterly cold that to unzip even for a few minutes while we rested meant to chill to the marrow. Over the top of the first part of the pass the wind blew in desolate fury, driving the snow in our faces bitingly. Tsering

# The Journey

Dorje had had a malarial attack a few days previously and was now having another spell of body shivering and he could not get warm at all even though we were now walking again and driving the animals. I gave him my long woollen scarf as I was well wrapped up with fur coat and fur hood. The far side of the pass, being more exposed, was carrying a lot of snow and, what was worse, had long stretches of ice over which the horses could not go. This meant that we had to cut steps in the snow or dig for soil beneath the snow and sprinkle it on the ice, or even to unload the horses and spread the horse blankets on the ice for the horses to walk over. All this delayed us considerably so that we were not able to reach our first objective, and just as dusk was setting in we managed to arrive at a lone house in a lone valley where we decided to stay the night.

Tsering Dorje, having been Rapga's personal servant and then Topgyay's for several years, was able to give Loshay a few points on how to get things really organized; and in next to no time I was relaxed on a pile of rugs beside a blazing fire and drinking several cups of cocoa. I decided to use up the bread and dried meat, as the tsamba[1] would keep better for the latter part of the trip. The house was the usual sturdy stone-and-mud-built fortress type, built to keep out wind, cold and other things, with an outside fence of stacked wood for the winter. Its single story had been divided in half in order to stable the cows, yaks and sheep in one half and the husband, his wives and four of a family in the other. The open fireplace took up most of the half in which we were, so that when all were finally seated we formed a solid half circle of red-and-gleaming-faced content. The only light being the light of the fire, and wood being scarce, we retired early to bed—which consisted of stretching out as and how we were. The Tibetans merely slackened their girdles and their voluminous robes served as bedding, while I climbed into my sleeping-bag and proceeded to dismantle inside, to the obvious interest of the female section present. However, by this time I had learned Tibetan customs and unlearned Western

---

[1] Tibetan "barley flour" staple diet.

# The Journey

inhibitions, so the incident was pursued to an unembarrassed conclusion on both sides.

## 18th January

We did not seem to sleep very long before we were awakened by the landlady moving around getting the fire kindled and the water on, and one by one we got up. I had no idea of the time for my third watch had been broken some time before and I was now living in a timeless, or, at least, watchless present. It was still dark outside, and even after we had eaten, packed and loaded the animals the stars were still diamond clear in the blackness of the heavens. We had travelled for at least an hour, each following the other's vague outline in the darkness, before dawn broke. The darkness did not seem to affect the horses or mules at all for they picked their way unerringly over the broken trail. It was again bitterly cold and the sound of Tsering Dorje chanting his prayers was muffled through thicknesses of woollen scarf. Ice-fields blocked the trail continually and again and again we had to make a path by flinging dirt, branches, and stones, etc., on to the ice. The trail grew rougher and steeper and two of the mules turned out to be hopeless, continually stopping for a rest, and when they slipped on the ice, just lay and surveyed the landscape like a Western tourist.

We reached a point where a stream had frozen on its way down the mountainside and which seemed absolutely unnegotiable. We split up, each taking a different part of the mountainside to see if we could find a way across, but because of the steepness of the slope and width of the stream we had to return to our original point. Here we unloaded the animals and proceeded to cut steps across the ice with our swords. These we overlaid with branches hacked from surrounding trees, and sand dug from surrounding mountain and finally saddle blankets and rugs. All this ostentation was not because we felt the animals deserved it but because the frozen stream continued to emulate a very effective chute for several hundred feet down the

38

mountainside. One by one we led the animals across, picking every step ourselves and almost picking the horses' steps for them as well. But "the best laid schemes of mice and men gang aft agley" and in this instance, although the scheme had been laid all right, it was one of the horses that went agley. With a swoop worthy of Margot Fonteyn, it left the guiding hand of Loshay for Regions beyond. It is not over-exaggeration to say that the sound of its passage was greater than the crash of empires, the sensation experienced like the fall of "Steel Consolidated". For it was not only a horse that was passing from a particularly horseless piece of country, but it was *my* horse!

The British, American or Soviet empire crashing would not have affected me then, but that horse crashing meant a hike for several days with a 20,000 foot pass thrown in, *and* a load to be carried as well, and all the money in the world could not produce a horse where one did not exist. There was a sad and introspective look on our faces which seemed to suggest that we were pondering on the profundity of the law of gravity, the law of averages and the law of diminishing returns; there was a disgusted look on the face of the horse which seemed to suggest that it was fed up with whatever law governs the functions of horses' legs, for neither leg, functions nor law seemed to have an answer appropriate to this occasion. And then it happened! About twenty or thirty yards down-stream the beast managed to spreadeagle itself on a flat ledge before the next and last precipitation downwards. If it had had a disgusted look before, the horse now had the most superciliously complacent look in the world, as if it had meant to land exactly there all the time! Furthermore, having accomplished the act successfully it was all set now to maintain the static whoa. There was only one thing to be done and we did it. I held on to an overhanging branch of a tree and then Bajay, Tsering Dorje and Loshay joined hands and formed a human chain which brought Loshay behind the horse. Getting hold of its tail he managed to push, pull and negotiate it into a position where he could grab its ears instead. Then catching it lovingly round the neck, and with the others braced against the downslope of the stream, he managed

to get it on its feet, when it was dragged, pushed, pulled or otherwise manhandled—frankly, I don't know—to the side.

Because of all this delay it was evident that we would not be able to reach our intended stopping-place for that night, and so we began to look around for a suitable camp. We had been steadily climbing upwards for several hours and had long since left the tree line far behind. We were now in a valley whose only vegetation lay in a few bare patches of grass in an iron-hard earth, and an even rarer scrub where tough gnarled roots and branches seemed to coil in a snarl of defiance against the elements. The only movement in all that empty vastness was the slow plod of our animals, the only noise, the occasional snort of a horse, the grunt of a yak and the creak of saddle leather. Tsering Dorje, too, must have felt the weight of that silence for he sat hunched in the saddle without a sound. It was a valley remote from the world, an antidiluvian throwback, a Shangri-la without romance or life. The mountains hemmed us in on either side, shut off our trail behind and hid the trail ahead in surly blankness.

Soon the late afternoon wind arose and moaned its way through the snows and silence with its dirge of death and icy contempt of furs. Tsering Dorje grunted and indicated some point ahead as a camping site. I could make out nothing at first to distinguish it from any other place near at hand until Loshay enlightened me. "Dung", he said. What I had taken to be the usual scattered piles of stones turned out to be small heaps of yak dung suitable for fuel. We still had some distance to travel, however, and, just to make the journey more interesting, a few more ice-fields to cross. We dismounted, we walked, we slipped, we fell, we arose, we muttered, we groaned, we yelled, we arrived. There is a psychological reaction about arriving at a camping spot, for no matter how utterly weary one may have felt only a moment before, yet as soon as the horses start milling around the spot there is a period of feverish activity, when girths are being slipped and packs unloaded and the previous silence is split by rough and noisy banter. It was so now. In next to no time, saddles, bridles, rugs and packs were lying scattered

# 18th January

about all over the place, Bajay was driving the animals over to one side of the valley so that they would not wander too far away, Tsering Dorje was already kicking together a pile of yak dung to make a fire and Loshay was building up the saddles and unwanted loads into a barrier against the bone-piercing wind. I stamped around, flapping my arms, trying to sort out which parts of my body were most uncomfortable, which parts with no feeling, and which parts with feeling just coming back. Tsering Dorje had decided that there was not sufficient yak dung to keep the fire going once started, and he called to Loshay to take a blanket and collect some that was scattered at intervals on the valley floor.

Lest the reader should be labouring under some misapprehension regarding this most indispensable yet detestable, peculiarly Tibetan commodity, let me hasten to explain that in the arctic temperatures existing in these parts, the dung was in hard frozen cakes. In less remote and more civilized communities, the dung is mixed with straw, preferably by hand, and then formed into pancakes about six inches in diameter and slapped on to the face of any wall in the vicinity. When the correct texture and consistency is reached with the co-operation of Nature, the pancake falls off and is placed in stock for further use. This, as I said, is the usual practice in the best social circles, but as our present camping place was conspicuously devoid of straw and walls, we were reduced to the primitive necessity of using the dung "raw".

In our absence from the camp site (for I too had sufficiently thawed to be able to pick up a piece of dung with the others) Bajay had kindled a fire. Now there is nothing of particular moment about this, for every Tibetan over three years of age can successfully accomplish this act, and probably every Tibetan over five is capable of lighting a fire from stone and steel as Bajay had just done. Bajay's claim to fame is that he had never lit a *yak-dung* fire before, or to be more correct, he had never lit a yak-dung fire *properly*. That there is a difference was soon to be evident. As we approached the fire (on the assumption that there is no smoke without fire) Bajay suddenly metamorphosed

41

like some genial and lachrymose Mephistopheles from his en-
shrouding pall of grey. "Goon-cho-soom,"[1] he swore feelingly,
"it won't catch." Tsering Dorje's smile was wickedly sardonic
and Loshay's laugh mercilessly exuberant. I grinned.

"You blankety-blank-blank," coughed Bajay, "if it's amus-
ing you, you try it and I'll laugh." Loshay was incapable of
speech as he doubled up on the ground. Tsering Dorje solemnly
addressed the world at large: "If ever I want anything done
wrongly, or messed up, if ever I need a brainless, useless idiot, I
shall without hesitation proceed to Kham, and Minya in
particular, and pick out what passes for a man there. Get out of
my way, you Khamba horse-thieves and Minya bandits, and
I'll show you what to do. If you want a good job done, do it
yourself."

From a comparatively safe distance I watched as Tsering
Dorje with reckless courage plunged into the holocaust of smell
and smoke to retrieve the situation and his dignity. Gradually
the former was obtained at the expense of the latter. His antics
were a joy to watch as he hopped like a hen on a hot girdle
amongst the scattered dung ash and smoke. He mercilessly
bawled for the laughter-weeping Loshay and the smoke-weep-
ing Bajay to get the smoking embers covered with dirt, and then
I beheld a never-to-be-forgotten sight. The pall of smoke
lessened in density, but extended in area, and in the midst of
this Tibetan un-fiery furnace, I watched the Tibetan Shadrach,
Meshach and Abednego move about, but with this difference,
that for days to come the smell of fire—and other things—
remained with them. I lay down—out of the wind, of course—
and wept. Then slowly, in the midst of this phantasmagoria,
another weird figure took shape. With Biblical incidents well to
the fore in my mind, I was already associating the new struc-
ture with the tower of Babel. Tsering Dorje was directing
operations and under his hand and guidance the cakes of yak-
dung were being piled up in a circular tower with alternate
air spaces between the cakes. When this had reached a certain
height, some of the hot ash and a precious piece of resinous

[1] Tibetan oath: "By the Three Gods, or Trinity!"

pine were put in the centre, with a branch or two of withered shrub which had been picked up en route. A spark from Tsering Dorje's tinder, a magnificently courageous approach to effective blowing distance—and a more balanced and bearable quantity of fire and smoke appeared. At least, perhaps I ought to qualify this by speaking of "fire", in the strict sense of heat and light caused by burning and not the popular idea associated with flame.

When we had carefully gauged the direction of the howling wind the loads and saddles were built up around the fire, and Loshay proceeded to lay out my sleeping-bag right in the path of wind and smoke. But as each one of us complained that the smoke was driving straight towards us, it seemed useless to argue the point. Loshay and Bajay sought to maintain that the difference in Bajay's effort and Tsering Dorje's was negligible, and certainly the spluttering coughs, sneezes, sniffs and tears were strong evidence in favour of their argument, but Tsering Dorje was crowing triumphantly that he had produced a greater ratio of heat and colour. The fact that the pan was already boiling was an irrefutable fact in his favour and I accordingly gave him the benefit of a very considerable doubt. The memory of Bajay's impenetrable and unapproachable pall was still strong upon me.

Night having stolen up on the heels of the wind and smoke, we were further interested to note that in our concentration to produce a fire and tea, the horses had chosen this opportunity to disappear into the darkness. As it was Bajay's job to look after the animals he gave vent to some untranslatable and, in any event, unprintable Tibetan, and trudged off into the night. I suggested to Tsering Dorje that this was an unsolicited testimonial to the effectiveness of his fire, but Bajay strenuously refuted this from a fading distance and said that anything was better than stumbling over the ice in the dark and the piercing cold of the wind. We were vociferously sympathetic and Bajay's trailing words in the darkness suggested that he had taken a poor view of human nature.

With several bowls of scalding Tibetan tea on its way to my

toes. I was able to release my mind from its pre-occupation with the primitive factors of cold and heat and to devote it to the equally primitive factors of food and rest. The fact that I had only a few tins of food for the whole journey did not worry me unduly since I could live on the tsamba and dried raw meat of the Tibetans as long as they could, and I did feel for some inexplicable reason that the present situation demanded some sort of celebration. It was unique. It had to be observed. Recklessly I ordered Loshay to open one of the two tins of sausages and fry them with some of the flour-and-water scones—if the frying pan could support them without giving way under the weight. In the meantime I would crawl into my sleeping-bag with all my furs still on, and fortifying myself with bowls of peculiarly-flavoured tea (there is a point at which analysis must stop) and memories of Rudyard Kipling, John Masefield, Robert Service and Marco Polo, await that nostalgic moment of campfire-lit contentment.

Wae's me! The barricade of saddles, loads and yak dung, the fire of embers, smoke and yak dung, were unable to keep out the freezing cold. And, to crown it all, Loshay informed me that the food would consist of sausages, verdigris and yak dung. Any decent self-respecting pioneer after one look at that slimy green-coated conglomeration of bag-bursting mystery, would have instantly demanded the healthy, if hardy, tsamba. But I had suffered much. I was psychologically conditioned to explode and the only manner in which I could adequately express myself was by watching said sausages explode in a bath of melted butter. "Remove the verdigris and outer layer of sausage," I commanded firmly, "and proceed as directed."

The saddle rugs that weren't beneath me I proceeded to pile on top of me and then fell to wondering, as I often had in different circumstances and on different occasions, whether Hegel was really correct in his dialectic. He stated categorically the law of quantity into quality, but he had never been in Tibet at the height of 18,000 feet and tried out his theory experimentally by applying blankets and rugs to produce heat. For my part I state equally categorically that there is a point

44

where his theory is completely unacceptable—in this instance, the point of suffocation. I panted under the weight; I froze in the cold. I froze under the weight; I panted in the cold.

Somewhere outside the limited circle of my own feelings I noticed in a detached way that the horses had arrived; I could see them. I also noticed that Bajay had arrived; I could hear him. His steady flow of invective directed impartially among the animals, Loshay and Tsering Dorje was monotonous in tone, but picturesque in content. I gathered that he had had a difficult time in finding and rounding up the animals and that he was attributing the difficulties to some peculiar qualities in the ancestry of his companions and of the animals. If his fervour were any criterion he seemed to be deeply informed in these matters. But Tsering Dorje was not to be outdone by any young upstart and, with the advantage of a little heat and ten bowls of tea, he became almost lyrical in reply. He supported his statements by quotations from poets and philosophers (of doubtful origin and reputation) and by calling on principalities and powers to witness to their veracity. When the wind, howling louder than ever, carried away parts of the barricade, they each with remarkable celerity claimed it as supernatural evidence in their favour.

With the horses stabled out for the night, we piled up the fire in an abandoned manner and between periods of waving our hands at the glow sought to satisfy the clamant desire of the inner man. I had decided that nothing would persuade me to take off my woollens and furs and that as I was, so I would remain for the remainder of the night—I might have to get up and walk about to keep myself warm. The others were preparing for the night: they spread hot ash all round the fire and then, burrowing down into it, made a hollow to hold their bodies out of the force of the wind. Beside each one there was a pile of yak dung, and Tsering Dorje gave orders that when they wakened each one was to throw a handful on the fire to keep it going.

There was a little sporadic leg-pulling and then gradually silence closed over the small glow in that great immensity. As I lay in my sleeping-bag gazing upwards, the stars seemed almost

artificial in their brilliance and nearness in the surrounding darkness. The wind lifted and fell on its moaning journey south, the horses moved and snorted softly, but otherwise we were alone on the outer fringes of infinity.

## 19th January

I dozed fitfully, waking at odd intervals with the intense cold, and on almost every occasion there would be a murmur of conversation amongst the others from which I gathered that they were finding it difficult to sleep as well. This was scarcely to be wondered at as their only warm clothing consisted of their lamb's-wool lined gowns, which were supplemented by a few saddle blankets. On coming out of a doze I found them all up and huddled round the fire in a squatting position and building it up again to give out more heat. The aluminium cauldron which serves as a tea-pot is never taken off the fire in Tibet and so there is always tea, and they were consuming great quantities of this as they sat.

There was no difference in the night around me, the darkness still only faintly illuminated by the light of the stars. I missed the sound of the horses, though, and seeing that they had been untethered, gathered that they were being allowed to graze before departure.

"Is it time to go?" I enquired.

"No," replied Tsering Dorje. "This pair of immature goats who know nothing of time or travel, think that it is about dawn and have built up the fire again. Anyone with my experience would know by the stars that it is only about midnight."

"Anyone with your experience would be in bed," Loshay interrupted rudely. "You are too old to travel and your bones feel the cold so much that you could not sleep, and so you built the fire and started guzzling tea."

"Yes, and not content to sit in the warmest place beside the fire swilling tea, he also ordered me to turn the horses loose to graze," added Bajay to me. "And then watch if he hasn't the

colossal nerve to ask me to go and bring them in in a little while."

"One of you pour out tea for the Sahib," said Tsering Dorje with lofty disdain, "and have less to say or you will be sent home to grow up."

For a little while there was silence as we took part in the early morning rite of tea-drinking. I shuddered at the almost incomprehensible thought of being colder than I already was when I got out of the sleeping-bag and layers of rugs, and sought to build up a considerable resistance by imbibing vast quantities of scalding butter tea. This was only to hasten the inevitable, though, as it increased the necessity of getting up and out.

"Now that we are up, we might as well be moving," said Tsering Dorje. "I think it's light enough to see by and anyway the trail up the valley isn't too difficult."

There was a pregnant silence. Then Loshay and Bajay, choosing their words carefully, told Tsering Dorje what they thought of him.

"You decrepit offspring of a long line of Amdo purse-snatchers, why didn't you think of that earlier, then we wouldn't have turned the animals loose? Now we'll have to round them up in the dark. But no! You haven't got the brain to think that out," they said with mock bitterness.

"It's your fault for wakening me out of my peaceful repose," replied Tsering Dorje, "and so you can pay the price of your youthful folly."

"You lazy old he-goat! You can sit at the fire until your ageing bones rot. We'll go and do your work for you," flung back Bajay as he trudged off.

Loshay, Tsering Dorje and I began to roll up sleeping-bag and blankets and pack away utensils, stopping every few minutes to warm up numb fingers by rubbing or heating them at the fire. We could hear Bajay call out several times to the animals but gathered by the rising inflexion of his voice that he was being exasperatingly unsuccessful.

Having completed packing except for the cauldron and bowls and the remainder of the sausage and "bread" which I was

going to eat, we took to the night to look for the horses. Tsering Dorje might firmly believe that there was enough light by which to see the trail, but before long I was equally firmly convinced that there was not; and from the bawled imprecations that came from two other points of the mountain, it was evident that I had hearty support. We worked our way back to camp in a wide circle to enclose the animals, and finally arrived there—without the animals. Loshay and Bajay explained in detail what they felt had only vaguely been said before. We had thrown a wide loop and there were no horses, so it followed as a simple conclusion that the horses must be further afield.

"You sit here and pour out some tea for the Sahib," said Bajay with exaggerated solicitude. "You've done enough for one night. And I'll sit by the fire and see you don't die of over-exertion."

"No, I'll stay by the fire," said Loshay, "as I want to learn how to build and feed a yak dung fire successfully."

"I am responsible for the stuff," I added hastily, "so I had better stay here and watch it in case there are any bandits around."

"We'll all go out again," said Tsering Dorje remorselessly, "and these two will take the high slopes of the mountains as they are expert horse finders—when the horses belong to other people. Let's see them find their own for a change."

I don't know whether the challenge gave Loshay and Bajay fresh impetus, but at any rate, as we swung back towards the camp again, we could hear the snorts and scrambling sounds of the horses returning. When we arrived at the camp we could hardly get near the fire for the milling horses, but I never found out whether it was the horses' own inclination to be near the fire or whether it was the Tibetans who brought them there to be loaded. One of them was so close that its tail caught fire, and as Tsering Dorje happened to be loading that animal, Loshay and Bajay surpassed their previous efforts in vituperation and wit.

Soon there was only the tea cauldron and our bowls left beside the fire. Either because of thrift or thirst, the Tibetans

emptied the lot and gave the leaves to the smallest mule. There can be no waste in this land.

We started off with Bajay leading and then the pack animals with Tsering Dorje, myself and Loshay behind. It was still so dark we could hardly see the outlines of the animal in front and we stumbled so often on the uneven trail that finally we decided it was better to ride the animals. They picked their way sure-footedly in the darkness and in this manner we climbed for some time huddled in our saddles. The fringes of my woollen Balaclava and fur hood, and even my moustache and beard, were soon frozen stiff as my breath froze in that merciless atmosphere.

As the stars began to fade in the greyness of the dawn I found myself watching, with the intensity of a starving man watching for food, for the rose colour which would herald the sunrise. I knew from experience that it would be some time before there would be any actual heat, but to see the sun and know that it contained that heat which I craved, became an obsession. I watched the edge of its approach down the mountainside with hypnotized fascination, and tried to gauge the time for its arrival from one boulder to another. For we were now in a huge amphitheatre of savage barren mountains whose sides and feet were covered with shale, stones and boulders. The whole place in that early morning light gave the impression of being a vast iron-grey bowl filled with some strange rose-coloured liquid. It did not seem credible that those mountains could ever shed their iron hardness to weep, but that they did could be seen in frozen streams and frozen lake sparkling brilliant in the hollows.

Soon we were over the rim, but only to climb other valleys. Always the trail wound upwards and we left the floor of the valleys only to climb perilously across the face of the mountains. It was only a single-track trail on a shale and loose dirt slope, and every so often the hind feet of the animals would slip over the edge to be pulled back scramblingly to safety.

As the morning advanced I began the usual peeling off of clothes, starting with the flinging back of my fur hood, removing

D              49

of my Balaclava, then my woollen muffler, then my fur coat, then my first woollen sweater, then my second woollen sweater until I was sitting on my horse in shirt and riding-breeches—and still sweating. What a country!

Thousands of feet below the river looked like a white scar on the dark shadow of the valley where the sun had not yet reached. A lazy spiral of smoke indicated a camp we could not see from our present position. It came as something of a shock to think that there could be other people around. We had seemed as remote and cut off as if we had been on some unknown planet.

The going having become so dangerous on the moving mountainside, we had to dismount and lead our animals. Then I was really conscious of the heat and altitude as, scrambling upwards in heavy riding-boots and having to throw my full weight on the reins to keep the horse from going over the edge on occasions, I was soon left breathless and dirty. There was no question of the others helping because they had their own animals and the pack animals to look after as well. Every few yards we had to stop to rest our blowing animals and our equally blowing selves. The jagged rim of the mountain showed cruel and remote against the far serenity of an unfeeling blue sky.

Hours later, soaked and sobbing for breath, we topped the last rise and looked down, down, down, into the distance and saw the eye-caressing green of grass. To sit around in such a state for any length of time would have been fatal though, and so we began the long descent.

The Tibetans have a saying about "testing a horse going up and a man going down". That gruelling climb had been a strain on us all and we could pick out the quality of the animals now. My horse and Bajay's had stood it best, Loshay's and Tsering Dorje's were looking rather worn and one of the mules was dragging badly. If the climb had been difficult, the descent was hair-raising in the extreme. The trail was so steep that both men and animals slid in the loose scree at every stride. The loads and saddles on the animals also began to slip over the animals' necks and I gulped incredulously on occasions as I watched the

# 19th January

Tibetans imperturbably adjust loads or saddles while balanced precariously on an unstable ledge above a seven or eight thousand feet drop. The demands of the trail had effectively silenced them for some time but now the descent and the rising green of the valley floor released them from their self-imposed taciturnity and once again they leg-pulled amongst one another, handling animals and loads with careless ease and nonchalance and seemingly oblivious of all danger.

Soon we were on the rolling grasslands and our aching leg muscles could relax as we swung along without the strain of having to maintain balance. I discovered suddenly that I was hungry, starving as a matter of fact, and only preoccupation with myself and the surroundings had hidden that from me so far. I conveyed my discovery to the others, who, it appeared, were in a like condition, which was hardly surprising considering that we had been on our way now about ten hours. We had been up several hours before dawn and it must have been about midday then. However, the sky was blue, the sun shone, the air was like wine, the dew sparkled on the grass, the ice crackled underfoot and the trail wound away ahead—what more could a man want?

Rounding a shoulder in the mountain we came down to tree level, and reaching a glade through which flowed an icy, crystal-clear stream we decided to unload the animals and eat. As soon as the loads and saddles were off, the animals gave themselves up to the enjoyment of rolling on the grass to get rid of sweat and dirt. The Tibetans, moving like a well-organized team, were stacking loads, collecting wood, building a fire and making the inevitable tea. It is an unwritten law in Tibet that everyone high and low takes tea on making camp before there is any attempt to prepare food for the official or master, since no matter how tired a Tibetan may be, after he has taken several bowls of the strong, salted, butter tea, he is again ready for anything. It was pleasant then to lie back in the warmth of the sun with a bowl of buttered tea carrying away the dirt and fatigue and look down on the world rising and falling away into the misty distance. Beneath me the mountainside dropped down

51

and down in darkening shades of green to the blackness of forests thousands of feet below, through which wound the gleaming white thread of a river to be lost in the folds of other mountains and valleys. On either side and in front, as far as the eye could see, for hundreds of miles stretched range upon range of snow mountains, their lower slopes showing all the modifications of grey, and green, blue, brown and black. I was intoxicated with the immensity and glory of God.

Fortified, saddled and loaded, we took to the trail once more, but once again we ran into a series of ice-fields which blocked our way. We had to hack steps in the smooth surface, sprinkle dirt and branches, and even at times unload the animals and lead them carefully over one by one, reloading on the other side. It was monotonous, exhausting and heartbreaking work, but at least we had the encouraging knowledge that we were going down and forward. The ice-fields became fewer but the steepness of descent became a problem again as our legs lacked the early morning resilience. We rode occasionally in the more open parts, but as we still had some distance to go to make our stage for the night we tried to conserve the animals' strength as much as possible.

Soon we turned into a beautiful valley where the trail widened out to pass between an avenue of various kinds of trees, spruce and larch and other varieties of deciduous trees instead of the monotonous pines of the higher slopes. At times it might have been some forested path of England we were passing through while the afternoon sun lay lengthwise across the trail and birds sang around us.

As the trail turned down steeply once again, one of the mules lay down and refused to get up, and we had to transfer its load to Loshay's horse. The other was also stopping and resting at longer intervals so we transferred part of its load to Bajay's horse in order to keep going and get in before night. Our objective was a small Tibetan village high up on a rocky mountain promontory above the Yangtze River. As the trail came out of the trees into the open occasionally, we could see the Yangtze far below marking the political boundary between China and

# 19th January

Tibet. The racial boundary we had left far behind at Kangting.

Just as the sun was setting we arrived at the first house in the village, which happened to be the largest and also our rest-house for the night. There was nothing of note in the house, it being the usual Tibetan house of square fort-like type with thick sloping walls of stone and mud. The compound walls were of the same thick stones and mud covered with drying cakes of yak dung and heaped with stocks of cut, wooden logs for fuel. The ground floor, as mentioned already, was the stable for yaks, cows, horses and pigs and a barn as well, with a wooden ladder leading to the first floor and dwelling-rooms of the house; or, rather, dwelling-room, the others being used as store rooms for supplies and lumber of various kinds. There is usually only one large main room in which the family lives, moves and has its being, and it was so in this case.

When we had made our way through the crowd of gaping villagers who were seeing a white man for the first time—and a bearded one at that!—our animals were taken and rapidly unloaded by the ever friendly and helpful Tibetans while we made our way upstairs. Bajay supervised the stacking of our loads in a corner, Loshay went to see if he could find eggs and milk, and Tsering Dorje made a comfortable couch for me beside the fireplace of saddles and saddle rugs. From there I could watch the bustle of preparation in a pleasant state of relaxation, and be watched by the members of the family inside and various members of the village outside. I returned their interest with interest. Superficially speaking, I was dirty. If I had not had a wash for days I certainly had not had a bath for months. Not that this condition gave me any perturbation or was allowed to upset the equanimity of my existence, for if the truth be told in all its appalling clarity I could not remember when I had even washed my hands last—and I couldn't care less. I felt a warm glow of satisfaction at my reckless daring in defying the hygienic principles of civilization and thus suffering in consequence only an unalloyed pleasure. *Athanasius contra mundum.* Thus I could gaze upon these specimens around me with all the

53

# The Journey

benevolence and confidence of a Descartes looking upon his doubts, knowing that they were at once the rejection of all accepted standards and the reason for accepting them.

Let me state the fact simply and solemnly—they were all with one accord dirty. Even in my present condition of generosity and magnanimity to all men, and Tibetans in particular, I must concede that it was a condition in which they must have been since they first entered on their earthly journey, to judge by their appearance. But let me hasten to add in their defence that to them soap was an expensive luxury obtainable one month's arduous travel away, while to us civilized creatures it is an accepted necessary commodity obtainable around the corner. However, as this is a record and not an apology I must grudgingly stick to facts—they were dirty. Over my shoulder and through the narrow window I could see the Yangtze far below, adding its quota of millions of tons of water to the oceans of the world. In my hand was evidence that this people could utilize that commodity in no inconsiderable quantity to satisfy the demands of thirst. I could only assume, then, that they considered the inner man of greater importance than the outer man, and in this philosophy they were adequately supported by authority. If they were mistaken it could only be in ratio not in principle. Let those who would hasten to differ remember the Pharisees and tremble.

They were dirty, then. The dirt was ingrained in every wrinkle and hollow of their bodies. It was in their hair and their ears and their necks and their chests and their knees and their legs and their toes. They were, literally, covered with dirt. If they had taken off their gowns they would have appeared as one colour all the way down with no contrast of body whiteness, for men, women and children went about stripped to the waist during the day and only pulled their gowns over their shoulders in the cool of the evening. Thus they were dirty with an abandoned dirtiness. But Nature had provided them with compensating factors; their eyes and their teeth gleamed pearly-white in the surrounding blackness, and always they shone in friendly mirth. The children smiled, the girls giggled, the

54

women smirked and the men laughed. A stranger had come into the unbroken monotony of their lives, and it was funny. It was even funnier than they thought, if they could have appreciated it, for they had to accept the whiteness of my skin as a "white man" by faith, since it was effectively hidden by beard, tan and trail dust.

The people were much more interesting to look at than the place for, having seen one Tibetan house, one has seen them all. A large open fireplace about six feet square with a small opening in the roof to let the smoke out. (It occasionally does.) A rough iron tripod to hold the large iron cauldron in which the water is forever boiling for tea (and incidentally other things). Around the walls churns of various sizes, bridles, saddles, blankets and farming odds and ends. The rest is space.

Loshay had been able to procure some milk and eggs and these were bubbling away merrily on the fire beside the tea. I had decided that the drink with my food was to be cocoa as I had already drunk about ten bowls of butter tea, and also I felt I ought to replace some of the energy expended throughout the day. Whether it was because of this that Loshay considered the occasion demanded other foreign amenities I do not know, but, anyway, he produced a dish-cloth, soiled, naturally, but almost Persil-white against the surrounding background, and proceeded to lay out the "bread" (flour-and-water scones), butter, eggs and salt in neat heaps upon it. Maybe it was just to show to the others another way of life. If that was the reason he was eminently successful for such a display not only called forth comments but cockroaches as well.

I had noticed several running about as I had sat drinking tea, but since these are part of the domestic scenery all over Tibet I had paid little attention to them. Whether it was the heat of the fire, or the sight or smell of food, or the general excitement which called them out of their lairs or holes or nests, or wherever-it-is-that-cockroaches-dwell, I cannot say, but from a negligent wave of the hand to restrict the activity of an occasional reckless specimen I had now become absorbed in beating off attacks on what was legitimately mine. If their activities had

been limited to attacks upon my food I might have been constrained to concede some of it for the sake of general socialistic principles (or "peace at any price"), but they not only attacked my food and my drink but proceeded to crawl over me and inside my shirt as well. This was communism with a vengeance, and I immediately leapt into a struggle of class distinction and mass extinction, hitting out right and left with a will. The struggle was doomed to failure, there were too many of them and we had no adequate means of attack, so we had to rely on a vicious if feeble defence. The floor swarmed with them, from the very small quarter-inch to the large three-inch kind they ran hither and yon with their loathsome lurch, and I fervently wished that they might smash into each other two by two and so eliminate themselves by concussion. All this was to be seen in the circle of firelight. As I looked up at the roof and round at the walls and saw the light reflected from thousands of moving scaly bodies, I shuddered to think of the night.

I had been in the habit of sleeping on the ground or on the floor without bothering to use my camp bed, but my mind rebelled at the thought of such equality with cockroaches. As George Orwell said so profoundly: "All animals are equal, but some are more equal than others", and I intended demanding my share of equality by using a bed on this occasion. The others were going to stretch out as they were around the fire with the family just as usual, and the cockroaches were presumably going to stretch out with them. It would not have been so bad if they had stretched out and left matters there, for one seldom minds sharing what one does not miss anyway. It was their revolting activity, robbing one of appetite, contentment, concentration and sleep, that repelled.

My sleeping-bag was no sooner unrolled on the bed than the cockroaches, with obnoxious curiosity, began to disappear in a steady stream inside the opening. I wished fervently that they might die slowly of asphyxiation. I climbed in beside them and callously began ejecting them. The ejected must have felt aggrieved and gone and told the others for they came back in greater numbers to teach me a lesson. I was at a serious dis-

advantage for I was in the process of divesting myself of my clothes while sitting half in and half out of the sleeping-bag. This position requires great aplomb to be carried off with dignity, especially while being watched by a mixed and interested company of Tibetan males and females. I had congratulated myself on the perfection of my technique in the past but now a new factor had entered into the proceedings. My back was to the wall and my dignity to the winds. I writhed—I wrestled—I gibbered—I dived down—I leapt up—and, finally, with abandoned recklessness, I zipped the sleeping-bag as far as it would go, undeterred by the thought of suffocation within the confines of the sleeping-bag or strangling with my beard in the zip. It was impossible—but it was true! There were still cockroaches inside the bag. Summoning all my reserves, I went Oriental. I was not very sanguine of success for I could both see and hear my Tibetan companions, and had I been personally immune I could have enjoyed their antics. Their comments on the night life of the cockroaches were an education in the extent and use of abuse in the Tibetan language. My faith in Oriental imperturbability faded.

The fire had died down to a dull red glow. My companions were indistinguishable as they lay stretched out around the fire with the eight or nine other members of the family, all wrapped up in their gowns. The old man pottered about doing one or two odd jobs, and his wife or eldest daughter (I learned later she was both) breast-fed her baby as she moved around. The only sound was the breathing of the sleepers, an occasional muttered imprecation, and the moaning singing of the old man as he chanted the endless Tibetan prayer-formula, "Om mani padme hum". Finishing his jobs, he turned to the fire and began to prostrate himself upon his face before a few ragged scraps of dirty, smoke-grimed paper on the wall behind the fireplace, his voice rising and falling in some mumbling prayer to his gods. Soon he too lay down and I lay sick at heart staring into the darkness. And God made man in His image and after His likeness, I thought, and this is the state to which he has fallen. I could have told the man of a God who could take him

as he was and make him fit to stand before Him, but there was no medium of communication between us. My Tibetan was still limited to the dialect I had studied and this country was so vast, its valleys so remote, its people so far removed from each other that those in one valley often did not understand those in the next. Loshay and Tsering Dorje had had the greatest difficulty in following the dialect spoken here even when asking for the very little we required. The dirt of the body is often only an outward indication of the inner dirt of the soul, although not always a necessary corollary even in its converse aspect, and when this is the case it calls forth revulsion and pity, anger and sorrow; revulsion and pity at the condition of the individual, anger and sorrow at the system which exploits that condition to its own advantage at the expense of the individual's soul. Organized religion has been responsible for more evil than good and has a terrible judgment awaiting. I shuddered, and, turning to the comparative cleanliness of the cockroaches, slept.

## 20th January

Sleep was difficult and so once again we were up and moving very early in the morning. Dawn was only just breaking as we prepared to leave and it was grippingly cold, although not nearly so cold as the night before. The Tibetans with the village helpers were loading the animals below to the usual overtones of the voices of men and the grunts of animals. I sat beside the fire and read from my pocket Bible to give me some mental and spiritual food for the day ahead when I could fill in the long hours of travel with profitable searching of the things of God.

On leaving the village we continued to descend steeply towards the river which we had to ford at some point as yet unseen. It was an awe-inspiring sight. The mountains rose sheer out of the waters of the Yangtze and folded back reluctantly only towards the summits, thus making the whole valley at this point a savage gash in the earth's surface. The trail wound in a wide zigzag downwards so steeply that in a few minutes my toes began to ache excruciatingly with the constant rubbing against

the inside of my boot. The animals slithered down most of the time on their haunches, and the loads kept falling off and were in constant danger of being lost down the mountainside. The horses and mules still had not got over the effects of yesterday's journey and showed a distinct reluctance to move, having to be continually urged forward. Soon the mule which had lain down yesterday did the same again and this time refused to budge. The loads were so distributed that the only way in which we could apportion the mule's was to divide it up between our riding animals while we walked. As it was absolutely impossible to ride, anyway, on such a trail, we did this, and then left Bajay to drive the animal at its own pace after us, for even unloaded it was scarcely able to walk. This was quite a blow to us as we still had two or three days to travel before we could find a replacement.

As we neared the river we could see a village appearing on the shoulder of the hill on the far side, where a small valley led away westwards towards inner Tibet. The houses were all built with their backs to the sheer face of the mountain and from where we now were, far above them, they appeared to be very precariously perched above the river. However, when we arrived on the banks of the river about noon they were seen to be some distance away on the opposite bank and all our shouting and halloo-ing could call forth no response. Finally Tsering Dorje unslung his rifle and fired a shot in the air which echoed and re-echoed in the surrounding valleys and which brought some people running to the water's edge on the far side. A shouted conversation gave us the information that the loads and men would have to be ferried over, and the horses would have to swim.

As they bustled about launching a coracle, we began to unload the animals in preparation for the fording. The fording-point on our side was only a small natural inlet of stones beside the river, but on the other side it opened out into the mouth of a small valley to the right of which lay the village. Between, the river whirled and eddied by with sullen force. As I watched the coracle being carried swiftly down-stream by the speed of the

# The Journey

current in mid-river I was dubious whether this land, which could provide more difficulties in one day's travel than any other in the world, could offer a satisfactory answer to this. That it had been accomplished successfully before was no comfort to me now. About a hundred yards down-stream the three men in the boat managed to propel the coracle out of the mad race in the middle to the comparatively quiet eddies of the side, and with a few powerful sweeps on the short, flat-bladed oars were soon beside us.

The coracle looked even more crude at close quarters, being of yak-hide stretched tightly over a rough wooden frame work, and the seams daubed thickly with pitch.

"Take the loads first, with Tsering Dorje," I ordered. "Then Loshay and I will send the horses over and Tsering Dorje can round them up on the other side while we are crossing."

As soon as I saw them safely over the mid-stream current I gave Loshay the all-clear and we drove the horses and mules into the water. They were unwilling to go, and I could hardly blame them as I had felt the water and seen its force, but we required them on the other side and go they must. With stones and yells we finally got them out of their depth, when they ceased struggling and with heads high and tails streaming began swimming for the other side. All except my horse. It refused to take the plunge no matter how much it was beaten, and at last we decided it would have to be towed across. The others were now several hundred yards down-stream and I had some bad moments when I thought they would be carried beyond the sloping sides of the valley-mouth to the sheer-sloped channel beyond and so be lost. But they managed to get out of the current in time, and soon Tsering Dorje with a few others had rounded them up and they were rolling in the hot sand of the river bank.

It was now our turn to go over, and as the coracle rocked under our feet I was in two minds whether to leave the horse and see if it would come after us when we had gone. The rowers of the coracle, however, insisted that everything would be all right once we had it swimming and so began a tremendous

tug-of-war with the horse which the horse almost won. Just when I thought it certain that we should topple over into the water, the horse overbalanced and had immediately to concentrate on swimming to keep its head above water. I am certain my eyes were rolling in no less panic-stricken a manner than the horse's when we reached mid-stream. We were helpless in that current with the water hissing angrily past, but the three Tibetans dug in their oars at certain intervals with sure, steady thrusts and almost before I knew it I was breathing easily again in calmer waters. That journey paved the way for several grey hairs.

All this had taken about a couple of hours to negotiate and still Bajay had not arrived with the exhausted mule. However, I put off any decision as unnecessary at the moment since we should be eating at the village and should be there some time in consequence.

When we reached the far side an official, followed by several villagers, presumably municipal lesser-lights, came forward with all the superciliousness and pomposity of officialdom the world over. It would appear that power not only corrupts morally but mentally as well. Not having a desk and blotter to gaze at he tried to appear interested in the horses and saddles as if he had never seen such things before. This was presumably meant to clothe him with dignity and unclothe me of conceit. I adroitly reversed the position by staring at the horses and saddles as if I had never seen them before. In the meantime I wondered what would happen when the horses were saddled and on the move, for this would create a situation which civilized officialdom need not contemplate, desks and blotters not being mobile. I watched him out of the corner of my eyes watching me out of the corner of his eyes. He bit a mental pencil and concentrated intently on the problem raised of adjusting a saddle-girth firmly. I decided to move into attack and turned suddenly towards him. He turned to face me with the correct eyebrow-slightly-lifted-and-what-can-I-do-for-you attitude. But it was lost, for I had already focused my gaze behind and beyond him in the correct eyebrow-slightly-lifted-and-what-can

I-do-for-you attitude on his consort. It was demoralizing. She giggled. He coughed. Looking at Tsering Dorje, he asked where we had come from in the tone of where-do-you-think-you-are-going.

"Kham," I interpolated gently.

"Whereabouts in Kham?" he asked, which was hardly surprising since we were in Kham and Kham covers a greater area than the British Isles.

He was still looking at Tsering Dorje for an answer so I interpolated not so gently, "Bo".

Whether it was because of my Tibetan, or tone, or the fact that Bo suggested the name of Pangdatshang to him I could not say for sure, but in any case it was sufficient to make him look directly at me for the first time.

"Oh, you speak Tibetan?" he said interestedly.

"I speak Tibetan," I replied modestly.

The consort decided she had been ignored long enough, so she giggled and said brightly, "Oh, he speaks Tibetan."

Having discussed and seemingly exhausted the subject of my linguistic abilities there did not appear to be anything further for them to say, except to add a belated, "Come in." We went in.

The village was slightly larger than the one we had slept in last night and carried more evidence of officialdom—more people were lounging about doing nothing. We entered the village in procession with the official and myself in the lead and the not-so-private secretary two steps behind, then followed the horses being led, with some of the village unworthies walking with my companions, and last of all the worthy villagers en masse.

Having been unceremoniously escorted to a large room in a many-roomed Tibetan house overlooking the river, I sat down in state to receive the local functionaries—or defunctionaries. (It was a moot point, depending on the state of one's liver rather than administration.) However, I was under no great compulsion to speed. I was thirsty, and my liver was in excellent condition, so friendly relations were soon established over tea, wal-

nuts and dried fruits. There were several grinning young boys about but the giggling girl friend was absent, so matters could be discussed fairly reasonably without the off-stage sound effects, comment and applause.

The next day's stage being some distance away, it was considered advisable to stay here for the night as there was still no sign of Bajay on the face of the far mountain. While the meal was being prepared I discussed news of local significance and passed on some news of China to the local officials. The Tibetan Government-appointed official was a sort of frontier-cum-customs inspector and so I had to produce my passport and give a statement of goods carried. When he forgot his position he was almost a normal human being—and a nice one at that—and we got on famously. Thinking that I was not only white but green into the bargain he levied quite a heavy tax on the goods I was carrying, even after I had declared they were for barter and not for trade. My companions argued for a bit and then, thinking that these foreigners have always plenty of money to throw around anyway, would have agreed to the tax. But coming from a race which bitterly resents even legitimate tax demands I was not going to concede so easily an obviously illegitimate one. My fellow-countrymen would have been proud of me had they seen me in that hour. I was "fly". With a carelessly magnificent gesture I capitulated and then with an innocent smile asked for a wax-sealed receipt. Silent chagrin under Oriental blandness. I had won in one move. I was travelling from the highest official in one area to the highest official in another, so he dared not commit himself in writing in case I later delivered the receipt as damning evidence. He retired, ostensibly to write a letter, but obviously to try to cover this disastrous relapse. I pressed home my advantage, and at the same time "saved his face", by diplomatically dispatching Tsering Dorje with a gift and presentation scarf and a suggestion that two bundles of snuff would be considered an adequate compromise with an accompanying guarantee that no action would be taken on the sealed receipt. I still wanted that receipt as the spoils of victory. Tsering Dorje returned vic-

torious and also with the information that the official would supply a horse to replace Bajay's mule and a soldier escort to go with us to the next official two days' journey away.

Just as dusk was falling there was a faint halloo, and on looking out of the window we could see the vague outlines of Bajay and the mule on the far side of the river. The mule had collapsed in a heap and we wondered callously whether Bajay would have to sleep beside it for the night. The villagers, how- ever, very generously agreed to take over some grass and grain in the coracle and to tow the mule back. I will draw a curtain over the remainder of that night out of respect for the feelings of Bajay and the sensitivities of my readers.

## 21st January

I was not too sure but that the official, having a night to brood over real or imagined wrongs, might not produce some sort of bland reason for our not being able to travel. Con- sequently, my suspicious mind was pleasantly surprised to find the horse and escort as promised on the doorstep. The escort had the appearance of a mixed blessing, though, as he looked thoroughly piratical, I was relieved that Loshay, Tsering Dorje and Bajay stood between him and me in regard to any form of communication. His hair, in a long greasy plait lying down his back and caught in an ivory ring, was crowned by a conical, three-flapped, rakish fur hat; he had the long ankle- length, homespun gown which the "Bod-ba", or Lhasa- governed Tibetan, wears in contrast to the short knee-length gown of the Khamba. The distinction between the "Bod-ba" and the lawless, independent "Khamba" tribesmen can be drawn and appreciated by comparing the former to the London-born Englishman and the latter to the Scottish High- lander. The parallel is almost exact, from the superciliousness to the kilt-length gown. Our escort was a Bod-ba, Wang-du by name, and the others waved him ahead to lead the way. He seemed a cheerful enough type, or perhaps plausible would be a better term, as he had all the earmarks of the supercilious,

meaningless politeness which was so irritating after the frank likes and dislikes of the more open Khambas. I was biased, of course, because being a Scot I was sympathetic with the rebel Khambas—and anyway, the fellow wore a huge gold and turquoise earring which made him look ridiculous and effeminate.

There was not much opportunity to talk for the trail was rough and narrow, winding sharply upwards out of the Yangtze gorge. It remained cold for some time as the sun did not penetrate the narrow confines of our present valley until late in the morning. After the difficulties of the past few days, the trail was comparatively easy, and I let myself drift into a saddle doze— a sort of half-observant, half-contemplative condition. This is the only way in which travelling in those parts could be borne, I found; otherwise the boredom would be nerve-shattering and overwhelming. Long stretches of unbroken ice and snow, long stretches of unrelieved valley, long stretches of unbending trail, long stretches of smooth plateaux. Each part uninteresting in itself but intensely impressive in the comprehensive setting of the whole. And over all the majestic solitude and awesome silence. Woe betide the man with nothing in his mind and nothing in his soul in such a setting. The scene is set for judgment and the perspective is God's.

After four or five hours' climbing we topped the long sloping incline of the pass and entered a wide valley, down which at irregular intervals were scattered Tibetan houses as far as the eye could see, the whole valley being cultivated. Smoke curled lazily from the roofs of the houses and was then whipped away by the rising wind blowing straight up the valley. We had been comparatively shielded in our climb from below but now we were exposed to the icy blast again, and I zipped up my fur coat, while keeping my hood down to let the wind lift my hair. The sun still shone and gave the usual heat offset by the usual cold of early afternoon; a hollow out of the wind and the heat was almost tropical, a hollow out of the sun and the cold was almost arctic.

I thought idly as I rode along that some of the Tibetan

# The Journey

inhabitants must be feeling the cold more than usual, for there appeared to be a considerable amount of smoke coming out from the right side of the valley. Probably just clearing away a space for cultivation, was my next thought, as I saw fire among the trees. However, as we proceeded down the valley in the usual spaced-out single file I paid more and more attention to the blaze for, as far as I could judge—and I had had some experience of fires, yak dung, etc.—this one bore all the signs of getting out of hand, and with gigantic pine forests rising to the towering peaks and a high wind it appeared as if Moloch would hold high revel that night. Before we had travelled many miles my fears were confirmed and a mighty, raging inferno was crawling and slithering up the valley under cover of an ever-accumulating grey-black pall of smoke. We were about a mile from the centre of its path, and with the open valley between us, so long as the wind did not vary, we were in no great danger. The animals were restless, though, and kept cocking their ears towards the spot and occasionally stopping altogether to face the source of danger. We were now travelling in a sort of pre-mature twilight as the smoke had so thickened as to shut out the sun, the underside of the clouds a livid red from the flames, passing through greenish-grey to black. The howling of the wind had now been completely absorbed and superseded by the roar of the flames and the crash of falling timber. It was fearsome and magnificent.

Gradually the smoke thinned and we came out of that snarling, encroaching horror to the clean wind and air of the valley again. The force of the wind was driving all the fire and smoke up the valley away from the houses, so they were well out of danger. The valley had widened out as well and the trail was defined so that the horses plodded on their way without attention. As we passed each house an old wrinkled man or woman would stare unblinkingly at us and only his or her moving head gave indication of their interest in the sight of a strange foreigner. The men, women and children were in the fields, or on the flat roof-tops beating out the grain, and shouted an occasional greeting as we passed.

Shouts and jeers of laughter brought my wandering gaze and thoughts back to my companions, Loshay and Bajay and Tsering Dorje, and it seemed to have more pointed significance than the usual lurid leg-pulling. Then, suddenly, it dawned npon me! I, too, joined in the general caterwauling, and lying on my horse's back, I wept. Tsering Dorje gazed at me reproachfully but it was too priceless to resist and for the next few minutes we roared our way down the valley. Tsering Dorje of the imperturbable sangfroid and the inevitable answer was returning to his valley and wife—*and he had no idea what she looked like!* This incredible state of affairs was further complicated by the fact that he knew the valley but he did not know what house she would be in, and—last irony of all—she did not expect him so she would not be able to help him identify her. Tsering Dorje had been with Pangda Rapga in India and had married Rapga's wife's maidservant. When Rapga had left India for China, his wife had taken her servant but Tsering Dorje had gone back to Kham to join Topgyay and had travelled with him since without having an opportunity of meeting his wife in five years. Loshay and Bajay were almost delirious with delight and swayed in the saddle with great paroxysms of laughter as they rode. Time after time they had been defeated in verbal battles with the redoubtable Tsering Dorje and now they were mercilessly attacking their friendly foe.

As we passed a house the family on the roof-top stopped their activity to watch us ride by, and a few of them disappeared to run to the doors to get a better view.

"Hi! Tsering Dorje, look out!" bawled Loshay. "Here's your wife coming to meet you. She just fell off the roof when she saw you."

"Wah-wah-wah-wah-wah," guffawed Bajay.

"You pair of gibbering idiots," grinned Tsering Dorje ruefully.

A group of children huddled together to gaze at us, wide-eyed and solemn.

"Which one do you think looks most like Tsering Dorje?" Loshay enquired of me solemnly.

# The Journey

"They all look like Tsering Dorje," replied Bajay coarsely, before I could think of a suitable answer.

"Ha-ha-ha-ha."

"You pair of parentless, useless, hopeless Khamba thieves," grinned Tsering Dorje pityingly.

Was that a shade of embarrassment I could detect in that wooden countenance? Or was it just the usual sardonic grin preceding a return to the attack?

"If you paid as much attention to your work as you do to your own jokes you might turn out useful one day—if you live to be a hundred," he said sarcastically. He added—laconically—"Where are the animals?"

While Loshay and Bajay had been speaking they had been facing up-trail, lying on the horses' necks, while I had been across the trail at right angles to them. Tsering Dorje had been facing down-trail just as he had ridden up when they had stopped to joke with him, so he alone had been able to see the horses leave the trail and scatter in search of grass. Now, sitting cross-legged in the saddle, he wickedly got his own back as he shouted profane advice to the two shouting, madly chasing Khambas. With a grin, a wink and a lift of the eyebrows Tsering Dorje suggested that we move on. With an answering grin I settled in the saddle once more.

Wang-du shouted that he would ride ahead to inform the local official of our imminent arrival and of the arrangements which had been made at our last stopping-place. I shrugged and let him go, but I had no intention of staying with the official since I preferred to stay with Tsering Dorje and had agreed on this en route. To be with the local bigwig would mean an endless series of questions of one kind or another and an exchange of polite nothings, while there was bound to be fun with the others at Tsering Dorje's unique home-coming.

Reaching a spot where there were a few houses clustered together around a water-driven mill, we enquired the whereabouts of Tsering Dorje's wife. After a gaping stare for fully a minute the old miller pointed to a house a few hundred yards away on the far side of a hill. The sun had dropped behind the

68

mountains and again it was bitterly cold. As the horses crossed the stream, already beginning to form at the edges was the ice, which would spread rapidly as the night advanced until even the mill-race would be throttled in its relentless grasp, waiting again for the freedom of the next day's sun.

When we neared the foot of the hill we could make out figures on the roof of the house we were approaching, and when they saw that we were definitely heading their way they left the roof to meet us at the door.

"There are several men there, Tsering Dorje," said Loshay cheerfully. "It looks as if your wife has found another husband."

"Or several," suggested Bajay brutally.

"There are several women there as well, Tsering Dorje. Which one looks like your wife?" I asked with bland innocence.

"It doesn't matter," drawled Tsering Dorje, "any of them will do; but you need only look for *my* wife among the good-looking women—which is where I would not look for yours."

There was a sort of tenseness about him, though, under the lounging nonchalance, which was hardly to be wondered at as all his future equanimity depended on the next few minutes and how he handled the situation.

Suddenly, a female figure detached itself from the group, now only about fifty yards away, and came towards us at a run. I flashed a look at Tsering Dorje and his grinning relaxation in the saddle gave the answer. It was his wife. Good-looking in a free, eye-flashing, gypsy-ish fashion she, too, hid her excitement under a casual exterior, only her dancing eyes, as she held the horse for Tsering Dorje to dismount, showing her inward surprise and delight. The other members of the group had now run forward as well and we dismounted amid a bedlam of shouted greetings and milling animals.

The mummery of the next hour I will remember to my dying day. When we mounted the ladder to the living-quarters of the house, Tsering Dorje's wife led the way followed by Tsering Dorje, myself, and Loshay and Bajay carrying saddles and bridles. The villagers unloaded the animals and stacked the loads according to the usual Tibetan custom on arrival. Tsering

Dorje's wife immediately proceeded to pile wood on the fire and prepare more tea for the unexpected visitors while we disposed ourselves around the fireplace on spread rugs. For a few minutes there was exaggerated activity to cover up the general all-round confusion of the moment until, with all saddles and bridles stacked against the wall and everyone comfortable, there was nothing left to do but wait until the fresh tea was made. It might have been supposed by the casual observer that the confusion was due to the embarrassment of Tsering Dorje's and his wife's meeting after so long a time in front of strange visitors, and to the guilty consciences of Loshay and Bajay who had said so much in anticipation of this meeting. The former may have been true to a great extent on the part of Tsering Dorje's wife, Tsering Dorje himself only showing it by a restless moving about to fetch bowls and poke the fire; but the latter was most certainly not true. Loshay's and Bajay's manner was so meticulously quiet and controlled that Tsering Dorje kept throwing them sidelong, uneasy glances. When their glances met over the bent head of Tsering Dorje's wife there was a blank innocent expression on Loshay's face and a mouth-puckered, eyebrow-lifted expression on Bajay's. When Tsering Dorje's wife looked up and addressed some remark to them they replied gravely and then sat gazing silently into the fire. No sooner had she turned away to attend to something else than Loshay and Bajay were at their most wickedly suggestive eye-play.

"You blankety-blank-blanks," hissed Tsering Dorje hurriedly, on one of the occasions when his wife left the room; "what do you think you are playing at?"

Loshay and Bajay looked at each other innocently wide-eyed, and then, on a warning glance from Tsering Dorje to the door, to contemplating the flames once more. It was priceless, and I gave great sobbing gulps as my laughter rose to choke me. The sound of footsteps indicated the return of Tsering Dorje's wife and also someone with her. I looked idly towards the door expecting to see the usual gaping villager—and saw the villager all right, but it was I who did the the gaping. Framed in the doorway was one of the most magnificent-looking young women

I have ever seen. She was almost six feet tall and the bulky sheepskin gown hung on her like a wispy robe. A long plait of jet-black hair lay over one shoulder and reached to thigh-length, framing a face of cameo-perfect proportions. The wool-lined gown was thrown carelessly back from one shoulder exposing the whole upper part of a magnificently sculptured body and, to complete the unconscious grace of the picture, a six-months-old baby fed at one breast. I took a deep breath and then, conscious of the silence, looked at my companions.

They too had turned to the door at the sound of the girl's entrance but whether they had been impressed as I had I could not say. If they had, they gave no sign of it but turned on Tsering Dorje with the most significant, accusing, suggestive expression it was possible to convey in a look. It was lyrical. Tsering Dorje, caught off guard as he turned to talk naturally to the others, took it amidships like a naval salvo. It was not defeat—it was disaster. His mouth dropped open in questioning surprise and then slowly over his usually inscrutable, granite-like face spread an unbelieving dawn of comprehension. With tears streaming down my face I lay on the rug and gave way to sobbing, uncontrollable laughter; all the muscles in my chest seemed to be thrown into physical anarchy as I battled for control, and then, remembering that last look, went into hysterics again. When I had recovered myself in a measure I noticed that the pointed significance had gone from the situation, washed away in a flood of general laughter. The two women looked curiously towards us and then, thinking it was some private joke, continued quietly and smilingly with their preparations. Between Loshay, Bajay, Tsering Dorje and myself no explanations were necessary. In that father of all looks had been conveyed the story which age would not wither nor custom stale. Tsering Dorje had been accused of having two wives; one, the younger, being tired of his absence and age, had let her eyes and feet wander and had returned with the inevitable consequences. It was not the accusation that had appalled Tsering Dorje, for this after all was a normal happening in Tibet, but the awful possibilities in the situation interpreted in that look.

# The Journey

The tea being now boiled and churned the conversation became normal and general. Tsering Dorje's wife remembered foreigners and foreign customs from her travels in India and China and was inclined to apologize and fuss over the lack of amenities, but was soon set at rest by my protestations.

Some time later Wang-du arrived with another soldier to say that he had informed the official of my arrival and that the official had prepared a place for me to stay. I expressed my gratitude in appropriate terms for this display of hospitality and my regrets at being unable to take advantage of it as I had made previous arrangements to stay with Tsering Dorje; would he convey my apologies to the official for not accepting his kind offer and for my being unable to call as I was too tired and expected to retire immediately? For a few minutes there was a vehement, low-voiced colloquy from which I gathered that they were rather taken aback at my choosing to stay with Tsering Dorje in preference to the official, but my companions finally succeeded in convincing them that that was my intention and they left, bowing and breath-sucking politely.

With an upsurge of fatigue, remorse and sympathy I intimated that I would like to retire, knowing that this was an occasion when there would not be the usual crowded promiscuity around the fireplace. My sleeping-bag was laid out in a little box-room, which had just been built, to judge by the appearance of the wood of the four walls which I could touch with outstretched arms. Loshay and Bajay were to be housed in the lumber-room attached to the main living-room. My room must have been intended for the god-room, for the flickering yellow light from the small butter lamp lit up the faces of the various household gods who appeared to leer and scowl and snarl in a manner startlingly alive in that interplay of light and darkness. As their faces dimmed and finally flickered out in the darkness, and sleep began to lay her hands caressingly on my closing eyes, I wondered sleepily if Loshay and Bajay had been successful in their unspoken threat of domestic blackmail unless Tsering Dorje proved co-operative—or communal.

# 22nd January

## 22nd January

The night before Tsering Dorje had made arrangements for a
change of animals to take us to the next stage, where we should
change again for the final stage to Gartok. I had insisted on a
long stage for today in order to reach Bumda valley, the family
estate of Pangdatshang. Actually, Pangdatshang's name had
been translated wrong phonetically as it should really have read
"Bumda"-tshang. It was this valley I wished to reach today in
what was normally a two days' journey. I had decided, also, to
leave Tsering Dorje behind to enjoy belated nuptial bliss.
Topgyay had offered to let me have him all the way to India if
I wanted him and he was agreeable to going. At first he had
been full of the idea but I had sensed inner reluctance growing
as he approached his home, and so I had relieved him of the
necessity of deciding by saying that I did not require him. It had
required quite a bit of thought to do this because he was one of
the very few Tibetans who had ever made the complete trip
over the trail I intended taking to India, although his memory
of it was necessarily hazy as it had been several years ago.
Then again, he knew a little Hindi which would have been a
considerable source of comfort to me, for once the trip across
Tibet was completed there would still remain an unknown
period of travel until an English-speaking centre in India was
reached; finally, there was his ability as a personal servant,
learned in tough situations and hard places, and his unfailing,
cheerful good humour which I should miss most of all. I was
however strengthened in my decision by his wife coming to me,
as I went for a stroll outside while the animals were being
loaded, and asking me if I was taking Tsering Dorje with me to
India. She was a Tibetan, she would not cajole, obeying the
rugged masculine laws of that rugged, masculine land, but she
had the appeal of all women in her eyes. It was a moment
which might have been cheapened by laughter or made maud-
lin by sentiment. I thought for a little, as if I had not pondered
the question before, and then nodded my consent to his re-

73

maining. She turned and hazed some calves out of the compound; I turned and continued my stroll. I had lost a companion and gained a friend. Even so, it was difficult to watch Tsering Dorje's too obvious fussiness over details, unusual in him, as the inborn lure of the road pulled at him more and more when the time for departure drew near. One word from me was all he needed—and wanted, at this moment!—and with leg across the saddle and rifle across the back he would have been with us again. I remembered lips too proud to speak and eyes too proud to weep, and kept my teeth upon my tongue.

The pack animals moved off, Loshay, Bajay and I swung into our saddles and, amid shouted farewells, we pulled the horses' heads away from the warmth of the stables to the cold of the trail. We galloped for a little while to catch up with our caravan, then pulled in to the steady plod of travel.

About an hour later I heard the sound of hooves approaching rapidly behind us, and thinking that we had left something behind, I called a halt. Round a bend in the trail swept a company of galloping horsemen, amongst whom I recognized our escort of yesterday. I waved a friendly hand to them, wondering at the same time if they had come to see us off or if they were all going to travel with us to the next stage. I was not left long in doubt. The leader, a tall, well-built man with strong Khamba features although wearing Tibetan dress, gave a curt order and his entourage dismounted, ordering us to do the same. He whipped out another curt command to Wang-du who cringed before such obvious displeasure, and then turned to me to state bluntly, "Kungo[1] wishes to see your passport."

I instinctively bridled at the whole procedure as it savoured too much of high-handedness to suit me. However, I held myself in by acknowledging to myself that he was probably annoyed at my choosing to stay with Tsering Dorje instead of his high and mighty lordship, and also I had committed a bad breach of courtesy in not calling upon him. As I had arrived late and left early, though, this was not so bad as it might appear, and in any case he had no right to challenge my

[1] Term of respect for official.

74

authority because I had been cleared at the border and it was not his responsibility.

I gave my passport to Loshay without comment, signifying that I had nothing to say and that all matters were to be handled by my servant. I would match authority with authority and rejoice in the battle. But I noticed with amazement that Loshay and Bajay were scared and taking the brunt of the conversation without attempting a reply. I had given no sign of understanding Tibetan as I leaned against my saddle, stroking the horse's neck and seemingly completely oblivious to the squabble going on in front of me. I was following the conversation closely, though, and when Loshay turned to me to tell me that the official was ordering a halt or a return to the village until he was satisfied I decided that the time had come to speak of other things.

"Tell the official he is a liar," I ordered Loshay as an opening line. Loshay gave me a startled look and then, thinking that I had not rightly understood, repeated his previous statement.

"Tell the official *I* say he is a liar," I repeated firmly. "The British passport is in order, the Chinese passport is in order, the Tibetan passport has been issued by Dege Sey with Dege Sey's seal on the authorization of the Tibetan Government. If he cannot read that, he is a fool; if he says that it does not say that, he is a liar."

Loshay blenched, but had no alternative than to go ahead as I had spoken loudly and everyone had understood what I said anyway.

There was dead silence following this pronouncement, and also while they digested the fact that I had understood what they had been saying all the time. The official did himself the credit and me the honour of turning to address me personally.

"You are a British subject?" he questioned brusquely, although I noticed that some of the curtness had gone out of his tone.

There is only one thing more satisfying than seeing undelegated authority flouted or wrong justice flouted and that is to do it oneself. I did it. I did myself the discredit and him the dis-

honour of not replying, but merely tilting my chin disinterestedly towards the British passport in his hand.

There was an even deeper silence. (This was possible as breaths were held.) I made circles in the dust with the thong of my riding-whip.

"You have come from China?"—a slight hesitation as if unsure how to proceed.

I gave him an amused glance, telling him silently not-to-risk-making-a-fool-of-himself-as-he-already-knew-he-was-defeated-and-was-only-striving-to-save-some-dignity, and tilted my chin disinterestedly towards the Chinese passport in his hand.

He rushed in. "This is not an official Tibetan passport." It was a desperate last stand.

I had warned him, and he had refused to take the implied hint. He had to learn the lesson of all who take to themselves authority without authority—he that takes the word shall perish by the word. The melodramatic silence had gone on long enough. I slapped my riding-whip against my booted legs, knocking off the dust in small clouds, then turned to answer him.

"One, I am a British subject; two, I am coming from China; three, I am travelling to Gartok at the invitation of Dege Sey, your Commander-in-Chief, whose letter and seal you hold in your hand; four, I am carrying letters from Pangdatshang for Dege Sey at Gartok, for Chamdo, and for Lhasa. Do you want to see them as proof? Or would you rather admit that it is none of your business?"

I held his glance until he finally looked away, confused, at the letters in his hands. He had nothing to say and his own pride had been his downfall. I was now in a position to ruin him as a friend of Pangdatshang in Kham and as a friend of Dege Sey in Tibet. I was tempted to deflate him even more by driving this home in front of the others, as Tsering Dorje had told me that he had been only one of Pangdatshang's muleteers who had worked his way up to his present position. However, I spared him this indignity, more from a sense of my own negligence in not paying him a courtesy visit than from any natural sym-

pathy. The memory of his contemptuous and high-handed treatment of Loshay and Bajay still seethed within me.

"I'm sorry if I inconvenienced you in any way," he spoke up courageously, "but no foreigner has passed this way before, and with the war in China I have to be careful."

He knew the rules of combat so I played the game accordingly: "That's all right," I immediately replied; "it was my fault for not calling on you last night or even early this morning, when there need not have been all this bother. I'm sorry if I have caused you any trouble."

The tension was gone and the atmosphere returned to the normal camaraderie of Tibet. Soldiers and servants mixed in a friendly manner where a few minutes before there had been two distinctly hostile camps, with the soldiers on one side and Loshay, Bajay and my muleteers on the other.

"Are you sure you have enough animals?" enquired the official anxiously. "You have a high pass to cross. Have you enough warm clothing?"

I assured him gravely that everything could not have been arranged more satisfactorily, and that thanks to him I should arrive in comfort and safety. He still wished to do something to make up for his former truculence, however, and so I finally accepted his offer of another two soldier escorts. Giving them strict orders to see that everything was arranged to my satisfaction, and to tuck me in at night, he at last bade me a friendly farewell. It might have been a difficult situation, I gathered from the explosive comments of Bajay, who knew the man and his methods, but everything had turned out all right. Taking advantage of my present undoubted ascendancy over the other two I denounced them for not handling the situation more effectively, for allowing themselves to be bluffed and browbeaten, and for not obeying me implicitly in everything I had said. Their awe at my temerity and success was still upon them. We rode on in silence and great peace.

Their spirits were too ebullient to remain quiescent for any length of time, however, and soon they were leg-pulling with the unfortunate muleteers who had been sent with us to drive

the animals and who had consequently relieved Loshay and Bajay of their former guarding duties. As I jogged along behind them I could hear occasional snatches of conversation, and soon pricked up my ears when I discovered they were talking of Tsering Dorje, his wife and the young woman.

As I had surmised, they had unmercifully pulled his leg about hiding the news of another and younger wife and would have none of his hot denials. But to add to their cheerful perfidy they were shamelessly discussing a conversation they had overheard between Tsering Dorje and his wife after they had gone to bed. It appeared that the young woman was a relative of Tsering Dorje's wife and she had had a baby to someone who had passed on into the Tibetan horizon. However, as Tsering Dorje's wife was nearing forty and had no family, she wanted Tsering Dorje to take the young woman as a second wife and have children by her; they were very close friends and just like sisters, anyway. As I have said already, this sort of situation was quite common in Tibet in the areas where it was possible to find sufficient women, just as it was equally common to find one woman with two or three men in areas where women were scarce. It was the unknown lengths to which this incorrigible pair were willing to go to exploit the situation for a joke that made the present situation unique. I dropped well behind the caravan as I turned my thoughts to nature instead of man for a change.

We had been climbing gradually since leaving our friends and were now on the high grasslands at about fifteen thousand feet. The trail wound away ahead on the undulating plateau, covered with primulas, gentians, rhododendrons and a variety of herbs, sometimes discernible and sometimes losing itself in a hollow. The animals plodded ahead in an extended line instead of the usual single file which the restrictions of the trail determined. We dropped down into a valley in which there were a few houses, and on Wang-du informing me that a junior official of some kind lived there, I decided to avoid any further complication by paying a courtesy visit. In any case there would be tea there and, also, I could have breakfast as I had not eaten

## 22nd January

before leaving Tsering Dorje's that morning, only having drunk the usual bowls of scalding tea. Wang-du went ahead to announce my arrival in the customary fashion. The official was short and fat and curious. His daughter was short and fat and curious. The villagers were curious. The dogs were curious. His underlings were curious. I was hungry so I answered their questions at the ratio of one reply to two bites of food. Everyone being satisfied I then left in an even better state than I had entered—inwardly and outwardly.

We climbed for a bit then dropped down into a beautiful wooded valley through which flowed a placid river. It was so peaceful after the usual savage scenery with raging torrents that I jogged on through the hours in a pleasant half-dream, until Wang-du once again announced that it was time for him to ride ahead as we were approaching the village at which we must change animals for the next stage to Bumda. This ought to have been the normal stage for the day, but my insistence on reaching Bumda tonight meant that we should lunch there, then pass on.

It was quite a large village and the house to which we were led was one of the largest I had seen (apart from Pangdat-shang's of course) since leaving Litang. It occupied three sides of the inner compound, with a wooden gallery running round the outside at the living-quarters level. Inside, the living-room was spacious and panelled in wood which had not yet had time to become begrimed, and so was lighter than in most Tibetan houses. My eating of tsamba, dried strings of raw meat and vast quantities of butter tea called forth exclamations of surprise and delight on the part of the populace jammed outside the door. A bite-by-bite commentary was given by one of the more fortunately placed inside and was carried back by repetition to the unseen watchers behind.

It appeared that some local celebration was being held and that accounted for the number of people to be seen in the village at a time of day when most were usually in the mountains or in the fields. The holiday was to prove a nuisance in other ways when, after we had finished eating, I stressed the need for haste if we were to arrive in Bumda that night.

# The Journey

Like all holidays the world over, the local festivities gave rise to serious transport difficulties, only here instead of strap-hanging or corridor-clinging they meant yak-chasing. It appeared that nearly all the horses had been driven up the mountains to graze, and since it was a holiday no one could possibly go and fetch them, in which case we should have to take yaks to carry the remaining loads. Now let no one think that I view the yak disparagingly. It is a wonderful animal. If someone's reply to the question, "Give a reason for your belief in God," was, "Because of the hair on a bee," then an equally legitimate reply would be, "Because of the yak in Tibet."

Without the yak life in Tibet would be impossible. The existence of this huge, placid, lumbering, buffalo-like animal with the long shaggy hair reaching almost to the ground is the one fact which more than any other ties Tibetans to Tibet. Without the yak they could have no milk; without the milk they could have no butter; without the butter they could have no tea; without the tea they could have no existence. Selah. Without the yak they could have no plough; without the plough they could have no crop; without the crop they could have no food; without the food they could have no existence. Selah. Without the yak they could have no loads; without the loads they could have no goods; without the goods they could have no barter; without the barter they could have no existence. Selah. Without the yak they could have no wool; without the wool they could have no money; without the money they could have no goods; without the goods they could have no existence. Selah. There are also a multitude of minor considerations. Without the yak they could have no yak-meat; without yak-meat there is insufficient of other meat to feed the people. Without the yak they could have no yak-tails to send abroad, which would create an international crisis, as Santa Claus has his beard made out of yak-tail, wigs are made out of yak-tail and of course there is the ubiquitous tinned "ox-tail" soup. Taken by and large (and a yak should not be taken any other way) the yak is absolutely necessary to Tibet. But we must not forget the question of reciprocity. The balance of nature must not be

disturbed. And we are happy to say that Tibet is absolutely necessary to the yak. Briefly, without Tibet the yak could have no existence.

Now, having said that, I suppose I shall be inundated with letters telling me that there is a well-known case of a yak being seen on the plains of India, or that the author seems to be ignorant of the fact that there has been for several years a yak in the New York Zoo, or that a creature closely resembling a yak was seen wandering above the snow-line on Ben Nevis. Before the battle is joined, let me humbly submit that in all my experience I have never yet seen a yak below seven thousand feet that was not in a distressed physical condition. The high altitude is for the yak and the yak is for the high altitude.

As I said, the villagers wished us to take some yaks in the place of unobtainable horses, but I was flatly against it. I did not want the worthy animals, because I was in a hurry. And the fierce-looking but remarkably docile yak is compliant in everything but this matter of haste. It has a set speed-limit and beyond that it refuses to go, as it has no use for speed except when angered—and then it has no use for man, who has then no time or inclination to reason or remonstrate. We were doomed to defeat. We could either wait until the next day when we should be given horses or we could insist on leaving immediately and take the yaks. We took the yak, and at the same time I threw out dark and vague promises of judgment to come if we should be stranded en route and not be able to make our destination. The first round being theirs they knew that the second round would indubitably be ours, and there was a sudden rush and scurry to get on the way.

My new horse was small and scraggy, with a most uncomfortable gait, and as I continued to inculcate the need for haste on the drivers, I was made to pay a very stiff price in my own body. However, I grimly stiffened my upper lip—and promptly bit it as the horse stumbled; which made me glance furtively at the others to see if they had noticed my discomfiture. Loshay and Bajay kept circling to keep the yaks from straying too far from the trail as they were inclined to fan out instead of keep-

ing to single file like the horses. At the same time these two made lurid promises of the whipping they were about to administer to the drivers, who immediately transformed their spleen to the yaks who, like the army private, had to bear it stoically.

About the middle of the afternoon, I was jolted out of a semi-comatose condition by a warning shout from Loshay. Heading down the valley towards us was a billowing cloud of dust which indicated a company of riders, and as any group of riders, and a fast-moving one particularly, was viewed with suspicion, we prepared for the worst. Bajay swung his rifle round on his shoulder to be within easy swinging-reach of his hand and Loshay loosened the flap of his holster to give the revolver free play. Both of them slid their swords up and down in their scabbards to make sure that they would come out easily in action. The free-trailing animals were bunched closer together so that they would not be panicked and separated, and we were ready.

I rode to the head of the column and some distance in front to draw attention, since I was well-known as Pang-datshang's friend and if recognized might be able to ward off an attack.

A group of about twenty hard-riding Tibetans gradually emerged from the dust-cloud and, with loud shouts and yip-yippees, rode down on us quickly. I held to the middle of the trail and they fanned out in a double line, pulling up in a wide semicircle in front of me, with the careless ease of confident horsemanship. Even the sight of three women amongst them did not dispel the doubt that they were bandits, for women were still the legitimate spoils of war in this fantastic country. I greeted them courteously, keeping both my hands well in sight, and there was the usual outcry and sudden laughter at the foreigner speaking their language.

The customary trail-greeting being "Where are you going?" the leader replied they were soldiers making for the river boundary where there had been some fighting lately. We did not slacken vigilance for an instant on being told they were soldiers; if anything, Loshay and Bajay became even more alert

as they, too, faced the group, slightly behind and on either side of me. With one hand resting lightly on the butt of rifle or revolver and the other on the hilt of their swords, they lounged easily in the saddle but showed they were ready for anything. Soldiers were well-known to rob and then lay the blame on some non-existent bandits.

The leader eyed us and then the animals lined up behind, and asked:

"Where are you going?"

"Gartok," I replied.

"Oh! You must be the foreigner that Dege Sey is expecting, then," he said. "We have just come from Chamdo and brought your passports from the Tibetan Governor."

The tension eased, and a few questions were asked about the conditions of the trail by both groups; and then with polite farewells they threw their horses into a sudden thundering gallop and disappeared again in dust behind us.

Loshay and Bajay exploded into violent epithets. I gathered that if we had not faced them out we should have been reckoned as lambs for slaughter and our liquidation assured. Both Loshay and Bajay were openly contemptuous of the soldiers, whom they considered afraid to face a showdown, and seemed to be blissfully unaware that they were about fifteen heavily armed men to two of themselves. I pointed this detail out to them in case it had escaped their notice and they looked at me pityingly as they explained.

"They are Tibetans, we are Khambas." The full significance of this weighty sentence will only be appreciated by those who have heard a Scotsman say "They are English, we are Scots." Not only were all the same subtle nuances conveyed, but the more obvious similarity of the rolled "r" was there as well. I accepted the rebuke with meekness and humility. There are moments in life when feelings are too profound for expression. This was such a moment.

We headed towards the sunset or in the general direction of the sunset, hidden as it was beyond the surrounding ranges, in contemplation interspersed with occasional bursts of vituper-

ation. For hours we had been travelling due east up one long valley and now were turning to the north and dropping down a long incline.

A break in the far range opened to let a stream of blood-red sunset pour down on us, while at the same time demanding the price for such a spectacle in the unshielded blast of a Siberian wind. I thought of the Scripture: "For I reckon that the sufferings of this present time are not worthy to be compared with the glory which shall be revealed in us." Tibet could provide the ultimate in the testing of the body but it could also provide the ultimate in the triumph of the soul. Puny man and an infinite God in a vast solitude with the perspective set. With all surrounding elements rising to overwhelm him, he could still fill his cup of life to the brim with the presence and beauty of God in Christ and exult in his intoxication with the Infinite.

We were in Bumda valley. One of the escorts pointed out a large white house built on the lines and scale of a fort on the other side of the valley about three hundred yards away, and informed us that this was Topgyay's house. I could only make out the outlines but it appeared larger than his house in Bo and the man told me that the inside was far better furnished and ornamented than the one I had left behind. Topgyay had made arrangements for me to stay here and so I was very annoyed when I found out that we should have to go further up the valley before we could unload the animals, as the changing-stage was there. As it was really dark by the time we arrived I was deprived of the opportunity of seeing this famous place. Loshay and Bajay had to ride down there for fresh supplies of tsamba and dried meat and butter, and I had to stay behind and take control of the unloading and the ordering of fresh animals for the next day.

My legs were numb, my hands were numb, my lips were numb: so I was rather at a disadvantage in trying to insist on urgency in arrangements for transit tomorrow. It was already late, we had not eaten, all the villagers would be in their houses for the night, scattered over the valley, but I wanted to leave at the first streak of dawn. What was it Rudyard Kipling wrote?

# 23rd January

*Now it is not good for the Christian's health to hustle the
    Aryan brown,*
*For the Christian riles and the Aryan smiles and he weareth
    the Christian down,*
*And the end of the fight is a tombstone white with the name of
    the late deceased.*
*And the epitaph drear: 'A fool lies here who tried to hurry
    the East.'*

The process of hurrying is infinitely more difficult when one
is faced with a very smooth, oily, plausible landlord. He was so
amenable to suggestion, so alive to threats, so anxious for our
welfare that I was convinced he would have nothing prepared.
However, we were hungry, we were tired, so we were sanguine.
A meal of iron-hard "scones" spread with slightly rancid butter
and eaten with strips of dried meat, washed down with bowl
upon bowl of butter tea, soon restored the circulation and
the bonhomie. The absence of Tsering Dorje meant less badin-
age but the irrepressible Loshay and Bajay soon found ex-
pression in telling tall stories to the landlord and his cronies.
The faces of the others, the bustling of the womenfolk stoking
the fire, pouring the endless bowls of tea, the monotonous
chanting of "Om mani padme hum" by a withered old crone in
the dark corner, began to grow pleasantly remote. I was warm
and full and content. I was asleep.

# 23rd January

My doubts of the previous evening were confirmed, for we
had risen, eaten and were ready to go and still no horses had
put in an appearance. When they finally did arrive they were
sorry-looking specimens, and again we had to take some yak.
The servants anathematized the landlord but of course it was of
little use as we had to be away immediately. I had been given
Bajay's sturdy grey pony which was the best of the lot, in order
to make an impressive exit fitting for one who was friend of the

85

# The Journey

leader in this particular area. For this was the centre of Pang-datshang's estate and influence.

We climbed steeply out of the valley for two or three hours into the face of the chill, early morning wind and freezing cold. The trail was wide and of very loose earth so that the horses were soon blowing heavily as they laboured upwards. The scenery in this part was particularly beautiful when we were once again in the high flowering grasslands, and dark pine forests swept up from the valley floor on both sides, to be crowned on the peaks with the towering purity of virgin snow. The blue of the sky was matched in the wide sweep of the river to be lost again in the foaming whiteness of spray. The sun shone out of a cloudless sky as it had been doing for months at this time of the day.

Arriving at the few houses where we had to change animals again we decided to eat and then ride non-stop for Gartok. As soon as we had finished eating the animals were loaded and we were on our way.

We continued to travel along the wide level floor of the valley which swept away into the distance, where presently showed up black on the horizon ahead some mountains, which were pointed out to us by the drivers as being the mountains en-circling Gartok. I was rather dubious about being able to arrive after all for they looked so distant, but Loshay just grinned and said:

"Leave it to us."

They then proceeded to put the fear of death—or something worse!—into the drivers and I have never seen yak moving so quickly, driven along by shouts, blows, stones and threats.

All day we pushed on and I had to get off occasionally to ease the ache in my back and limbs because of the punishment they had taken, and were taking. I had long since got over the usual effects of exertion in high altitudes and could swing along at a good pace at 12–15,000 feet at least. Naturally, I was still no match for the Tibetans who, born to it, could take the slopes of a mountain at a run at 20,000 feet when on the trail of wild animals.

## 23rd January

Rounding the shoulder of a mountain we came out on the edge of a wide expanse of plain which looked like a huge airfield, at the far end of which could be seen the houses that constituted the garrison town of Gartok. Loshay gave orders to the muleteer to continue to make good time and to follow quickly as we were going to ride ahead. I was still riding Bajay's horse since my own had worked a sore on its back and was unfit for riding, while Loshay and Bajay were riding hired horses obtained from the last stage. The trail was wide, meandering off into the grass on either side because of the smooth flatness of the plateau. All over busy field mice and marmots popped in and out of their holes as we trotted up and passed and I was a bit uneasy lest the horses stumble and break a leg. I need not have worried. Loshay and Bajay were adequately equipped with the philosophy of the Khamba that the best way to overcome any danger is to have a sublime indifference to the odds.

With a wild yell, Loshay kicked his horse into a mad gallop and Bajay was away a split second later. My saddleless horse joined in the race and, shielding my face against the flying dust and stones, I leapt into pursuit. I had to bury my face against the horse's mane to avoid the shower of gravel spraying upwards until I had swung wide and then drawn level. Loshay's horse was the worst of the string in the caravan, but he made up for it in sheer recklessness of riding and was almost under its neck as he swept it forward with ear-splitting encouraging yells.

The two Tibetan escorts had been a bit startled at such unorthodox behaviour but probably put it down superciliously to mad Khamba custom. However, as Tibetan custom demanded that they remain with me, they had to gallop as well to keep up, although maintaining a more dignified posture in the saddle. I waved a halt and decided that it was time for the escorts to ride ahead and announce my arrival. This was the sort of thing the escorts understood and could do with advantage and decorum without having to resort to such undignified practices as impromptu yelling horse races. They wheeled their horses at a fast trot and as they passed by I nodded to Loshay and we brought

down our whips with a crack on the horses' rumps. With a jerk
that almost lifted them both out of the saddle the two horses
gave a mighty leap forward and set off at a hammering gallop
across the plain. Bajay gave a whoop that died out in a sobbing
wail of laughter and thunder of hooves, and we were away
again. The two escorts threw startled glances over their shoul-
ders to see what was happening and then, having decided that
we were probably going to ride into Gartok at this mad pace,
settled down to do their duty and get there first. I choked with
laughter and dust as I saw Loshay wrench the head of his horse
round to get in behind them again and give their horses another
cut, the sound of which was lost in his shout. The horse he was
riding was a headstrong brute and a bloody froth was blowing
backwards on its neck and spattering the madly riding and
deliriously happy Loshay. We pulled in after a time to spare the
strength of our horses and the feelings of our escorts, and they
drew ahead. I wondered idly what sort of stories would be told
in the barrack-room that night.

We crossed some frozen streams and a wide but shallow river
on our way and then we were nearly there. A small cluster of
flat-roofed houses nestling at the foot of the mountain and a
large walled fort made up this garrison of the Tibetan Govern-
ment troops in South-East Tibet, or Markham Gartok as it was
called. Around the heavy wooden doors of the whitewashed fort
most of the township seemed to have gathered to watch our
arrival. Loshay dropped behind me and Bajay behind him
again to conform to Tibetan rank and custom.

The crowd surged forward and several men took the reins of
our horses to lead us the remainder of the way, between the
jostling crowd of sightseers. I maintained a gravity that would
have delighted the hearts of our escorts if they could have seen
it, but it was only with extreme difficulty, as I could hear the
comments on my peculiar appearance (bearded, blue-eyed,
brown, curling hair, etc., etc.)

I had been well schooled by the others in appropriate be-
haviour and so I did not dismount on reaching the two-leaved
doors, but bent my head only as we passed through. We entered

a wide courtyard which was also packed with people round the sides, but I had not time to notice anything else as my eyes rested on a well-dressed Tibetan coming towards me. This must be Dege Sey, I thought, and permitted myself to be helped from the saddle by several servants.

As I walked the remaining distance towards him with a pleasant smile on my face, I hastily ran over my choicest honorific phrases in Tibetan with which to greet him. He was the highest Tibetan official I had ever met, and with the warnings of Tibetan philologists regarding the consequences of misuse of the honorific sounding in my mind, and the comments of the crowd in my ears, I set myself for the ordeal. My last panicky, incoherent thought was: His smile looks pleasant but his gown looks expensive; and then we were together.

"Have you had a pleasant journey?" Dege Sey asked in good English. With a supreme effort of split-second adjustment I found myself replying calmly.

"Very pleasant, thank you. It was cold and rough at times, but very interesting."

"Let us go inside. It is warm there and we can have some tea while we talk."

He gave a smiling nod to Loshay, Bajay and the escorts who were standing respectfully behind with heads bowed and spoke a few words regarding them to a servant, then we moved towards a smaller gate leading to an inner courtyard. I decided that I really ought to try to recover some of the situation for the sake of the prestige of Western philologists, who had spent so much time and sweat in compiling sentences on "What to say to High Tibetan Officials without offending". So I launched out—in English, of course:

"You speak very good English."

"No, my English is very bad."

"Not at all. Your English is very good."

"I only have a few words."

"You speak very well. I was surprised."

"No, no. I think you speak Tibetan better."

"Not as well as you speak English."

# The Journey

"Bod-gay yak-bo kyen-gi-yod-dro." (Hon. "Probably you know Tibetan well.")

"Lak, yak-bo shay-gi-med." (Ordinary. "[term of respect]. Not very well.")

With this exchange of compliments I paid my respects to the philological dead and proceeded to enjoy myself in two languages with the ethnological living.

The inner courtyard was small, being probably not more than twenty yards square, with one-storied rooms all facing inwards on three sides. The light was failing so I did not pay much attention to detail when we crossed to the far side where the most elaborately ornamented rooms appeared to be. As we passed a door on our right Dege Sey halted, and asked if I would like to wash first or have tea.

"Your room is here. The servants' quarters are next door. Tea is nearly ready but perhaps you want to wash?"

I did not particularly *want* to wash although I was carelessly conscious of needing to wash. I wanted to drink tea first. However I thought that I had better start off in the normal Western fashion if I was an ambassador of Western goodwill. I decided to wash first.

Dege Sey then showed me my room and pointed across the passage-way to a door on the other side which led to his rooms where he would be ready when I was. Several servants immediately began running about to lay out basin and towel and soap as if I were going to make an occasion of it. I steadfastly resisted their subtle blandishments and even Loshay's more obvious protestations that I ought to have a "good wash", and merely swilled my hands and face. In white silk shirt, olive-green riding-breeches, polished brown top-boots and fur-lined jacket I was in a fit condition to drink tea with any prince—especially with a day's thirst strong upon me. With a lordly wave of my hand I ordered the water to be carried out, and then, weakening, agreed that I would have a "good" wash later. The most pressing need at the moment was lubrication, not titivation. I headed teapotwards with glad abandon. What a country! What a life!

90

# 23rd January

Seated crosslegged on a rug-covered dais at the end of the room was Dege Sey and he waved me forward to a seat beside him. In front of him was a small ornamented gilt table and he clapped his hands to indicate that we were ready for service. There was an immediate bustle and several servants with different functions began putting things on the table. I gaped. Pardon the crudity of expression but it is just what I did and there is no other way of describing it. For there in front of me were being placed beautiful delicate china cups and saucers, silver cutlery, foreign cream biscuits and—let me separate the phrase worthily from its ordinary fellows!—Indian tea. Yes, there was the western-style teapot and milk—and cube sugar. With a feeling of pleasure bordering on near ecstasy beginning to enfold me, I made the classic understatement of all time.

"Laks-so. Tu-jay chay." ("Thank you.")

Dege Sey smiled deprecatingly, and we were friends for life.

In the next hour we drank tea and discussed my journey out from Britain to China and from there to Tibet, then went on to talk of Dege Sey and his travels. He had been in Gyantse in West Tibet in his youth and while there had studied English under Frank Ludlow, who had been appointed teacher to young Tibetans by the British Political Mission. He had also been friendly with a Mr. Williamson and his wife who had been P.O. in Tibet at one time, had stayed with them on several occasions and had thus been given the opportunity to use the English acquired under Ludlow's tuition for eighteen months or so. Since then he had occasionally read English books as opportunity afforded and so had been able to keep up his early knowledge. His only other foreign contact had been with Tolstoy and Dolan in their trip through Tibet during the war years, and with a few people he had met during a short trip to China three years previously. This trip he had cut short as he received word that his wife was seriously ill, but even his hurried return had been too late for his wife died before his arrival. Earlier in the discussion he had told me his age was thirty-eight, the Tibetan custom being to ask in about the third sentence after meeting the amount of honourable years attained.

# The Journey

When I insisted that I really could not take any more tea, Dege Sey suggested that I might like to go and change before we ate.

I went back to my room and found that Loshay had taken over command and had everything in order as befitted the majordomo of an "important" foreigner. The big bed in the corner with the best rug had my sleeping-bag laid out on it and my change of clothes spread out ready for wear. The table on the far side held basin, soap, toothbrush, toothpaste, comb, mirror, towel, in impressive array. Another bed waited in solitary grandeur for an occupant I could not supply. Along one side beneath latticed windows ran a low rug-covered dais in front of which was set the usual low table.

My arrival caused an immediate scurrying among servants and sightseers who stood back respectfully as I entered, some of them in an excess of politeness putting their tongues out on their chins. I could think of no more significant act in return than to ask for water for a wash. I was about to ablute. A huge open charcoal fire in the centre of the room modified the ordeal somewhat but it was still cold enough for me to splutter as the hot water rapidly cooled on my manly chest and shoulders. For I had stripped to the waist. I *might* have gone further if the audience had been exclusively male, but it appeared that I was an object of interest to a considerable number of the female community as well, which increased my modesty more than my pride. However, having rapidly towelled myself into a condition of near warmth, I put on undervest and shirt and then proceeded to divest myself of riding boots and breeches. There was a murmur of interest—I am certain it was not consternation—and then an almost imperceptible stabilizing of equilibrium when it was seen that I was still in a condition to be seen. I merely wanted to wash my legs and feet. With Operation Occident at last complete, I proceeded to array myself in my best lounge suit complete with tie, holeless socks and shoes. I felt almost awkward at being dressed after such a long time—or maybe it was just at being washed!

Loshay and Bajay had stood by like graven images during the

# 23rd January

whole proceeding and had solemnly passed me studs and cuff-
links, and had even held my jacket. Even my best breezy com-
ments in the true T.D. tradition had failed to elicit any re-
sponse from their expressionless countenances. I felt a bit dis-
appointed that the first big occasion should so overwhelm them
that they lost their naturalness in a strained attempt at a false
dignity. Well, well, I ruminated, many others better equipped
than they had been unable to sustain sudden eminence. I shot
my cuffs and shrugged myself more comfortably into my jacket.
Bajay took a large bowl of butter tea in a silver Tibetan bowl-
holder from a servant and handed it to me. I hesitated, for the
fragrance of that Indian tea was with me still, but the steaming
flavour bewitched me and I drank. If it was going to take one
servant to pour the tea and two servants to pass it to me, there
was no great danger to my liver, I thought.

The bowl was immediately refilled.

"I won't take any more just now as I am going to eat," I said
to Loshay. "Are you all fixed up?"

Loshay gave a bewildered sort of nod.

"What's wrong?" I asked impatiently. "Have you gone
stupid?"

He gave me a long stare and then announced gravely:

"I've got a servant. Bajay's got a servant. Even our horses
have each got a servant. I have gone stupid."

I hooted with laughter. No wonder they were dazed out of
their normal exuberance. It was not due to their importance as
my servants, as I had imagined, but to the fact that they them-
selves were now masters. The experience was so novel and sud-
den it had caught them unawares.

"Is that all?" I queried. "In that case behave yourselves and
don't get into mischief. I am going to eat. Where is the silk for
the present?"

The Tibetans are such a hospitable people that they never
think of charging for hospitality. However, it is customary on
visiting a friend to give a present with the usual ceremonial
white scarf which is always exchanged in greeting. In our travels
amongst Tibetans of various ranks we had found it best to have

a variety of silks and brocades, obtained in China, to present to our many hosts, and graded according to rank. For the present visit I had decided that a full roll of beautifully designed brocade and a roll of silk ought to be given to accord with Dege Sey's rank and the importance of my visit. This was the present which I now asked Loshay to bring.

I returned to Dege Sey's room followed by Loshay and Bajay carrying the gift on top of a white scarf and, on Dege Sey's rising to greet me, offered it to him. He refused to accept it at first, also according to custom, then thanked me and the servants warmly. Before the servants retired he asked if everything was to their satisfaction, and on their murmured approval told his own men to serve them food. We then resumed our former seats and I handed over the letters I had received from Topgyay and Rapga to deliver to him. He would have laid them aside, but I asked him to read them and then we could discuss their contents and other matters afterwards. He gave orders for the food to be served and read the letters while we were waiting.

A few minutes later a servant entered bearing a tray of steaming dishes which were quickly placed on the table before us. As I bowed my head in a short blessing my salivary juices were already working at top pressure, and I could not help remembering whimsically Charles Lamb's essay on this same subject of grace before meat, and his argument that grace ought to be said after eating, since the mind was too occupied with the food about to be eaten to be really conscious of gratitude to God, and any prayer said before eating was more likely to be offered to the God of our bellies. I felt there was a lot of truth in this but at least thanked God for a good appetite to enjoy the food.

There were several dishes of meat, vegetables and eggs, cooked in Chinese fashion with different flavours and spices, and eaten with chopsticks.

"I suppose you can use chopsticks all right?" said Dege Sey, and I smiled assent.

"I am sorry I am only able to offer you Chinese food but my cook does not know how to make foreign dishes. It is difficult for

# 23rd January

a foreigner to eat our Tibetan food, so I thought that Chinese food would be more to your liking."

"I am very fond of Chinese food, but I am fond of Tibetan food as well," I replied. "For a long time now I have been eating tsamba and dried raw meat, and also frozen, fresh, raw meat as a special delicacy. Butter tea, of course, I have been drinking for years."

"Oh well, in that case I shall have no difficulty," he laughed, "and we shall have a happy time together."

Throughout the meal and for a short time afterwards I gave him an account of what was happening in China with the rapid advance of the Communists there. He cut short the recital with the suggestion that as I had travelled far that day I was certain to be tired, and it would be better if I retired right away. To-morrow we should have plenty of opportunity to talk, and in the days following, for he hoped I was going to stay some time as his guest.

He escorted me back to my room to see that everything was all right and that I was in need of nothing, and being assured bade me a pleasant good night. He was one of the most charming men I have ever met.

# 24th January

Before I left Bo Topgyay had said that I should carry some syphilis injections with me as the incidence of syphilis was very high, particularly among Tibetan soldiers, but he had advised me not to take other medicines, or I should be inundated with requests and would find difficulty in keeping to a rigid schedule of travel. I had read various reports on the high incidence of venereal disease in Tibet, some figures quoted being as high as 90 per cent. I was rather hesitant about accepting such a percentage at first, but during my travels I found that, as far as any generalization can be made on Tibet, the figure was probably correct. In many areas throughout Kham—the largest and most populous province in Tibet—I even found places in which it was safe to quote a hundred per cent incidence. The Tibetans

themselves when they visited Kangting on the Chinese border always made a point of visiting the doctor to have some injections, much as a Westerner would pay a visit to the dentist, and think nothing of it. In fact a good solid medical practice could be built up successfully on a load of arsenic for syphilis and santonin for worms. For with a very few exceptions these were the only consistent internal diseases which I found in all my travels in Tibet. Nor would there be any fear of running out of patients, for having received the medicine the Tibetan cheerfully goes back and starts the bug-producing cycle all over again.

Tibetans are neither completely polygamous nor completely polyandrous, they are completely promiscuous. Polygamy and polyandry exist but the incidence is determined by choice or circumstance, not custom. Among the upper classes polyandry is practised more than polygamy. But throughout Tibet promiscuity is practised at all levels. Where there are few marriageable men, such as in the vicinity of a large monastery because the priests are supposed to be celibate, polygamy is practised: one Tibetan friend of mine has five wives. Where women are scarce in any area there polyandry is practised, as in another area in Kham where every woman has three husbands. In both the polygamous and polyandrous communities promiscuity is practised before and after marriage, *and* indulged in by the priesthood as well. (Unofficially, of course, but widely nevertheless; although their practice is sodomy and pederasty.)

With this in mind then, I had brought quite a supply of neo-arsophenamine and maphenchlorsine, a Chinese preparation, and I mentioned this to Dege Sey when I went in to breakfast.

It was the same room in which we had sat the night before, but then it had been mostly in darkness lit only by flickering butter lamps. Now the windows on the whole of one side were wide open and the morning sun poured through, illuminating every corner. At the opposite end from the entrance the raised dais of the master was placed. As this also formed his couch at night it was larger and deeper than usual, with elaborately

painted panels in the Tibetan mode of religious significance. The predominant colours were vermilion, cerulean blue, yellow ochre and ivory black, all made locally and so skilfully used in juxtaposition that the whole effect did not jar, as might be supposed, but blended perfectly. The north side of the room, facing the windows, was lined with deep cupboards standing waist-high and the doors and top of those, too, were painted in the same pattern as the panels of the couch. On the cupboards were placed the gold and silver bowl-holders used by wealthy Tibetans and an array of gold and silver-chased copper vessels used for tea, beer, wine, etc. The whole of the south side, as I said, was filled with windows with a fine white cloth in lieu of glass to cover the intricate lattice-work. Underneath the windows ran a long low dais covered with beautifully coloured, thickly piled Tibetan rugs. At the western side had been built a combustion stove, which crackled merrily as it devoured huge quantities of wood, warming the room pleasantly. The floor gleamed like the paved foyer of some first-class hotel, and when I commented on this unusual feature in a Tibetan house where the floor would generally be either wood or packed mud Dege Sey said that he had discovered a certain type of clay, like Western cement, which dried hard and could then be polished with oil and friction; it was certainly a success, for the floor gleamed like polished black marble.

"I am just having my usual food for breakfast as you said you liked Tibetan food," said Dege Sey, "but if you'd rather have eggs done in foreign fashion your servant could instruct my cook and I will have them done for you."

"No, thank you," I replied, "I'd rather have the Tibetan food."

The servants were given the order and soon afterwards plates and bowls were appearing on the low table in front of us. One large bowl was placed before each of us, and then smaller bowls containing various kinds of cooked meat and vegetables on the middle of the table between us. The cooking was not so elaborate as the previous night's, the meat being cooked plainly instead of in various fragrant spices, and the vegetables the same,

some of the latter being cold but soaked in sauces and vinegar. The plates contained strips of dried raw meat and frozen raw meat. Dege Sey made the usual apology for such mediocre fare and I made the usual laudatory speech on the magnificence of the banquet, and we set to.

After sampling a little from each, Dege Sey called for tsamba and a servant brought a large container filled with finely ground barley flour. This is the staple diet of the Tibetans as rice is of the Chinese. A bowl is filled with the tsamba, as the barley flour is called, and then sufficient butter tea is poured in to make a dough, and then this is kneaded by the fingers and eaten in lumps as desired; the whole process being done by hand. I had been provided with a large spoon, besides my chopsticks, as a concession to my foreign background and upbringing no doubt; but how in all the world a person was going to mix a dough-ball with a spoon in a small bowl was beyond me. It was probably beyond Dege Sey as well but he had politely said nothing in order not to embarrass me, so that his amazement was even greater when I proceeded to mix tsamba and tea in the most approved manner of the best circles with revolving bowl and manipulating fingers.

"You not only eat Tibetan food but you eat in Tibetan fashion?" asked Dege Sey in amazement.

"Yes, it is much easier that way," I replied. "You see, in the West we use from four to fourteen instruments or even more in eating food, different instruments for different food. It is all very complicated."

"Yes, it is complicated," he agreed. "When I visited foreign friends I was always afraid of sticking the fork in my tongue when eating meat. Also, it is very difficult to hold a piece of meat on the plate with a fork and cut it with a knife." He laughed merrily at some reminiscence.

We talked about various customs in many lands as we ate slowly, and it was very pleasant to linger over a meal without freezing or hurrying to get on the trail again.

When we had finished Dege Sey sent for one of his captains and told him to draw up a list of soldiers requiring treatment for

venereal disease, and in a little while he returned with a list numbering thirty-eight. I was amazed and thought I had not heard aright, but Dege Sey repeated "Thirty-eight" distinctly and I lay back and contemplated the roof. Something was wrong somewhere, definitely, but I could not at the moment lay my finger on it. The Tibetan was not afraid or ashamed of admitting that he had the disease as it was not associated in his mind with immorality, so that was eliminated. I had said I was giving the treatment free in return for Dege Sey's hospitality so there was no question of being unable to pay. Then I got it. The officers probably thought I had only a limited supply and had merely given their names instead of collecting patients from among the ranks. I grinned as I thought of the answer to that one.

"Tell the people who want the injections to line up in the compound," I told the captain, "and I will give the injections outside."

The captain looked startled for a moment and then went off to make arrangements.

I set up a small table outside the door of my room and had a small charcoal fire brought out to sterilize my needles and syringes. By the time I had finished my preparations fifty or sixty gaping villagers had gathered around to watch. Their ranks were soon swelled by a column of soldiers who marched in, and as the captain came up to me to report that all was ready I asked him innocently:

"I thought you said thirty-eight?"

He looked slightly embarrassed and then replied:

"Well, sir, when I went back to the barracks some others had heard and asked for treatment as well. If you have not enough we can always dismiss them."

He was an engaging rogue so I laughed and told him I had sufficient for all that were there and more, but to try and keep some semblance of order or I should be overwhelmed in the crowd. For already over two hundred people had gathered.

I already had some experience of the potency of maphen-chlorsine, and seeing by the number of people that I was not

going to have time to make a close examination of every individual I decided to give half the amount to every person who came forward. This maphenchlorsine more often than not put the individual on his or her back for four or five hours after the injection. As there was no possibility of effecting a cure, the Tibetan only seeking immediate relief so that he or she could carry on less painfully than before, it was as good a method as any in the circumstances. With Loshay and Bajay breaking phials and others sterilizing instruments I disappeared in the crush of the demand for "shots". Four hours later I came to the surface only after Dege Sey himself had given orders to the people to disperse for the day and to come again tomorrow.

After a quick wash and clean-up I went in to drink some tea and during the break I discussed with Dege Sey the reason for such a high incidence of venereal disease. We came to the conclusion that one of the terms for the disease used in Kham might throw some light on the subject, the term "gya nad", or "Chinese illness". Either the Chinese soldiers brought it to Tibet during their campaigns or the Tibetan muleteers picked it up on their visits to the Chinese border. The muleteers travelling continually from China to India would easily pick it up and then the nationally practised promiscuity would accelerate the spread. There was certainly a high percentage of sterility and also infant mortality. Many of the ordinary Tibetan women expected to lose two babies out of three, and this was not due only to carelessness on their part for both men and women here were very fond of children. In any case the ones that survived grew up to be amongst the most magnificently built people in the world.

Having leisurely quaffed great quantities of Indian tea and biscuits I excused myself to go and change before eating our evening meal. On reaching my room I could scarcely get in for the throng of people gathered round the door. Inside I found Loshay and Bajay and some of Dege Sey's servants throwing dice and gambling noisily, watched by an amused and enthusiastic crowd. They jumped up when I entered, with the usual pouring of tea, but after a few questions I waved to them to

carry on. I was a bit surprised to find that the crowd having melted away at my appearance there were still three good-looking Tibetan girls remaining in my room. Such female interest is not usual in Tibet where public decorum is much higher than in the West, but I concluded that my unusual appearance was the cause. However, apart from an occasional glance and giggle, the girls paid no attention to me but watched the dice-players. I threw an uneasy glance at Loshay whose attraction for and to the fair sex I had experienced before, but he was completely absorbed in the fall of the dice and never once did he or the other players cast a glance in the direction of the girls. I was greatly surprised at this—for I did!

Having washed and changed I read for a little while and then, the falling twilight making reading difficult, I left my happy family as I had found them and went to Dege Sey and food.

## 30th January

The last two or three days I had spent in lounging, eating and reading. There was nothing of particular note in the village and I did not feel greatly inclined to go out riding over the plain. Dege Sey by virtue of his rank could not often go out in public, and as his guest I had to observe the proprieties.

The demand for syphilis injections was so great that on the third day my syringes had given out under the strain. I had only brought two with me and one had broken and the other had become so worn with use that when the plunger was depressed air bubbles formed in the fluid or the fluid escaped. I was forced to stop. It was an amazing sight while it lasted, reminding me of some lines of a poem I once read:

> Long, small, and broad, short, fat and thin,
> In an unending stream they appeared to come in;
> If Adam had seen this result of the Fall
> He'd have buried his Eve with her apple an' all.

Officers and men, women and children, filed past with bared arms to take the injection, even the village cripples and idiots

were brought to this modern Pool of Bethesda, as it must have appeared to them. I had long ago given up trying to check on symptoms and simply asked about three leading questions then went ahead. Some of the more well-to-do called on me, like Nicodemus, secretly and by night, for the injections, offering me large sums for several injections. Dege Sey's cousin was one of these and I was rather awkwardly placed in regard to him, as I had steadfastly refused to make any distinction in favour of rank, giving the same amount to each. I had done this for several reasons, but mainly because the Chinese doctors had become notorious for diluting the medicine for ordinary people and giving the good medicine at an extortionate price to the rich. I wanted to show new values with emphasis on the value of the soul over the body, the spiritual over the material.

A blunt refusal of further injections to Dege Sey's cousin, however, might have had awkward and unfortunate results as he looked the type of individual who delights in producing awkward and unfortunate results. I adroitly avoided any unpleasantness by suggesting that he take one dose for a start and then see how he felt afterwards. I told him seriously that some were affected more than others and that it was always advisable to see how individuals reacted after the initial dose. All this was perfectly true—but the initial dose I gave him was the full amount and not the half-dose I had given to the others. It had the effect I expected, causing intense agony for four or five hours, and he himself pleaded with me not to give him any more. Thus was avoided the chance of making a dangerous enemy.

When the syringes gave out I gave the few remaining phials and medicines to Dege Sey as a present. There had been the usual heart-breaking sights of patients blinded or crippled or wounded or diseased beyond the capacity of any man to heal, especially one with my limited knowledge, supplies and equipment. On other occasions when, by sheer force of the circumstances of life or death, I had been forced to treat or operate, by the help of God I had been successful to the point of the miraculous so that my reputation was away beyond my actual ability.

In a country where the most potent medicine was the faeces
and urine of the priests—the higher the priest, the more potent
and expensive the "medicine"—even simple remedies and treat-
ment came with the impact of the miraculous. So that I had no
sooner arrived at a place than people began flocking in from
several days' journey away in the mountains, some almost dead
already, some requiring careful hospitalization, all victims of a
hellish superstition that damned their bodies and souls to hell
without an opportunity of relief to either—while ten thousand
miles away in comfortable chairs beside comfortable fires men
and women read of the illusory stupidities of an impossible
Shangri-La and rose to condemn indignantly the interference
of missionaries with a happy, carefree race. May God have
mercy on those modern sons of Cain who have surpassed their
father's: "Am I my brother's keeper?" He was a murderer and
they are not less so. However, this is not the place to develop
such a theme, and so with the simple record that I had to turn
men, women and children away to die in hopeless pain because I
had not sufficient time or equipment or ability, I will pass on. Of
course, as I have mentioned already, there were many other
occasions when I was able to help, even beyond my ability; but
these occasions must wait to be incorporated in another book
at another time: too many people would be too intimately
affected by such a publication at this time.

Among those who had called was the official next in rank to
Dege Sey, Kungo Dzong, the Civil Governor of Markham,
whose child had a sore on his ear. When I suggested that he
bring over the child and let me see him for treatment he replied
by inviting me, with Dege Sey, to spend the day with him when
I could bring medicine and treat the child.

The rigid observance of rank in Tibet kept these two men from
having practically any contact even in that small and remote gar-
rison town. Both were charming persons, Dege Sey being only
thirty eight years old and Kungo Dzong thirty, and although the
latter was certainly more strikingly handsome yet the former
was far more commanding in appearance. As I said, it was a
lonely existence for Dege Sey, remote in the circumstances of

rank, and without even his wife for company. Even more start-
ling to Loshay and Bajay than the fact of their being provided
with servants was the fact they reiterated time and again to me
of Dege Sey's devotion to his family and dead wife. In a country
where officials had several women for their pleasure even while
their wives were alive, it was bewildering to them to find such
fidelity to a memory; particularly when the man concerned was
such an obvious "catch". For Dege Sey was liked by all, servants
and soldiers, which made his self-imposed celibacy even more
mysterious. His family, a daughter of ten and two boys of six and
four respectively, were looked after by old female servants.

Kungo Dzong on the other hand had not long been married
and his young wife had just had her first baby several months
before. It must have been very tedious for her also because of
the same social observances, which forbade her from mixing
frequently with the lower ranks and confined her to the house
all the time.

It was to this house, then, that we wended our way at nine
o'clock in the morning. I had sent Loshay and Bajay ahead with
a ceremonial scarf and roll of silk as a gift, and shortly after-
wards Kungo Dzong's secretary arrived to escort us to the
house in Tibetan fashion. Dege Sey and I went first, then Dege
Sey's personal servants and officers, followed by minor retainers,
and then the villagers and soldiers en masse. I thought I had
over-dressed for the occasion in my best grey lounge suit, blue
poplin shirt, maroon tie, grey socks and brown shoes, until I saw
Dege Sey. He was in a Tibetan gown of yellow brocade pat-
terned with large old-gold circles in exquisite design; highly
coloured, embroidered Tibetan top-boots; long hair plaited
with red silk and tied on top with a gold and turquoise orna-
ment, the whole crowned with a hat of gold thread em-
broidery and fur. With our colourful escort and the equally
dazzling sight of the good-looking Kungo Dzong, I began to
feel like the man without the wedding garment, but consoled
myself with the thought that even Highland evening dress
would have appeared insipid in such company.

While the usual polite formalities were being exchanged on

arrival we drank the inevitable butter tea from Chinese bowls in beaten gold and silver holders and once again I went over the situation in China and the possibilities in the future. During the conversation Kungo Dzong's wife came in to ask if we were ready to eat. She was a small, slim, pretty girl in her early twenties, with the usual demure bearing of the Tibetan woman on her first introduction to a stranger, and she gave only a shy glance at Dege Sey and myself as she made a charming curtsey with folded hands raised to the forehead in salutation before taking command of the domestic arrangements for eating. She did not sit down throughout the whole of the meal, passing in and out of the room to supervise each course and see that everything was moving smoothly, and only stopping for a few words in conversation when we had lain back to drink tea leisurely and nibble confections when the meal was finished.

With the whole day before us it was pleasant to recline on the carpeted Tibetan couch and only exhaust topics and language for a change, instead of the body. The advance of the Chinese Communists made it inevitable that the subject of Communism should loom largest in our conversations. The Tibetan, be he lama or layman, is prepared and even eager to discuss religion at any time. Religion is his whole existence from the time of his birth when the lama names him, after consulting the gods regarding his fortune in the future, through his life when he pays taxes to the lamas, propitiates the gods through the lamas, solicits the goodwill of demons through the lamas, is married by the lamas, on auspicious days determined by the lamas, takes all his journeys after consulting with the lamas, until he dies with the chanting of the endless prayer-formula "Om mani padme hum" of the lamas in his ears. Even after he is dead the lamas continue to be with him to guide his soul through "Bardo", the Tibetan region of the dead equivalent to Roman Catholic purgatory, this privilege having been paid for before his death or by his family afterwards. His days are spent in the shadow of the lamas of some monastery; his nights are spent in the shadow of the demons of some mountain. All his life he is made conscious in some way of the immanence of the spiritual.

# The Journey

History is blurred in the mists of mythology. Reality is blurred in the mists of superstition. Even in fighting, that unspiritual activity entered into with such joyous abandon by the fearless Khamba, the spiritual predominates—afterwards, as usual, of course!—when the combatants debate the efficacy of their individual "god-boxes" in turning aside the point of the bullet or the edge of the sword. (The "god-box" is a small "house"-shaped shrine in which is kept some charm or relic accredited with supernatural powers. The accounts of the supernatural qualities associated with these boxes are too well-established and too seriously affirmed by conservative opinion in Tibet to be dismissed as fictitious or superstitious, and I myself in my investigations have come to accept the supernatural explanation. It is too wide a subject to be discussed here, however, and again I leave the record of the supernatural in Tibet for some other time.)

With several centuries of such belief and practice as a background, then, it was scarcely surprising that Dege Sey and Kungo Dzong should be anxious to discuss the significance of the materialistic Communism and its possible impact on Tibet. My views, of course, were necessarily conditioned by my experience and I had long since rejected the theory of fundamental "sameness" in all religions. To me religion is either a dynamic or a drug. If the former, then the "Supernatural Being" solicited should give transcendence over the natural to His devotees where the circumstances of that natural were not in accord with His own character—that is the only evidence we could have of an "interested spirit" or "Deity" and the only possible use for religion in life; if the latter, then its character, and consequent uselessness are self-evident, and Lenin's allegation of the "opiate of the masses" and the necessity for elimination of the social impediment follow as a matter of course. If religion cannot be interpreted in terms of life then, like the fruitless tree of which Christ spoke: "Cut it down; why cumbereth it the ground?" Now, all religions inform us *what* to do, but Christianity alone informs us *how* to do it. That power of transcendence in the natural and supernatural was manifested and

taught by Christ, culminating in that greatest display of power over life and death, the resurrection. It is the significance of the resurrection that makes Christianity; it is the rejection of the significance of the resurrection that makes Christendom. Christendom can be aligned and compared with the other religions of the world for it is dead as they are dead; but Christianity contains the dynamic to change the world for good. Christendom is founded only on the Mosaic Law and the Sermon on the Mount; Christianity is founded on the whole Canon of Scripture. The tragedy of Christianity, as G.K. Chesterton said, is that it has not been tried. I had spent the last seven years of my life trying it in the most extreme circumstances imaginable, experiencing that power, where appropriated according to divine principle, working the miraculous in the natural and spiritual realm. Therefore, as I said, I was conditioned by my experience to argue that this new, virile Phoenix of materialism which had arisen out of the ashes of dead religion was certain to conquer until it met the transcendent Christ in His obedient disciples. This would be particularly the case in Tibet where religious superstition had kept the people in thrall for centuries and had mercilessly exploited them to its own advantage. Tibet was the country that Marx must have prayed for in his early days of struggle. The tragedy of Tibet would be if its enlightenment came by violence or force.

Thus we talked and ate and drank the day away in a muted quietness until the mountains deepened into purple and the clear light from outside was replaced by the smoky, spluttering flame from a row of melted butter lamps placed before the household idols, whose placid gilded faces looked down unheedingly on troubled men.

## 31st January

For a day or two I had been tactfully suggesting to Dege Sey that I ought to be leaving but he in turn equally tactfully suggested that I ought to stay longer—say, two or three months. I could think of nothing that would have given me greater

# The Journey

pleasure but the circumstances demanded that I leave, and that as soon as possible. The journey had to be completed before the snows and rain swelled the rivers and made crossings impossible. Added to this was the time that would be required in India to see officials and arrange for supplies. And all my travels, heretofore, had been child's play compared with what lay ahead; that slow surge of excitement at the prospect of an unbroken trail ahead was growing more insistent and harder to resist. I had already gone over my proposed journey on the best map available with Dege Sey and a few of his men who had travelled over some parts of the country near at hand, and had discovered that many of the places and distances on that map were so far out as to be useless. I would have to depend on my compass and knowledge of the language to reach successfully my objective on the Indian border at Upper Assam.

Food would be the biggest problem. The country being unknown, I could get no details of population or possibility of renewing supplies. On the other hand the necessity for haste meant that my loads had to be kept to the absolute minimum, especially as there might possibly be no way for the animals to proceed and the loads might then have to be carried by men, if we could find them, or ourselves if we could not. Already I had gone through some of my precious tins of food but the remainder would have to be kept for the time when we reached the foothills and jungles of Assam where meat could not be kept or carried; in the meantime I could carry on on a daily diet of tsamba and dried raw meat, which was easy to carry if not to sustain.

Having broached the subject once more to Dege Sey, and skilfully emphasized my sorrow at the approaching parting but its inevitability, I succeeded in getting his agreement to my leaving next day. Once again I had to sort out the loads carefully and take an inventory of all that I had, so that I might be able to lay hands on anything at any time. Food, clothing, medicines and goods for barter had to be divided to strike a balance between availability to avoid confusion at stopping-places, and the possibility of losing an animal over a cliff or in a

river, when the loss of the loads would mean certain death if they contained all of everything.

As I stood in the centre of the room with all my goods and chattels spread around, I was once more the object of an admiring and interested audience. While in that attitude assumed by all mortals from time immemorial when faced by the dilemma of getting the maximum amount of goods into the minimum of space, I was disturbed in my contemplation by the crowd parting to reveal an amazing sight. A procession of servants was arriving, each one carrying a fully laden tray of food, or sack of flour, or skin of butter. I think I counted eleven as they filed in, bowed, and retired with increasing difficulty through the accumulating pile on the floor. Tsamba, flour, cheese, butter, dried fruits, walnuts, dried meat, tea and a host of other things had been given by my hospitable host as his parting gift for the road. When I went to see him some time later to thank him for his gifts he produced even more, a beautiful Tibetan saddle rug and an ornamented silver bowl-holder.

I still was not finished. Every so often another official, or officer, or grateful patient, would call with another gift until I had visions of riding into the sunset with a caravan whose beginnings were in the sunrise. Dege Sey, guessing something of my discomfiture, laughed cheerfully and told me not to worry as he would give me an authorization with my passport to use "ulag" on the trail all the time I was on Tibetan-governed territory. This is a system by which each village or group is taxed in Tibet by being called upon to provide sufficient animals for officials to travel from stage to stage on their journeys. Instead of having to pay extortionate prices for the hire of animals according to the whim of the owner who could demand what price he chose of the traveller, they give only a small sum for the use of whatever animals are necessary under "ulag". This was an unexpected offer and I jumped at it, for it would solve most of my transport problems—always with the proviso that there were people to give "ulag", of course.

Dege Sey further offered to provide me with an escort of as many as I wanted and suggested ten soldiers. I demurred since

# The Journey

I did not consider that number necessary, and the more people I had the more difficulties would arise in travelling. Finally I agreed on two as being sufficient. I had decided to send Bajay back from Gartok in any case, so this kept my immediate escort down to three people, Loshay and the two provided by Dege Sey; there would be others, of course, who would serve in the capacity of muleteers but they would vary in numbers according to the amount obtainable under the "ulag" at each stage.

The discussions having been protracted through the evening meal and beyond, I finally made my excuses and retired for the night, with Dege Sey's assurances of an official send-off in the morning to make my dreams more pleasant.

## 1st February

The official send-off meant that I should have a delayed start and so, not being able to get off at dawn, would have to make my first day's stage at a village called Lawo. As this was only three to five hours' ride away, it was not necessary to hurry my departure and I drank my fill of leisure—probably the last for a long time!—during breakfast.

Outside in the sun-drenched courtyard there were all the sounds of preparation for the trail to stimulate the rhythm of pulse and lungs and draw the eyes to slits in anticipation.

"Do you want to ride your own horse or would you like to ride one of mine?" queried Dege Sey, as an officer stood by for further commands.

"I would rather have one of yours, if possible," I replied promptly, "but how can that be arranged? Won't it be too much trouble to change over when you return?"

"No, we won't change over on the way, I will send one of my grooms and he will go all the way to Lawo with you and he can bring the horse back tomorrow."

I was delighted. A few days ago I had gone out with the grooms who were exercising Dege Sey's horses and had seen them being put through their paces. Among the animals were two almost identical powerful palominos from Sining in North-

# 1st February

West China. These were Dege Sey's personal favourites in his string of animals and it was a great honour to be allowed to ride one with him. My own grey which I had left behind in Bo could have more than held its own in any official cavalcade but the bay I was riding, while stylish, was not in the same class as these pacing chargers, and I duly acknowledged the double compliment of esteem and ability.

Dege Sey then sent the officer to saddle and called for the servants to bring other clothing.

Loshay, his boots, shirt, teeth and hair gleaming, reported that all was ready and asked if I would inspect the animals before he sealed the loads. I saw that all boxes were padlocked and all sacks tied, and then Loshay sealed them with a wax seal and a Tibetan seal so that we need not travel with them but could check the seals on arrival.

Bajay was standing by and I gave him a letter to take back to Geoff asking him to send an English Bible and some books to Dege Sey, who wished to improve his English. I also gave Geoff a short account of my stay together with Dege Sey's assurance that he would provide help and escort for any who chose to come that way.

With a parting word of thanks I swung up in the saddle, Dege Sey being already mounted, and nodded to the grooms to release the halter. There was a rush for the main gateway in the outer courtyard as the crowds poured out into the narrow streets to the outside of the town, and two officers moved into the lead to keep the way clear. I came next, with Dege Sey and his young son just behind, and then the remainder of the officials and escort following on. The cavalcade was a weaving line of brilliant colour against the drab background of the crowd and the white walls of the houses. The yellow brocade, white silk and maroon cloth of the riders barely exceeded the splendour of coloured saddle-rugs and flashing saddle-iron, some of it gold and silver-inlaid, of the horses. The horses caught the excitement of the crowd and aided by their only too willing riders, who were never averse to giving a display of horsemanship, were soon prancing and cavorting all over the place to the

delight of the people, the riders meanwhile controlling them with the supreme carelessness of practised ease. This is where the Tibetans tested a man, and I grinned to myself as I eased the reins and let the powerful brute under me go into a few bounds prior to a gallop and then, with the two officers ahead separating to let me through at a warning shout from the crowd, pulled it right round in a half-circle to hold my place.

When we reached the outskirts of the town we gradually out-distanced the crowd and settled down to a steady trot. The Tibetan officials' horses have all been taught to "pace" or "amble", that is, to move together both legs on one side alter-nately with those on the other. This makes for very easy and comfortable riding once it has been mastered and conversation becomes effortless instead of spasmodic. A horse that ambles is exactly twice the price of a horse that does not; and this applies also to mules, which are preferred for long-distance travel.

Having ridden thus for two or three miles, we soon turned into the mouth of a valley and here Dege Sey said they would turn back. We dismounted and rugs were placed for Dege Sey and me to sit together while others were scattered around at various distances according to rank. Once again we went over the formalities of gratitude and Dege Sey reminded me of several things I could bring him on my return from India, if possible. I in turn solicited a like hospitality for Geoff and others, should circumstances arise to bring them that way. We talked idly for a little while in conformity to custom which demanded that I as a guest wait until given leave to depart, and that Dege Sey as host protract the leave-taking as long as pos-sible. Our conversation becoming desultory, he called to one of his officers and he came forward carrying a long white scarf. The time for departure had come. First Dege Sey, then each official in descending scale of rank, draped my shoulders with the ceremonial scarf until I was completely snowed under. Then it was Loshay's turn with smaller scarves presented by the smaller ranks. I reciprocated by shaking hands all around which seemed foolish after the graceful ceremony just performed. A last word from Dege Sey to the two soldiers who were to escort

me to see that I was attended to in every detail and not to
oppress the people as they travelled (the reason for this was to
become evident later), a quick wave of the hand as the horses
pranced restlessly, and then we were away up the valley at a
thundering gallop, for the benefit of those watching, settling
down to a steady trot when we turned a bend out of sight.

I peeled off the many layers of scarves which had almost
smothered me in that first burst of speed and stuffed what I
could inside my coat, giving the remainder to Loshay and the
escorts to put inside their capacious gowns. I should require
scarves in the future when the time came for me to present some
gift or meet some official.

Our caravan was now two or three hours ahead of us, but as
our travelling speed was greater than theirs we could probably
catch up on them before they arrived; in any case it did not
matter because my loads had all been sealed and the head
muleteer would be responsible for loss or breakage of a seal. As
the day's stage was short we took our horses along faster than
the normal rate of travel, occasionally breaking into a fast trot
as we paced or raced each other. The enjoyment of this how-
ever was more in the movement than the contest for Dege Sey's
horse was infinitely superior to the mounts of the others.

I gazed interestedly at my escort: this was the first oppor-
tunity I had had of inspecting them although Dege Sey had in-
troduced them to me. I appeared to have been fortunate, for
one, whose name I gathered was Aku, was a perfect, two-legged
Tibetan version of Long John Silver. With his matted hair held
in place by his loosely tied pigtail, his large ear-ring swinging
from his right ear, a wicked gleam in his almond-shaped eyes
and a gap-toothed grin flashing out at times of private amuse-
ment, he looked more like a pirate than any who ever sailed
with Morgan. His companion, Dawa Dondrup, also long-
haired and ear-ringed, was more respectable in appearance but
looked as if his outward advantages covered a capacity for any
mayhap and mayhem that might be going. From his bearing I
gathered that he was assuming the leadership of the caravan
and I decided that I had better be ready to throw around a

H

little judicious authority when a suitable occasion arrived. In the meantime I would let him carry on as he appeared to be enjoying himself and a good time was being had by us all.

They had been drinking. This was evident not in their inability or otherwise to walk a straight line or repeat the Tibetan equivalent of "She sells sea shells" correctly, but in the rakish angle of their fur hats, their inclination to be unusually verbose and the careless abandon of their riding as we rode dangerous trails. Remembering Loshay's riding on the day of our departure from Bo when he had joyously absorbed everything that was poured his way, I glanced uneasily at him now, but, apart from a reckless grin and the appearance that he was seriously considering taking his horse over the cliff backwards to ride on space, he seemed all right. It was no use my trying to ride ahead, for as soon as I began to draw away there would be a series of whoops and we were away on another spree. I waved them forward as I began to feel such merriment exhausting—it can be, when the path is bounded on one side by a very solid mountainside and on the other by a very un-solid amount of space.

The valley through which we were passing was now leading downwards, and up ahead it bifurcated into two long arms receding into the distance. Shrubs and bushes covered the valley floor except in an odd place or two over on the far side where it had been cultivated by a lonely farmer. I wondered how much success he had in produce because our valley was more or less unproductive, although Dege Sey in Gartok at 12,000 feet seemed to have quite a few vegetables. The grass here seemed green enough too and, unlike most parts, there were plenty of small streams to water the ground.

Musing over the problems of cultivation in Tibet, I had not noticed that the others had stopped until I was almost upon them. As I rode up I could hear they were having a heated argument from which I deduced the simple fact that we were lost! I looked incredulously at Aku and Dawa Dondrup for they had been chosen because they knew at least the surrounding country, but the growing embarrassment on their faces was

sufficient proof that neither of them was really sure. Aku said that we should turn up the valley to the right while Dawa Dondrup was equally dogmatic that it was the valley to the left. Loshay was being most unhelpful by pouring scorn on both. They were going to divide and scout up each valley, but I stopped them and said that we would ride over and ask the people in the house on the far side of the valley. It would take us out of our way, but hardly to the same extent as going up the wrong valley. It was a gratifying thought that with two months' journey ahead we were already in doubt scarcely two hours away from Gartok. Aku and Dawa Dondrup were not really at fault: it had been several years since they had come this way and they had said so before we left.

I was inclined to take the right-hand valley because that was more due west than the left; and after we had consulted the farmer—and insulted him, sad to say, for my companions grew exasperated with his open-mouthed bewilderment at our appearance—the right-hand valley it was. It was a narrow and pleasant place and I could already see the few houses ahead which marked the village of Lawo. Dawa Dondrup asked permission to ride ahead to make preparations and I nodded consent. Several people were already running out as they had been watching for us since the arrival of our pack-animals, and so I drummed the horse into a fast gallop for the entrance scene.

The house in which we were to spend the night was large and spacious and I tramped my way about comfortably amongst the people, straw, hens and dogs. Here, at least, I could once again establish my own proprieties and instead of retiring modestly from the public gaze to the seclusion of my own room could stretch myself out beside the huge open fireplace and quaff bowls of tea while I talked. However, the pleasure of discourse was not to be mine from now on, as I could not understand the dialects spoken in those remote parts and the people could not understand me. Even Loshay was not understood and Aku seemed to be the only one able to make himself understood, and then it was mostly to the headman. I had a sneaking suspicion that it was the very obvious meaning of his expressive

face, gestures and looks that was interpreted rather than his words.

## 2nd February

The stage for today was to be a long one, and so we took sufficient food out of the boxes to carry in our saddle-bags as a snack. As we were leaving with our caravan today it meant that we should arrive ahead of them, and should have to wait until they arrived with the loads before we could have a proper meal. This was where I appreciated the tsamba and dried meat. For no matter how sustaining porridge and the like might be in the civilized West, I had found such food insufficient during my travels in Tibet. The high altitudes, the rarefied atmosphere and the constant exercise created a tremendous appetite a few hours after the heaviest meal of bread or potatoes or porridge, and with the prospect of another six or seven empty hours ahead one lost one's confidence in Western conceptions of food values. Thus I had come to prefer the nourishing monotony of tsamba and dried meat rather than the unsatisfying variety of Western food; further, there were insuperable difficulties in the supply and transport of the latter. With two or three bowls of tsamba and a handful or two of dried meat dipped in pepper tucked away inside me, and a supplementary lump of tsamba and a few pieces of dried meat tucked away inside my gown, I was ready to face the elements and the future; and thus it was on this day and occasion.

I was now back on my own bay, having sent back Dege Sey's horse with his groom, and with this reminder that all trimmings were past I settled down to the grim journey ahead.

Almost immediately we were reminded of just how grim the journey was going to be when the trail led suddenly into the dry bed of a river. At first there was a trickle of water among the stones but gradually this died out and we were left in remarkable surroundings. The valley had narrowed until there was no room on either side of the river for even a trail over which a horse or man could go. The place must have been completely

impassable when the river was in spate: now what little trail there was disappeared in the course of the river and appeared at times among the small stones and huge boulders of the river bed, and the horses picked their way with the greatest difficulty. The sides of the mountains were so steep that no sun entered at this time of the morning, adding to the already eerie character of the gorge. When the muleteers let out an occasional yell at a horse or mule or yak which wandered to the sides in search of grass, the sound seemed to rise in a diminishing spiral until it escaped over the distant tops of the mountains.

It must have been about three hours later when we found a path leading out of the river bed, which was by that time beginning to fill up with water from some invisible source. I had been growing more and more anxious as the boulders grew in size, towering above us, and the water rose gradually all round us gurgling ominously in that grey half-light as it met resistance from the stones. However, just when it appeared that we might have to retrace our steps, the water now swirling about the horses' knees, a faint path appeared on the left bank and snaked its way up the sheer side of the mountain. We followed this trail over the high shoulder of the mountain still keeping that menacing gorge under our stirrups until we were two or three thousand feet above it, when it dipped into a hollow and led to a few scattered houses. The unconscious strain of that journey must have been tremendous for when Loshay suggested a short stop for tea I felt a surge of relief which was almost physical in its impact; the others showed it too in an exaggerated belliger-ence and impatience with the startled villagers.

We waited until the pack-animals had caught up with us, and then, having checked the loads, which had received a severe knocking-about among the boulders in the river, we took to the trail again. The shoulder of the mountain had flattened out somewhat to form a sheltered declivity in which the houses nestled, but the sound of the river from that forsaken gorge could still be heard. Once the end of the declivity had been reached we descended sharply again, and I received another rude jolt. For an almost identical gorge was unfolding itself

# The Journey

before me but this one had to be crossed by bridge—and what a bridge! Heath Robinson was never like this! The supports (excuse the term!) of this contraption consisted of roughly trimmed logs laid crosswise on each other to form the tapering sides of a tower-like structure on either side of the gorge, in much the same manner as we built houses of matches when we were children, and these were spanned by two trees from which the branches had been trimmed and over which some boards were loosely tied by creepers. Underneath this appalling sight there was not even sufficient water to make a probable landing bearable, only the grey nakedness of giant boulders leering up at us invitingly. Well, it had to be crossed. Fortified by a deep breath, several bowls of tea, and a—comparatively!—blameless youth, I recklessly lunged forward wishing fervently I had had tennis shoes instead of heavy riding boots as I felt the boards move uneasily beneath my feet. Now to cross that structure alone would have been a superb feat for an iron-nerved trapeze artist, but when one had to lead a horse across as well it became a nightmare (and I hope you'll pardon the unintentional pun). I do not know what the horse felt like but if outward appearances were any criterion then I reckon we were the two biggest hypocrites in the animal world at that moment, for my apparent sang-froid was excelled only by the horse's. I had horrible memories of a similar occasion when, in negotiating a "bridge", Geoff's horse had slipped down between the boards on a wildly swinging suspension above a raging river in the dark. I was ahead and could not move forward, Geoff was behind and could not move at all. The memory of that horrible night will haunt me for ever—and it haunted me now. I had a confused idea that I was being unconsciously sacrilegious as I got mixed up in my prayers for myself and the horse; but this was understandable, since I was not sure whether to hold on to the horse if *I* slipped, or hold on to the horse if *he* slipped. And then, suddenly, space stopped heaving around me and I was on terra firma once more, and so, miraculously, was the horse. I gazed hypnotically at the Tibetans as they crossed, wondering if their calm was natural or assumed and coming to the conclusion that

118

if it was natural it was supernatural—and if any philosopher reading this book thinks that a paradox, let him cross that bridge.

For some time after that, I was unconscious of my surroundings as I pondered on the mutability of things in general and bridges in particular and only noted vaguely that we were climbing again. It was the roar of the river gradually increasing which brought me from the speculative to the real and I noticed that the river of our morning's journey was once again in sight and was now raging forward in snarling flood. While the valley had widened perceptibly, the river was still confined to the narrow limits of the gorge and was racing forward to pour itself into a larger river flowing at right angles to it. Just before meeting this river ahead it had to pass through a narrow channel of solid rock, rising on both sides sheer out of the depths, and it was the roar from its foaming madness at this immovable barrier which had attracted my attention.

As I said, we had been climbing steadily over the shoulder of the mountain and we were now nearing the ridge where we should be in a position to scan the country for miles around. Already I could see that an impassable range of mountains lay ahead from north to south and that we should have to turn down the valley to the south before we could find a way through. This was confirmed when, topping the ridge, I saw a large unfordable river filling the valley as well. The confluence of the two rivers blocked the way to the north so the way to the south alone was left. If the valley out of which we had just come was savage, the one we now entered was majestic, although it had something of the same cruelty. Perhaps the feeling was lessened somewhat by the greater width and calm of the river and the greater height at which we were travelling, for we were now five or six thousand feet above the river below. This was the Dza Chu or Mekong river, I gathered from the map.

As we went forward parallel to the river the trail became more and more precarious, and Loshay went ahead with Dawa Dondrup while Aku followed behind me. The path, such as it was, was only about two feet wide, and wound upwards across

the sheer face of the mountainside. This in itself would have been difficult enough to negotiate, but there was also a loose scree slope to be considered. While I held myself easily in the saddle with an appearance of nonchalance I could yet feel my abdominal muscles contracting into a hard lump. The path was moving beneath our weight and stones being kicked off the edge would turn and jump all the way down in horribly delayed fashion to disappear in the river far below. There was not a tree or bush or shrub even to break that slowly executed drop to eternity. I kept my eyes glued to a spot about a yard behind Loshay's horse and eased my feet until they were almost out of the stirrups, hoping that I might be able to make a safe landing if I had to throw myself off my horse. Occasionally a horse would slip on the narrow path and the rear hooves go over the edge and the rider would have to throw himself forward along the horse's neck as it scrambled wildly to regain its balance. The others would then sit back in their saddles and roar with laughter at the antics of horse and rider, careless of the fact that failure to recover meant certain death. I had heard previously that a Tibetan's laughter at such a moment is not mockery at a companion's predicament but a defiant defence against the evil spirits who wish their destruction and who would take advantage of any evidence of fear to accomplish this. But while I was quite willing to concede this at times yet there were circumstances when their laughter was too spontaneous to be other than sheer delight in danger. Twice I went over and started two small landslides before I managed to pull the horse desperately back on to the trail, and Loshay merely sat in his saddle and laughed. There was no question of shouted advice or help. Balance and desperation were the only things to be used and the others had to sit and watch because there was no room to dismount; to attempt to do so meant instant death for horse and rider.

We must have travelled for three or four hours like this before we reached more solid going and the trail widened and allowed us to relax. It was cold, bitterly cold, but I was soaked with sweat and the horses were likewise. We dismounted and walked

for a time leading the horses to give them, and ourselves, a break, as the trail was now leading down to a small, shallow depression in the mountain above the river. Even from a distance it looked an amazing sight for there was not a bit of vegetation to be seen anywhere, mountains and valley being of rock, stones and earth in an awesome monotony, and the whole depression was covered with boulders, large and small, as if the river had risen in some incredible fashion and then had fallen to leave this incongruous saucer of stones a thousand feet up on the mountain; or, perhaps, they had fallen off the sheer slopes above in some landslide in the distant past. Where they had been gathered to build a few houses, there were patches that had been hopefully cultivated but whether they produced anything I seriously doubted from their appearance.

Our arrival caused the usual stir and on inquiring if this was Samba Druca, our stage for the day, we were directed to the other side of the river. It appeared that Samba Druca, or Samba Dring, as the locals called it, (Druca meaning "ferry" and Dring meaning "rope-way"—probably a corruption of "lding" meaning "suspension"[1]) was in two parts, one on either side of the Mekong River, but the far side contained the best houses and would also provide the animals for our journey. The people were very primitive and very poor, men and women wearing only very filthy hand-woven Tibetan gowns most of them in rags, while the children wore nothing at all. This was possible here as the valley was warm, sheltered by the jutting sides of the mountain.

We did not waste much time there but asked how we might proceed to the far side immediately, as it was getting on to late afternoon. I was mystified, and said so, in that I could see no way of getting to the other side even though the river had narrowed considerably at this point. The headman of the village then led me around the houses to where the mountain dropped away again into the river about two hundred feet below. I

[1] Note for philologists and cartographers: the phonetics are Jaschke's in the Tibetan-English Dictionary. See "lding-ba"—to be suspended, floating or soaring (in the air), p.290.

# The Journey

swallowed! This seemed to be my day for bridge nightmares. A bamboo rope, made of woven creepers about two inches in diameter, had been wound round a large boulder and held down by others piled on top and then led across to the far side about fifty yards or more away where it was held in the same manner. I gazed at the rope, I gazed at the far side, I gazed at the swirling waters beneath, I gazed at the horses, and then I gazed at the headman. I thought of Yoga and levitation and astral projection and hypnotism, and then came to the conclusion that the sheer necessity of my journey might drive me to attempt that crossing; but I had never yet heard of a horse being subject to such natural or supernatural compulsion, and so I shook my head.

"No," I said emphatically. "It is impossible to cross that"—then, in case he should think that I was afraid to cross it, I added hastily—"What about the horses and loads? We leave the "ulag" animals here, but we take our own riding animals if possible."

"Ah, we don't cross here at this time of the year," he said cheerfully; "only when the river is in flood, and then it is impossible for animals or loads to cross. But you asked where the bridge was and this is it."

I looked at him closely to see if he was pulling my leg but he seemed a simple soul and incapable of being funny—as funny as that anyway.

"How *do* we get across then?" I asked.

"Oh, by the ferry," he replied, surprised at my ignorance.

"Lead us to the ferry," I requested patiently, greatly tried.

I do not know what I expected, but whatever it was it was never like this. After descending sharply from boulder to boulder like a young hind and watching the horses being helped by their ears and tails, I arrived in a deep cleft in the rocky wall of the mountain beside the river. If from the point above the river seemed to swirl, from here it positively swished. Being compressed into this comparatively narrow channel of forty to fifty yards' width by the sheer slopes of the mountain seemed to annoy it intensely, and it raced angrily, gurgled

122

menacingly and leered invitingly in protest. Lest this chronicle should become monotonous from the number of deep breaths inspired, let me hasten to record: I expired deeply.

"Where is the boat or coracle?" I asked, looking around that cramped space in vain.

"It is kept on the far side," he answered. "I will shout and they will bring it over."

He gave a yodel, whose echo would have been amusing in other circumstances as it curled and rebounded around us for some time, and an answering yodel from the far side showed me where some people were already hurrying to the river's edge. The launching-point on the far side was slightly downstream and was also only a narrow gap in the mountain face, and from there in a few minutes two men pushed off on a raft. The swift current in midstream carried them away below us but in the calmer water of the side they paddled more easily upstream towards us.

Was this country ever going to cease to provide the unsuspected and marvellous? I thought. Six logs were half submerged in the water and water appeared in the space between the logs, as it dipped and plunged in the comparative quiet of the side-stream current. A load? Yes! With resignation, I thought. A man? Yes! In desperation. But, a horse? No! Under no circumstances whatever could I see a horse boarding, negotiating and alighting from that contraption. I was wrong.

The first trip was to take a man and some of the loads. Aku was chosen by unnatural selection—the survival of the slickest. They pushed off and one man paddled on either side, while Aku kept the balance and his eyes on the boxes—he could do no more; he appeared petrified while the raft dipped, plunged, and spun on its way across to the far side. It arrived.

A horse this time, and Dawa Dondrup's turn. He got his own back by taking his horse. He backed on to the raft pulling at the reins to drag the horse after him and then it baulked when its forefeet were on and the tail-end off. The problem was easily solved by a cut from a whip, and the raft gave a wild lurch as the horse suddenly arrived. This is it, I thought. But no, the

raft miraculously righted itself and the men on it even more miraculously likewise. It was only then that I was initiated into the secret of How To Ferry A Horse Across A Dangerous River On A Raft Its Own Size. A metal ring had been driven into a log and the reins, or halter rope, were passed through this and the horse's head drawn down until its nose touched it. This, coupled with the co-operation of a man holding its tail, was deemed sufficient to keep the animal steady during the trip. It was—or, at least, it appeared to be. However, when my turn came the world seemed to be filled with moving horses. I had firmly declined to sit on a box at one end and hold the animal's tail, choosing the more precarious end of the raft, if not the horse's, to take up my position for the trip. When the raft started pitching the horse snorted and tried to shy and I had to throw all my weight on the reins to keep it steady, but then when it quieted suddenly I was almost catapulted over the side, for I was ankle-deep in water most of the time. When the raft and the horse and the mountains and the world ceased to spin I was sitting on a boulder and watching the raft nearing the other side again.

There were no casualties and this formed the topic of our conversation as we sat in a filthy room over a charcoal brazier and drank tea. When I felt sufficiently fortified and settled, I told Loshay to get the hard-boiled eggs out of my saddle-bag and heat them; for the claims of my inner man were clamouring to be met. I think I had six—or maybe it was sixteen; I was not in the mood to quibble or nibble—for a snack, and then the soldiers managed to round up a quantity of fresh eggs, or, rather, a quantity of eggs with fresh ones amongst them. I looked longingly at one or two choice little piglets running around and wondered–if I should make my thoughts plain to the others, but knowing that the villagers would not sell and that my companions would probably stretch their authority to "requisitioning" to gratify my desires, I held my peace and the vision faded.

## 3rd February

Our landlord had told us that we could only do a short trip today because of the greater distance on the day following, the two stages being quite impossible to accomplish in one day. I wanted to risk it, as I had had some experience of landlords and headmen who did not want their animals pushed to exhaustion and who invented large distances to discourage travellers, but the others advised against it, and I finally agreed. Consequently, I had a good long rest and we did not leave until well after sunrise. While eggs were available I decided to eat them and conserve my stock of food against the time when I should not be able to obtain anything, and so I began that day with another six eggs. Perhaps it was as well that I had slept through cock-crow as I might gave been overwhelmed with guilt or, worse still, might even have sought to reply. My Tibetan companions had profited from the opportunity as well to the extent of twenty-seven eggs between them. When I ironically suggested that perhaps they might like to fill up on a little tsamba and dried meat, they declined seriously saying that we had only a short journey and could have something when we arrived.

For some time we rode along the course of the River Mekong, at first among small patches of cultivated ground that seemed amazingly productive and then among occasional shrubs as we began to climb again. It was warm and as the trail was narrow and we could not pass the slowly plodding yaks, we rode easily behind. Soon we turned up a narrow valley at right angles to the river and once more we were facing the west. Here it was colder since we were out of the sun but this was compensated for by the change in surroundings. Instead of the dry barrenness of the previous day here was vegetation of the kind found in high altitudes, rhododendrons, shrubs, and coniferous forests appearing as the valley widened.

After about three hours' riding we could see an occasional house high up on the mountain, so Aku rode ahead to warn the

inhabitants of our arrival. A duplicate copy of my official authorization had been sent in advance to the headman of the village with orders that he send it on to the next village and so on ahead of us till it reached the border. This was done that there might be no delay in providing animals and to warn the people of our coming. However, it was still necessary to warn them of the exact time of arrival so that everything down to the tea might be prepared, and one of my escorts always rode ahead just before we reached a village. This particular collection of houses ought to be the village of Jo according to the directions given us by the headman of Samba Druca.

The deep, booming bark of the ubiquitous Tibetan mastiff was taken up by the others over the mountainside and formed the chorus for our arrival. The headman's house had only been quite recently built and was of the usual square stone-built type, but in this instance was slightly different as it had the dwelling-quarters built on top in wood. Loshay with deadly accuracy was clearing a way among the many dogs who fled away from the proximity of his pitching arm with protesting yelps of pain. When a modicum of quiet had been restored I could hear further yelps of pain proceeding from above, but this time the sound was indubitably human. I looked round to inquire the possible cause of the altercation, with all the Westerner's reluctance to precipitate myself into a domestic quarrel, but—lo and behold!—everyone had suddenly vanished. The accumulating villagers had melted away and I saw the tail-end of Loshay's gown as he disappeared up the ladder leading to the source of the conflict. I sighed at the belligerent inclinations of humanity and climbed the notched log which served as a ladder to receive my blessings as a peacemaker. As I passed the hole in the wall which served as a window, I looked through and saw an amazing scene. Aku was holding the headman's head and was bending him forward while Dawa Dondrup belaboured him with a long baton of wood. Between the blows the headman's voice rose in apology and pleading, Dawa Dondrup roared in anger and questioning and the headman's wife wailed in fear and grief. I decided I had better interfere before his back

was broken and hurried round to the door where Loshay leaned, watching the proceedings interestedly. As I was about to push my way in he put up his arm and barred the way.

"Stay here," he warned.

"What for?" I queried. "To watch the man being beaten to death?"

"It is the custom," he shrugged, the Tibetan reply to everything they did not wish to explain.

I tried to look imperious and stare him down, and he replied by looking back at the others and keeping his arm still across the door. I was spared the necessity for further questions by Aku throwing the headman across the room towards the fire with a roar:

"Now, get things prepared."

It appeared my services as a peacemaker were required about as much here as they are anywhere. I drifted away towards the edge of the roof and took a look at the surrounding countryside. The valley through which we had come was a sort of cul-de-sac, the block end being formed by a towering semicircle of mountains. Scattered at various points over this face were the houses and cultivated parts of the village of Jo, which seemed at any moment likely to slip down to the valley floor far beneath. Pine forests rose above them to the tops of the mountains and I looked in vain for even the slightest indication of a possible way through. While I gazed around, the headman's wife came out and gave a loud yodel which was acknowledged from the next house and then in turn passed on to the next and so on until every house had answered. I gathered that this must be some sort of rallying call: my supposition was confirmed shortly afterwards when people began making their way by different paths to our house.

Having given the disputants sufficient time to get their differences settled, I went in to see how things were going. Aku and Dawa Dondrup were preparing a raised dais for me to sit on in true oriental fashion befitting my position as friend of Pangdatshang and Dege Sey and also Government-recognized, Loshay was digging into saddle-bags for bowls and food, the headman

was running around almost doubled up in his obeisances—or maybe it was because he could not straighten his back!—and stoking the fire, and his wife poured tea into a tall churn and churned madly. Villagers began to come in with gifts of wood and food and other things and gradually natural interest replaced the unnatural restraint and conversation began to flow.

When I got to my fourth or fifth bowl of tea I asked Loshay, under cover of the hum of talk, what was the reason for the beating. He said that the landlord had had nothing prepared and at first denied receiving the letter, then after some punishment had been administered he confessed that he had received it and had not sent it on. This was a very serious offence according to the primitive laws of Tibet and he had been punished accordingly. He (Loshay) had stopped me interfering as I had no right to and also my interference would only have made things worse: it would have induced carelessness on the part of the headman who might have chosen to ignore all official letters in the future. I saw the wisdom of this, even as I protested against the violence of the punishment administered which seemed disproportionate.

Loshay shrugged. "You don't know," he said, "and in any case"—and he grinned—"I remember in my valley back home we used to try and get away with it occasionally, arguing that it was worth while taking a little beating rather than having to supply many animals and much food for "ulag". Only when we were beaten really hard and we decided it was not worth it, did we finally supply what was wanted. We understand leniency to be weakness."

With the letter now on its way, eggs and wood supplied by the villagers, and pipes all drawing freely, the inevitable news of trail and country followed. When local topics were exhausted I was asked to tell of China, Christ, Communism and civilization, and so reclining on my rugs we whiled away the afternoon and evening until it was time for Loshay to spread out my sleeping-bag and another day had drawn to its close.

## 4th February

This was to be the day of the long stage; so we were up,
loaded, saddled and away as soon as it was light. The trail rose
sharply almost immediately and after an hour's stiff climbing
we passed in among the trees. Apart from the early morning
disinclination to talk, the cold was such that we were content to
huddle deep in our furs and gowns. Every hundred yards or so
we had to stop and give the horses a rest as they were blowing
so badly at the climb. Although there was only a few yards
between us the trail was so steep that, as we zigzagged upwards
and stopped, each rider was above the other and a slip from the
one in front would have carried us all down the mountainside.

Sunrise found us on the top of the pass and a wonderful sight
it was, not to be surpassed anywhere in the world. Once again
we were above the tree-line, but the mountains on either side
were clothed almost from summit to foot in the dark green of
the pine and fir, to meet at the banks of the river thousands of
feet below. Behind and beyond until they disappeared in the
morning mist were range upon range of mountains, snow-
covered, tree-topped and bare.

We turned down the valley on the left-hand side and the
path led on and downwards through the trees for hours. When
finally we came out of the trees, I was pleasantly surprised at
the warmth of the sun and took off my fur-lined coat. There
were patches of snow in the shade and all the pools were ice-
covered, but in the sun it was pleasantly warm.

We stopped at a lonely house to have some tea and I had the
inevitable eggs, my carefully hoarded supply of hard-boiled ones
being my only variety from tsamba and dried meat. The dried
fruit and walnuts were more for barter and presents than
personal enjoyment although we got through quite a lot of
them. We waited at this house until our pack-animals had time
to catch us up once more, and then left ahead of them again.

We crossed the river, which was very shallow and easily
forded, and pressed forward at a good pace. I was riding ahead

setting the pace when I heard a shout behind me and on turning round saw Loshay picking himself up from the ground. I was surprised, as Loshay had a great reputation for riding and I had never known him to be thrown from the wildest horse all the time he had been with me. I circled back to where they were crowding together and discovered that the horse had stumbled in a hole and gone right down on its knees, throwing Loshay forward over its neck. He was bruised here and there as it had been so utterly unexpected, but it was not nearly so serious as it might have been.

This was the only event of any interest during the whole of that monotonous day. The trail continued to wind upwards on the right-hand side of the valley until we seemed to be perched on the outside edge of space. The river, which had grown considerably, was no more than a white thread far beneath and on either side the mountains were utterly devoid of a blade of grass. We had climbed beyond even the small hardy shrubs and moved into a world that seemed cursed and dead. Towards late afternoon, the mountain face across which we were travelling seemed to fall back a bit and our trail seemed to rise and meet the top not far ahead; but the altitude and monotony made distances deceptive, and when the sun was already beginning to set we rode over the top into another valley.

Once again we were faced with a blank wall of mountain with a large river flowing through, although from this height and distance it looked like any mountain stream, and so we turned to the north-west as being the most likely direction. I was stiff with sitting in the saddle for so long and, as it is also Tibetan custom to dismount and walk a horse downwards after climbing a pass, I enjoyed stretching my legs for a change. After a steep drop down the mountainside the path widened into a broad ledge several hundred feet above the river, and we mounted again. I knew we could not be far away from some form of habitation because I could see an occasional goat grazing on the mountain with a few yaks also. On our rounding a bend in the trail some houses appeared ahead, and I waved to Aku to drive his tired horse into a gallop to announce our

## 5th February

arrival. A few minutes later people began to appear on the roofs of the houses and children ran shouting to each other as we rode past the huge "chöden" (cone-shaped religious monument) which gave the place its name of Tsawa Chöden.

I wondered suddenly if we should have a repetition of the summary justice we had had the day before, but was relieved to find that the letter had arrived ahead of us and the headman had been right on the job, even to the point of having raised platforms carpeted for servants and escorts as well. Among the gifts presented was a large bowl of flour, and I was so delighted at the thought of being able to have some ash-baked scones again that I ordered Loshay to give the headman a present of dried fruit and walnuts in addition to the usual gift. Loshay did not quite approve of my princely generosity; but then he had never known what it was to eat bread, and anything of that kind, even something as far removed as my "scones" were going to be, was enough to touch the well-springs of my being. It was dark even before I had started eating, and the combined effects of a huge charcoal brazier and the weight of the scones soon had me nodding sleepily. With my sleeping-bag beneath me and my trusty henchmen around me I plunged immediately into that satisfying sweetness known as the rest of the labouring man.

## 5th February

On inquiring about the next stage, the distances and trail I learned that there were no houses between Tsawa Chöden and Drayu Gompa, the next stage of our journey. Between them lay a high and difficult pass on which it was impossible to camp because of the cold and lack of fuel, and no amount of hard travelling could possibly bring us to Drayu Gompa in one day. On the very rare occasions when it had been a necessity for one of the headman's sons to go he had had to do it in three days— one day to the tree-line, one day over the pass, and one day from there to Drayu Gompa. I did not want to spend an extra day in travelling unless I was absolutely forced to do it, as there was always the pressing problem of the food running out, and so

# The Journey

I argued until the headman agreed to make arrangements for us to do it in two days.

The arrangements involved extra animals to carry supplies of fodder because none would be available at our camping-place just under the snow-line at 17,000 feet. And axes would have to be taken to cut down sufficient wood to keep us from freezing to death. The possibilities ahead had a sobering effect on our caravan and there was not nearly so much verve and action in our departure as usual. The whole village turned out, of course, and my companions shouted bawdy remarks to the village maidens who shouted equally bawdy remarks back, but the curvetting and other exhibitions were lacking. As it would serve no useful purpose to ride ahead, I dropped behind our caravan and gave myself up to my thoughts. There was nothing around to take up my attention for the valley was narrow, being less than a hundred yards across, and the mountains rose sheer and high above us. The trail was rising steeply, and shortly we entered a thick forest of pines.

About five hours later we turned off the trail into a small clearing in the forest and our muleteers informed us that this was Gotelatsa, our camping-place for the night. We were just on the edge of the tree-line and a piercing, howling wind through the tops of the trees numbed me even in my furs. The sun which had accompanied us for most of the journey had now clouded over and the greying sky looked heavy and ominous. As soon as we had swung stiffly from our animals, the Tibetans spread out to gather wood even before unloading the pack-animals—something which I had never known Tibetans do before. When a small fire had been started and the large pan for tea put on they divided up to unload the animals, stack loads, gather wood and distribute fodder. The axes and huge three-foot swords which the Tibetans always wore thrust through their cummerbunds were now brought into play as they attacked the surrounding trees with swinging powerful strokes. As I saw the blade biting deep at each blow I shuddered to think of that weapon in their hands in battle. Tiring of showing the keenness of their swords and the strength of their

arms on branches, they turned to the trees themselves and were soon bringing them down up to about eighteen inches in diameter.

It was so cold that I could not sit still beside the fire that was already blazing: I hurried backwards and forwards carrying huge logs and piled them on to make a still larger blaze. It was then possible to sit down and drink large quantities of scalding tea, but even with the almost intolerable heat in our faces our backs were frozen. I decided that such an occasion warranted a special menu and opened one of my precious tins of soup, noting that my stock was diminishing at a remarkable rate. I also gave out a handful of dried meat to each of the muleteers, whose food consisted of a plain ash-baked scone dipped in their tea. How such magnificently built specimens could be produced on such a meagre diet was amazing.

After we had eaten, we set to with a will to cut down as much wood as possible for we had to keep a fire going all night. The Tibetans carried no bedding, simply rolling themselves in their roomy fur gowns beside the fire wherever they might be, but it would have been impossible to sleep in this cold beside a dying fire. When we had accumulated a huge stack of wood we divided it up into several small piles which we placed beside each of us, so that whenever any of us awoke we could replenish the fire without having to get up. The others made a hollow in the spread hot ash and small bracken and, burrowing down in this, pulled their gowns about them. I climbed into my two-layer sleeping-bag, determined to keep all my clothes on as well, but after some cogitation came to the conclusion that I should never be able to face the bitter dawn, and so compromised by piling my clothes on top and stuffing them between the layers of the sleeping-bag.

For a little while there was some desultory conversation, which gradually died out and left only the hissing and crackling of the logs to compete with the rising wail of the wind. The leaping fire-light illuminated the clearing and forest for some distance, giving the impression of some ancient druid forest cathedral, while beyond lay impenetrable darkness. It was a

restless night all round, for as soon as the fire began to die down we were awakened by the cold and had to pile on more fuel before sleep again became possible.

## 6th February

Before dawn the Tibetans were up and moving around, heaping the fire with the remainder of the trunks and branches, and then only leaving its precincts to go and bring in an animal and tether it near by, when once more they unthawed before venturing away again. I had several bowls of scalding hot tea before I could even face the prospect of getting up to dress in that icy atmosphere. Tying on the loads was an excruciatingly painful ordeal for the muleteers as the boxes and leather thongs were all frozen stiff and their hands were numb before they began. Even in fur-lined gloves my fingers were absolutely without feeling. I had put on every bit of clothing I could find, with extra socks, pullovers, woollen scarves and gloves under my fur hood and fur gloves. The Tibetans had their gowns wrapped right up to their chins, their fur hats with flaps pulled down over their ears, and only their eyes showing.

Just as dawn was breaking in surly greyness around us we left the shelter of the tree-line and met the full force of the wind driving down the valley with a swirl of snow, shutting out the mountains around us. There was no sound at all, except the rise and fall of the wind, even the Tibetans being silenced in that intensity of cold. After three or four hours' climbing we came to a huge ice-field which completely blocked our path, filling the whole floor of the valley. We made one or two attempts to get the horses on to it, to see if we could get an unloaded animal over; but they fell down immediately and had to be dragged off by the tail. There was only one thing for it and that was to cut steps in the smooth surface of the ice with the axes and swords, to give us some sort of footing. There was not a bush in sight from which we could obtain some branches to spread over the ice when broken up, and as the horses continued to fall even on the broken ice we had to start digging in the iron-hard earth for

sufficient dirt to accomplish the same purpose. Even then, as we led the horses over like cats on a glass-topped wall, men and horses would go down with a crash and would have to be helped precariously back by some of the others.

All this delayed us about two hours and I began to wonder whether we should be stranded on the pass after all. I gave orders to the head muleteer to follow after us as quickly as possible and then took the headman's son, who had done the journey before, as a guide to go ahead with us. The snow was heavier now, blowing painfully into our eyes, since we could not wear coloured spectacles because of the ice forming on the glass, and shutting out everything. As we bent head and shoulders against the wind and driving snow it was all each one could do to see the rider ahead. We headed into this icy wilderness for hours it seemed, although I had lost all sense of time and feeling and direction.

Soon we turned into a narrow valley which must be the remotest, most forsaken and awesome spot on earth. It was no more than a half-mile across in every direction and was completely hemmed in by sheer, jagged, unclimbable snow-covered mountains. The silence was intensified after the recent shrieking fury in the other valleys: the rearing mountains strove to shut out the snow as well as the wind and sound. The snow lay like a pall over everything, the ice-covered boulders were like gravestones, the huge icicles like ghostly shroud-draped dead and the silence was the gibbering silence of a mortuary at midnight.

When the guide suddenly spoke I almost fell from my horse, for so long had we been silent.

"Can you see which way the trail leads?"

I threw him an uneasy glace. He showed all the overconfidence of a man who has lost his way. Loshay, Aku and Dawa Dondrup scanned the faces of the mountains closely and grunted a negative.

"I think it ought to go up there towards the right," he added, nodding towards the point where the mountains at the end of the valley joined at right angles the mountains on either side. I looked at the smooth incline on the mountain face towering

above us until I could just see the top with my head stretched back to its limit against my collar.

"That is impossible," I stated flatly, smiling wanly as I re-called having heard that before. The smile was killed at birth, however, due to insufficient inclination and elasticity of skin, for my moustache and beard were locked in solid ice.

"If that's impossible then so is that," said Loshay, pointing towards the incline on the left-hand side of the valley, where the snow seemed even more smooth and the face more steep.

"No, I think the trail is to the right," said the guide, but I knew the symptoms too well to be deceived.

"Where's my compass?" I asked Loshay, as I plunged my hand into my pocket hoping that that might give us some idea which one of the two ways to take, and suddenly finding it missing.

Loshay looked blank; so blank that I knew something was wrong. "A-tsay!"[1] he exclaimed. "It must have dropped out of your pocket during the night when you had your coat on top of the sleeping-bag, for I found it this morning on the ground. As you were not awake I put it in one of the loads for safety and then forgot all about it."

Well, that was that. Loshay's carefulness was commendable but it was likely to cost us a few uneasy hours if not our lives. If we waited until the pack-animals caught up with us to get the compass then we should have to spend the night on the pass, which would mean almost certain death in this temperature. If we went on at a guess and took the wrong turning then we should still be stranded in an even worse predicament, with cer-tain death to follow.

"Now, Lord," I breathed inwardly, "this is your world and I am on your work: which is the correct way?"

"To the left," came the immediate answer, and for a moment I doubted whether I had heard aright, or whether it was the evil spirits in that dread valley luring us on to destruction. I waved the others forward in that direction with a confidence I did not feel. Of the two ways the right seemed less impossible,

[1] A-tsay! Tibetan exclamation of dismay.

and from the dubious looks of my comrades as we headed to-
wards the left they would much rather have risked their lives on
the right. However, I had been so often right with my compass
when they had argued that they were now inclined to accept
my words without it, and so to the left it was.

For several hours we toiled up the face of that slope, or rather,
the horses toiled, for we had not the first idea where the trail
was likely to be in that virgin carpet and left it to animal
instinct and the guidance of God. The snow reached to above
their knees, and, when they stumbled on the trail, up to their
shoulders. It was no use our trying to dismount for we might
have gone right into a deep drift and been unable to get out, or
rolled down that sheer slope into a human snowball. When we
finally reached the top we were once again met by the raging
wind and snow. We dismounted to descend, and in order that
we might not be lost in a drift or slide we formed a chain by
holding on to the reins of our own horse and the tail of the horse
in front. Time after time one of us would go down in a heap, as
a man or a horse took a wrong step in that blinding blast and
smothering snow, and was only saved by the others going into
an immediate reverse.

After some time we reached a small gully where we huddled
together out of the force of the blizzard to talk over the situation
while the others smoked. The guide still could not say whether
we were on the right trail, and I could not blame him, for we
could see nothing at all that might have served as a landmark.
I suggested that we go on for a little while longer and see if we
could get to some place out of the worst of the snow, where we
might be able to scout around and look for a landmark which
would tell the guide if we were right or wrong. Once again we
faced the elements, a feeble speck in that raging wilderness of
white. A sudden drop in the valley brought us what we had
been looking for; and while the snow still fell thickly the wind,
probably due to some peculiarity in the contours of the moun-
tains, was carried in shrieking fury above our heads. Here we
spread out in a long line instead of a single file and ploughed
our way through the snow, shouting every few seconds to the

dim forms of each other a few yards away. A yell from over on the left brought us all to a halt and then drove us towards the direction from which the sound had come. Here the guide was pointing excitedly to a hollow under a huge boulder where there were definite signs of old manure. We had come the right way after all.

Some time later—a long time it seemed—the snow thinned, the wind eased and we once again jumped into the saddle and pushed forward faster. A turn in the valley and a sharp drop in the trail brought us out of the snows at last and with great sighs of relief we all dismounted to walk our horses which were almost dropping from exhaustion. Dawa Dondrup suggested that we stop and camp for the night when we reached the tree-line far below, where there would be wood for a fire—and then leave early for Drayu Gompa the next morning. I was against this though, as it would mean a wasted day, and also a very hungry and miserable night with insufficient dry clothing to be comfortable: I said we would push on for Drayu Gompa. We walked at a brisk speed and were soon so warm that we began to peel off our outer layer of clothing.

Just as dusk was setting in we saw some houses far ahead, and so I gave the order to ride and for Dawa Dondrup to go ahead. As we drew nearer I could see in the rapidly falling light that the houses were on the far side of a broad but shallow river, over which there was a large, soundly built wooden bridge. It was just as well, for I do not think I could have faced another bridge, Heath Robinson style, in my present state. The wooden boards of the bridge gave off a good solid sound while we rode over the hundred yards or so of its span, and helped to announce our arrival. We had only reached the other side when Loshay's horse lay down and refused to move further. This was embarrassing for Loshay as he could hardly enter the village on foot; it was just not done. However, Aku solved the problem by giving his horse to Loshay, and calling a villager to take charge of the casualty, he rode behind Loshay to the outskirts of the village and then dropped off to slip in quietly and leave the procession to us. In any case it was so dark that no one could

distinguish who were my servants and escorts and who were the villagers.

A long room in the courtyard of a large Tibetan house had been prepared for my arrival and was liberally spread with rugs, with a huge charcoal fire blazing in a brazier. I sank down on my couch with a prayer of gratitude for safe arrival and stretched my hand towards a servant for the ever-present tea. As I absorbed bowl after bowl of the eye-watering beverage I gradually unthawed and eased the knots out of my protesting body. The crowd passed the usual interested comments on my appearance with additional comments on my capacity, and then hastily divided to let through the officer in charge of the garrison at Drayu Gompa. He was a pleasantly ugly man with several men escorting him. Unwinding myself gingerly, I rose to greet him. He waved me to be seated and took a lower couch for himself to indicate that he was the inferior. We exchanged polite greetings in which he said he had received instructions from Dege Sey to facilitate my journey in any way I desired and he was mine to command. I told him I should like some flour and eggs, milk and butter, if possible, and, of course, animals to travel to the next stage. He said that he could supply these things but would I not consider staying a few days as his guest? I regretted my need for haste which deprived me of the pleasure of his company but I really had to go quickly. He then pointed out something which I had forgotten and which gave me a rude shock, namely, that my pack-animals had not arrived with my loads and it was getting dark! Would it not be advisable to stay for one day and make sure everything was all right before proceeding? I assured him fervently that the advisability was overwhelming to the point of necessity and that I should be honoured to have him as my host for the next day. On this exchange being completed he withdrew to let me eat, with assurances that he would see me on the morrow.

As soon as I had finished eating—and drinking—I lay down on the couch to sleep beside the charcoal fire just as I was. I had barely closed my eyes when there were shouts outside and some people burst in to say my loads had arrived: and did I want to

check them? I told them to bring in my sleeping-bag and then
shut the door, when I should require no more until the morn-
ing. I crawled wearily and gratefully into my sleeping-bag, as I
had never done in a feather bed, and was relieved to think that
I had a day to rest after all. It would give me time to check the
loads and replenish some of my food supplies, and also would
give the escorts a break to mix with their fellow-soldiers in the
garrison. I had driven them pretty hard and I dared not run
the risk of bad feeling in our caravan, as it could easily end in
tragedy all round.

## 7th February

I watched Loshay prepare for breakfast. Six eggs lay cosily
side by side on the rim of the brazier. For several minutes I had
been devoting all my mental energies to trying to think of a
new recipe for eggs. My trail was strewn with broken egg-shells.
Where the hen squatted there hawked I. The ubiquitous domes-
tic fowl spoiled by the equally ubiquitous foul domestic. For
years now I seemed to have lived my gastronomical life in a
cycle of eggs fried, eggs boiled, eggs scrambled. If I did not break
out of this cycle soon, I should build up a complex and end up
by seeing eggs rolling down mountains, flowing down rivers,
falling as snow-flakes, turning as wheels, growing as grass—and
believing that I was Humpty-Dumpty.

"How do you want your eggs done?" asked Loshay.

"Fry them," I sighed resignedly. There were two meals ahead
and one would be tsamba with dried meat, the other would
have to be eggs, but I resolutely put the thought behind me.

Dressing leisurely I gave myself a wash. It was the first since
Gartok and I felt no shame; in fact I had remarkably little feel-
ing at all in this matter either in itch or discomfort or in any of
the supposed consequences poured into my ears as a boy by my
anxious mother or as a student by my diligent teachers. My last
bath seemed to lie pleasantly in the mists of antiquity. I even
felt virtuous when I thought that no Tibetan could accuse me,
as they did other foreigners, of smelling peculiarly because I

was clean, and I never felt fitter in my life. Just to show how fit I was I spent two or three hours reclining on my couch reading. I had not had much time in the past few days to read, and as thinking seemed to be the only occupation I had so far discovered to be suitable and practicable while on the back of a horse, I obviously had to have something which I could think over. So I read through the lives of two of the greatest men in history, who thought usefully and translated their thoughts into achievement—David the Shepherd-Poet-King and Solomon the Wise, his son.

The escort had asked permission to visit the garrison and had gone off with some presents for soldier friends. I decided to go out and have a look at the place as it had been too dark last night for me to see anything. The valley ran due north and south with the River Dzi Chu[1] quietly flowing through. On the western slope of the mountain was perched the large village of Drayu Gompa which took its name from the large "Gompa", or "monastery", completely overshadowing the village. Tier upon tier of buildings containing the cells of monks rose above the village and the whole array looked as if it might topple over any minute and carry the village into the river. The buildings were whitewashed, with the wooden beams and supports painted in red, blue and yellow dice, giving it a very picturesque appearance from a distance, but at close quarters it was the usual filthy place with filthy people. The houses of the village were stone—and mud—built as usual by the same dirty, cheerful, captivating people to be found all over Tibet. The virility and charm of ordinary people made one forget their dirt, but the same could not be said of the priests, or lamas as they are called, whose presence and practices repelled. It was not a religious prejudice on my part either; I had had to treat too many of them and their acolytes for sodomic and pederastic excesses.

[1] I cannot guarantee the authenticity of this: it is asserted locally by natives. According to the Survey of India map included in Sir Charles Bell's Grammar, the Dzi Chu flows into the Salween *north* of Drayu Gompa, whereas this river (unnamed on his map) flows into the Salween *south* of Drayu Gompa.

With nothing else of note to see, and not feeling like throwing stones in the river, I returned to the house and found my escort and Loshay had arrived full of talk and new wine. From the general hubbub I gathered that the acting C.O. (as my officer visitor of the previous night was designated) wished to provide me with a feast; but that as he had not the necessary amenities at his place, and could not aspire to such an honour as my presence, he would send his soldiers with the food when I gave the command. I gave it promptly: the problem of the eggs loomed too close for prevarication. In return I sent presents for himself and his cook.

The presents must have served as a considerable fillip for he aspired to the honour of my presence soon afterwards, when the usual questions ensued. I was beginning to feel like a News Announcer and Information Service clerk rolled into one. When he rose to go he apologized for the meagreness of his gift and called forward three servants who were all carrying food of sorts. I could have yelped for joy when I saw several lumps of solid brown sugar. I had received a present of one pound of Indian tea from Dege Sey but I had no sugar, and now I could occasionally indulge in nectar once again. I bade my apologetic host an almost tearful good-night.

Drayu Gompa was at the junction of several trade routes, trails branching off to Chamdo on the north-east, Lhasa on the north-west, Yunnan on the south-east and India on the south-west, and it was from Yunnan in West China that these sugar cones were obtained. They were lumps of solidified molasses and contained all sorts of matter, animate and inanimate, but I hugged them to my bosom. They even made the eggs (scrambled)—which I had for supper—tolerable.

## 8th February

I was still in bed, when the Acting C.O. called with more presents as if he had been overwhelmed by mine of yesterday. He had told me that we should not be able to get beyond a

place called Kuli today because that was the stage, and so I had not got up at dawn, or before it, as we usually did on the trail. He now added that Kuli was only a few hours' easy riding away, with a small pass to cross; none of us therefore need trouble about breakfast, the usual quantities of butter tea would be sufficient.

As we climbed out of Drayu Gompa the sun shone, but snow and ice lay around in the patches of shade. Almost immediately we made a bad start; having ridden ahead of our caravan in our usual spectacular exit from the town, we headed for some distance up the wrong valley. I do not know why Aku should have asked a lone wood-gatherer if this was the correct direction, but he did and we were told we had chosen the wrong valley. Where we might have landed if it had not been for that fortunate meeting and question made an interesting speculation for the next few hours.

We retraced our footsteps and took the right valley, which had a much steeper incline and narrower trail and settled down to an easy walk. The trail rose so steeply that when we passed above a lonely house in the entrance of the valley I was able to look down into the courtyard. I was amusing myself by thinking how like a Tibetan doll's house it appeared, when my attention was caught by the actions of two people in the courtyard. A few minutes before one woman had been sitting quietly in the courtyard and another had come out of the door carrying something. As I watched the one sitting had rolled over and even from this height I could see that something serious must have happened as she rolled on the ground. The second woman had dropped whatever it was she was carrying and was now half-dragging, half-carrying the first woman towards the house. I shouted; and the woman looked up in startled fashion, as we were hardly the type of person who passed the door at 8.30 every morning, but I could not make her understand. This was not surprising since only a few of the men who had met other traders could make themselves understood, the others speaking in their own unintelligible vernacular. I asked Aku to inquire what was wrong as I had a few medicines and might be able to

help. The answer came back: "Smallpox." Dawa Dondrup in the lead immediately swung away at a fast trot followed by Loshay, and with Aku urging from behind I was carried on. They were afraid and did not care who knew it. They would die fighting with a whoop of laughter on their lips, but they would not stay near smallpox. It was the disease the Tibetans feared most. It was almost the only disease, apart from syphilis, which existed in the crystal-clear climate of Tibet, and was the most fearsome death. Hence the reason for my companions' haste away from the proximity of the illness. I could do nothing in any case as I had only a few medicines for first aid for ourselves, the rest having been given to Dege Sey.

We climbed steadily for an hour or two—the trail gradually becoming worse, first snowed over, then frozen. Aku went down with a crash on the smooth ice and was thrown among the boulders at the side of the trail. Then Loshay shot away on a long glide down an icy slope. Then my own horse went down and had to be stripped of saddle-bags, saddle, etc., before it could be lifted to its feet, while, during the process, we all slipped wildly and fell several times. We continued to climb, sometimes riding, sometimes leading the horses over the worst parts. As we climbed higher we reached heavier and deeper snow and the horses found great difficulty in making a way, and I began to wonder what it would be like when we came out above the tree-line on to the more exposed places. We were not left in doubt very long. The wind was blowing straight in our faces, lifting up the loose snow in great clouds and driving it against us. The trail had completely disappeared and all around us was a smooth white carpet except for where the trees away down the far valley showed black in contrast. I headed for an opening in the trees, hoping fervently that the trail beneath its covering of snow did not bend away sharply in any direction or that we should not step over the edge of the trail or a snow bridge in that great virginal expanse. We made the trees in safety and then it was comparatively easy again, until once more we topped a rise and a choice of two ways lay ahead. We had no guide as all the muleteers were with the pack-animals,

and we had now completely lost our bearings in the absence of landmarks.

So far we had come in the only possible direction: either forests, cliffs, or snows had blocked other ways, as far as we had seen; but according to the Acting C.O. the trail was supposed to be easy, with only one pass and the village near at hand. We had already been travelling on a trail which had nearly killed us all at different times, we had crossed two passes, and yet there was not a sign of an animal in all that expanse, much less a human habitation. It was too late to go back now, for if we had taken a wrong turning somewhere it must have been at the beginning of the journey and now we could not possibly arrive back in Drayu Gompa before night set in. We decided to go forward to the next pass and see what lay there on the other side, and let the caravan look for us by the horses' manure piles and the blaze-marks we occasionally made on the trees with our swords as we passed. I took a compass reading to get a rough idea of direction and chose the valley leading south-west instead of north-west and headed my horse once more into the snow. The mountains around were like giant waves of milk. The former rugged savagery was gone, replaced by a billowing smooth menace. Not a shrub, not a stone, disturbed the powdery perfection of the snow and we were thrown back on our skill at snow-surface reading and the horses' instinct to find a trail. I do not know if we were very successful. I do know that after about three hundred yards I had to fall to the rear and let Loshay take the lead, as my horse was exhausted and could no longer lift its legs to break a trail. Soon Loshay's horse was floundering more often than before and he too had to fall behind to be replaced by Dawa Dondrup. He had a heavily built animal and for a time succeeded in driving it ahead at a moderate speed, until it too refused to go any further and fell behind. It was now Aku's turn, and I watched the greying skies and thickening snow with some trepidation; already the top of the pass which had seemed quite close was blotted out and re-moter than ever. Soon Aku's horse refused to be driven any further and I called for a halt and a rest. We dismounted to give

the horses a breather—and sank waist deep in the snow, clinging to the saddles for support. After a short rest we began to go forward again and the distance between us gradually widened as we staggered on. Loshay's horse had completely collapsed by this time and refused to carry him, so he had to battle along on foot in our path. None of us could stop and assist him, as we were fully occupied in picking ourselves and our horses out of the drifts. It would not have been so bad if we had been sure we were on the right trail, it was the thought that we might be lost in that white waste which was nerve-racking. We could see nothing at all now because of the swirling snow but, carried on the wind, I heard a yell and struggling towards that point found that Aku had reached the prayer-flagged summit.

It was icy cold while we waited for the others, and Loshay looked like the Abominable Snowman when he finally put in an appearance, being covered from head to foot in snow from his falls. There was still no trail but away down in the valley below there appeared to be what might be houses. Whether it was the village of Kuli or not we could not be sure, but we had to make our way there anyway and shelter for the night. We tied the reins to the saddles of the horses so that they would not trip over them, then with shouts and snowballs drove them down the mountain in front of us. The late afternoon sun broke through behind a cloud and the reflected glare from the snow almost blinded us, and Loshay began talking about various people he had known who were victims of snow blindness. My own eyes were aching with the intolerable strain of trying to pierce the snow curtain, but for the most part we were all too occupied in trying to find a way down the mountainside to the houses to bother about a possible blindness. Every so often the horses would go away in a wild slither and miniature avalanche down the mountain, and then would begin the ticklish process of getting them out without being victims ourselves.

After descending in this fashion for over two hours we came through a small forest into a clearing with a few houses, and on inquiring the name of the place discovered that we had been right after all and that this was Kuli, our stopping-place. Dis-

tance in any part of Tibet is generally a matter of conjecture, because there are so many unknown factors to be taken into consideration, and where a part was unknown and untravelled as this was distance became purely speculative.

The Tibetans were convinced that the pack animals would never arrive that night, or, even if some managed it, that the others would most certainly die. This was cheering news, as all the bedding and dry changes of clothing were with the animals; and I resigned myself to a night spent sitting by the fire drying off our sodden clothes. In the meantime I fortified myself with several bowls of tea and five eggs—scrambled. The Tibetans, being slightly more peckish, managed to eat twenty-eight between the three of them. The headman, bending almost double in his submission to the two representatives of the Tibetan Government in Aku and Dawa Dondrup, had hastened to produce as many eggs as possible. Just to make sure that he produced plenty Aku demanded a hundred, knowing that this number was impossible but adding in an aside to us that inability to comply would keep the headman in an excellent state of amenability; when about fifty eggs had been produced, however, with butter, milk and some utensils to prepare a meal, we sat down around the huge fire and gave ourselves up to the present. With that aura of contentment, induced by food, shelter and heat, enfolding us, we bade the headman to join us to drink tea and talk. Almost the first contribution to the conversation was his news that they had smallpox in the valley and that one of the members of his own household was down with it. As I saw the horror spreading over the faces of my companions while they digested this, I hastily tried to remember how many years had passed since I had been vaccinated. There were only a few houses in the valley, he added helpfully, and all the others had more victims than his own. As a counter-balancing factor, however, he went on, there were two people in the valley, a man and a woman, who were both well over one hundred years old.

An interesting point arose from the ensuing discussion, and one which should be of value to all Homoeopaths, particularly

to that Grand Old Man of Homoeopathy, Sir John Weir, who knows no greater delight in his lectures on the subject than to be able to confound the critics of Homoeopathy with an irrefutable example. Loshay had protested against such a wide-spread incidence of the disease, which appeared to be in several of the valleys around as well, and said that in his part of Tibet they had an infallible method for combating it. As soon as it was established that a person had smallpox and the vesicles appeared on the skin, the vesicles were punctured and the serous fluid obtained dropped into milk and drunk by the other non-infected inhabitants of the valley. They produced the symptoms of smallpox for a few days and then recovered without incurring the disease and were never known to be infected afterwards.

As we talked of this and that, and I began to nod sleepily, sounds were heard outside and the animals had arrived. The muleteers were exhausted and cursed the snow and the darkness and the trail indiscriminately as they wearily stacked the loads in the room beside me. They said that at least two of the animals would die of exhaustion after that journey and wanted me to compensate them for their loss. I pointed out to them that I was not responsible for the blizzard, that the Acting C.O. at Drayu Gompa was certainly responsible for wrong information regarding the distance and our late start and that an appeal to him would be more in order.

The outside cover of my sleeping-bag was soaking wet, but I only required the inside as there was plenty of wood available for the fire. With confused thoughts of snow and smallpox and dying animals I drifted into sleep.

## 9th February

Kuli was only a small village and unable to produce sufficient animals of any kind to carry all my loads; so several porters, men and women, had to be supplied. This slowed the speed of our caravan and I resigned myself to making only a short stage. I had thought, from the very unsatisfactory map and the re-

# 9th February

ports I had gathered, that I might be able to cover as many as three stages today, but that was out of the question now.

Once we left the valley the trail began to wind in hair-raising fashion up and around the sheer face of the mountain for three or four hours, so that our left-hand stirrups hung over the edge of the trail above the sheer drop into the river far below. Finally, the trail became so bad that even the normally indifferent Tibetans dismounted and led their horses and we made very slow speed as we moved gingerly forward. Suddenly, Loshay let out a shrill whistle and shouted mockingly to Aku to look ahead. Aku, whose nerve would have been envied by any Swiss guide in the Alps, had, nevertheless, been dismounting recently oftener than the others had considered necessary for a Tibetan, and had been suffering merciless leg-pulling accordingly. It was because of this that Loshay now drew his attention to a part of the trail ahead which made all that had gone before look as safe as a meadow in June.

The trail took a right-angled bend at this point and then became only a thin line running across the face of the mountain, which seemed to run almost straight up and down at this part. Just to make matters more interesting, the whole face of the mountain had given way at one time and was now only loose earth and boulders. Not a shrub was evident to hold even a fraction of the earth together on that smooth invitation to death. As our caravan came to a halt behind, I asked the leading mule-teer from the village we had just left if there was any other way since this one appeared impossible. He said that this was the only way forward unless we wanted to retrace our steps almost to Drayu Gompa and try to discover a new way from there: he did not know of any. On the very few occasions when they visited the next village they usually took the journey on foot and not with animals. Well, it had to be attempted and so I gave orders for the crossing to be made with the animals, with people spaced out regularly so as not to have too much weight placed on one part of the trail at one time. Even without weight small stones were mysteriously being dislodged and these, gathering momentum and other stones in their descent, indi-

149

cated the manner in which we too should descend should we slip. It was crazy to go forward. It was impossible to go back. The only justification for such a reckless decision involving twenty lives lay in my unswerving belief in the purpose of God and my confidence in the power of prayer. Here was my challenge to Christ and to the world. No power on earth could take twelve people and eleven animals, including the massive yaks, across that mountain face, and no man had a right to gamble on the chance. If you have faith you shall move mountains, Christ had said. Right, equally possible to the One Who claimed to have all power must be the converse: to keep the mountains from moving.

I told the porters to move ahead first, then the horses with a muleteer leading each, then the soldiers, then Loshay, while I stood and watched and prayed. As soon as one person disappeared round the bend of the trail leading across the face of the mountain, the next person started out, until the whole caravan was strung out like moving beads on a thread in front of me. The silence was uncanny. I waited until the first porter had almost reached the out-jutting shoulder on the far side then I, too, started off. I had scarcely rounded the corner on to the worst of the trail when a voice ahead shouted that the mountain was on the move—and blind panic was let loose. Just in front of Loshay a young muleteer, no more than a boy, sobbed aloud as he tugged at his frightened horse and stumbled along with his gaze fixed on the mountain above. Loshay gave his horse a savage cut with the whip which almost drove it over the edge as he reached the corner and solid ground. I was last and threw myself after him, pulling at my horse, when the landslide passed down behind me with a dull roar. We leaned against the horses and mountainside to recover our breaths and composure before moving on.

The trail did not become much better as we progressed and we continued to mount and dismount at odd intervals. As we went along I thought of the incident just past and the conclusions to be drawn from it. I remembered the sickening puerilities of Somerset Maugham in his conception of prayer in

## 9th February

*Of Human Bondage.* I recalled the tragic ignorance of Edmund Gosse in his conception of prayer in *Father and Son.* I reflected on the question-begging superficiality of George Bernard Shaw in *The Black Girl in search of God* and in *Major Barbara.* Men intoxicated with their own littleness and imputing the same insignificance to God. Not that I was suffering from the effulgent after-effects of a major coincidence. For five years now I had tested the claims of Christ, observing *all* the conditions of course—a simple necessity which those others seemed to have overlooked—in all kinds of circumstances until all possibility of coincidence or chance was completely ruled out. There was no possibility of error. I walked with destiny in the person of Christ.

Far ahead a gleam of water showed the Salween running from north to south in the bed of a deep river valley. Between us and it, on the mountain slope dropping down to the river, were perched precariously a half-dozen houses: a place called Padi, which was to be our stage for the day. To reach it we had to descend steeply, and I thought that if we could make it quickly I might yet be able to get to the next stage before dark, as the sun was still overhead. I did not say anything to the Tibetans and it was just as well, for Aku had stopped and was waving to us to dismount. Hobbling the horse, I left it and walked forward to see what had caused the hold-up. I gulped. If anyone should ever ask me to give my impression of Tibet in one sentence I shall oblige quite confidently and adequately in three words: eggs and bridges. Not that they were ubiquitous. Rather that on the rare occasions when they did appear they seemed always to present an acute problem. It was so now. The trail must at one time have led round the shoulder of a huge rock jutting out from the mountainside, which since that time had been carried away by rains or landslides. Now the trail dropped abruptly into the river thousands of feet below, and some incredibly agile and hopeful Tibetan had made a platform of wood and supported it on the rock-face with a few wooden posts beneath and some creepers tied out of sight above. It appeared we would have to be even more agile and hopeful to cross it.

Loshay had stepped out carefully to where it ran round the shoulder of the rock and was now keeking round the corner like a mouse out of a hole to see how far it extended on the far side. He came back, grinning cheerfully, to announce: "Thirty yards." Thirty yards on a waving platform thousands of feet above the Salween? I grinned suddenly to myself as I thought of my recent confident assertions.

"Grab your horse and your hat," I said to Aku, who was looking gloomily at the depths, as I passed, "I have an appointment to keep in India."

We crossed. It is amazing to think that two words can span an event of such magnitude as that appeared to be, and it must be some sort of proof that English is not so decadent as the Germans, Russians, and Scots would insist. Certainly one thing I will admit, English does not contain sufficient or appropriate words to describe my feelings as we crossed. There the matter must rest.

I now felt so exhilaratingly triumphant that when we arrived in Padi shortly afterwards I told the headmen I intended leaving for the next village immediately after eating some tsamba and dried meat. Even Dawa Dondrup and Aku protested, but Loshay was prepared to attempt it and I was adamant. The unexpectedly long journey yesterday had made me suspicious of all headmen and I had neither time, food nor inclination to humour them.

The descent was now so precipitous and the trail so bad that loaded horses could not go down. Consequently all the animals had to be stripped of their loads, and the stirrups and reins tied to the saddles of the riding-horses, while the loads were carried by men and women. For four hours we descended the sheer face of the mountain, winding backwards and forwards across the scree at an acute angle in order to maintain our balance, and resting at every turn. Dust rose in clouds as horses and men slipped and slithered down the constantly shifting trail, and it was late afternoon before we arrived on the banks of the Salween, which at this point flowed wide, deep and sullen between the sheer slopes of the mountains. The crossing was by means of

a wooden raft of six large logs tied together with leather thongs and pulled across to the other side by hand-over-hand pulling on a fibre rope slung from one side of the river to the other and dangling on the face of the water. This novel method kept the raft from being carried away by the current but did not keep the water from washing over the raft.

Some of the people had gathered on the far side to watch our arrival. Loshay went ahead on the first crossing to meet them and to see what was being done in the way of preparations. After a few minutes' conversation he left with one of the men, and having climbed steeply up the mountain for a little way, disappeared over a shoulder. About fifteen minutes later some men appeared leading a horse for me to ride so that I need not wait beside the river for my own to arrive, and having topped the shoulder of the mountain a few minutes afterwards I found myself in Tangsho Druca. This was a collection of small stone houses rising not more than three feet above the level of the ground, with the spaces between their stones inadequately filled with mud. The cave-like appearance of these dwellings was caused by the fact that the floor was below ground level and the walls had been built only to give enough head-room to move around. The whole village thus appeared to be like a large pigsty. The appearance of the inhabitants was in keeping with their environment and I have never seen such a collection of utterly filthy and ugly people in all my life. Almost three-quarters of the adult population were suffering from huge goitres in grotesque shapes. The houses were shared by the livestock, and as I lay down on my sleeping-bag beside the fire I was only separated from the horses and pigs by a curtain of filthy rags which had been put up in my honour. The headman here also received a beating from the soldiers because he had not prepared tea or food of any description for our arrival; and so the rest of the evening was spent in watching the disgustingly obsequious service of the breath-sucking, bowing inhabitants.

# The Journey

## 10th February

The next stage was a village called Drashing and from where we now were, down beside the river, we could see it high up on the mountain above us. There we could either stay or change animals for the next stage, as it appeared to be a considerable distance to the place beyond that again. I decided to wait and see what sort of information I could pick up at Drashing before committing myself one way or the other.

We climbed steeply out of the valley for a few hours and finally reached Drashing before noon. It was a collection of houses scattered irregularly over the steep face of the mountain and looked as if a good push would start the top house rolling and carry all the others into the Salween, thousands of feet below.

As I looked around idly watching the horses being unloaded and stretching my legs, the escort went up the ladder of the biggest house to see if everything was prepared. Shortly afterwards I gathered from the sounds emanating from that direction that everything was not! I was met by the sight of a bunch of burly Tibetans crowding into what, judging from Dawa Dondrup's voice inside, I took to be my room. Children were crying, and a woman passed me blindly, weeping and wringing her hands. Looking over the shoulders of the Tibetans into the room beyond, I could see the owner of the house on his knees upon the floor, held there by hefty Dawa Dondrup while Aku whipped him with his horsewhip. A man detached himself from the crowd and went forward to intervene, laying his hand on Aku's arm. Loshay stepped forward swiftly and hit him a terrific crack with his fist on the side of the head, knocking him right across the room. The soldiers then took the landlord and, disregarding the pleas of the other Tibetans, tied him to one of the beams of his own house. I pushed my way through to ask what was wrong, although I knew the answer before it was given. The man was the headman of the village and also rated as quite an official in the surrounding area. He had received the

154

notification of our arrival but had made only a few careless preparations. In fact, he had gone so far as to place an insultingly low seat for the official who was arriving and high seats for the servants. This was criminal negligence in a headman and had to be punished accordingly. He would be tied to one of the horses and taken to his district official to be adequately punished. The visitors had dealt with him for the time being, and would now deal with the villagers.

Nearly all the villagers disappeared at this threat of general punishment, except for a few who were preparing rugs and a fire and tea at a run. A roar from Aku brought them back again, however, and soon from twenty to thirty Tibetans were hastening all over the place on various tasks. I thought this was an opportune time to suggest that I wished to leave as soon as I had eaten, and did so to Loshay. Dawa Dondrup and Aku were inclined to argue for they were almost certain to get anything they wanted now from the thoroughly intimidated villagers, but I insisted on the need for haste. This would also mean that I could not take this headman along for any punishment, I added. Aku gave his wicked grin and said that they had no intention of taking him along; that was only a little threat to make the villagers co-operative in certain demands which they had in mind. I saw one of the fruits of that co-operation shortly afterwards when several large containers of "chang", or Tibetan beer, were brought in and placed before them.

While I imbibed large quantities of the beverage which cheers and does not inebriate, and the Tibetans larger quantities of the beverage which cheers and does, a fat Tibetan priest hurried in. He was plainly worried. He had every reason to be. The headman with shirt torn from his shoulder was still tied to the upright beam a few feet away and Aku looked as if he could imagine no greater delight than seeing the fat priest join him. The priest's first tentative advance on behalf of the headman was met by an abrupt refusal with oaths. The priest hesitantly appealed to me, but I referred him to Dawa Dondrup who was the senior soldier and put in charge of these matters by Dege Sey. For several minutes the priest absent-mindedly

drank several bowls of chang. This must have given him a more hopeful opinion of human nature for he tried again. This time Aku, in whom the same hopeful spirit must have been induced by the same means, responded in more promising fashion by emphasizing the evident vices of the said headman. The priest, lubricating constantly, pointed out the equally praiseworthy virtues that would be theirs if they pardoned the headman. Several bowls of chang later, the price of pardon was settled to everyone's satisfaction and celebrated accordingly. The headman was then untied and told to give the necessary orders for our departure.

Our preparations did not take long as the villagers were only too willing to help us on our way, and they provided us with some of the best beasts we had seen up to the present. Before we had swung into the saddle they were already moving away quickly to breast the steep slope of the mountain. The trail rose so suddenly out of the village that we had to sit forward uncomfortably in the saddles while the horses worked their way pantingly upwards. Beneath us the village looked even more precariously perched than it had when seen from the riverside, and the Salween itself was now only an irregular white thread in the scenic garment.

Soon we had traversed the flat face of the mountain and were moving along a narrow ledge with patches of snow in the shade. On the more exposed parts it lay several inches deep and was at times treacherous with ice underneath. I had been following behind a villager whom we had taken as a guide and who had not yet mounted his horse; he treated the trail with the respect it demanded, so that our pace was rather slow if steady. My companions were strung out behind and had been enjoying themselves going over the recent incident in the village, to judge by their hilarious bursts of laughter. I judged from the monotonous repetitions and maudlin giggles of Aku that he was drunk. Loshay was suspiciously happy. Dawa Dondrup unusually loquacious. All might have proceeded as normally as could be expected in the circumstances had not Loshay made a drunken discovery. His horse could pace. He tried it out in a

few twenty-yard bursts with Aku following suit. After one startled glance over my shoulder at the two madmen capering blithely on the edge of destruction, I concentrated grimly on holding my horse to a cat-walk as far from the edge as possible. The ledge was three feet wide: the drop to the Salween about eight thousand feet. The twenty-yard burst became tedious. Loshay shouted to the guide to get up on his horse and ride or else— The guide mounted from the edge of nothingness while I snarled at Loshay over my shoulder. It was useless. I dared not turn right round in the saddle or it might throw the horse off balance on the icy surface and over the edge, and, anyway, I knew from the reckless laughs of the Tibetans that they would be impervious to black looks or steely gleams. We moved off at a fast trot and Loshay gave a loud whoop as he brought his horse right up to mine in a crazy attempt to pass. I brought my whip down on its nose and it reared backwards, almost throwing Loshay into the Salween. While he fought the scared animal, Aku tried to squeeze carelessly past him. I raged at them to no effect. They were enjoying themselves and they took about as much notice of me as a "psychologically" brought-up child does of its mother. The panic-stricken guide had decided that it was better to fall into the distant waters of the Salween than into the near hands of the Tibetans and pushed his horse to the limits of despair. I followed: not because I agreed with the guide but because my horse was forced to agree. It was a macabre performance against a Tibetan backdrop. Fear, Fury and Frivolity in high revel on a platform over the pit.

We rode over the top of the pass into a valley lying at right angles to the Salween. The trail was still too narrow to allow us to dismount and I had to content myself with a fervent promise to beat Loshay and the others black and blue when we arrived. Loshay sobered slightly when he saw that I meant it, but the others still frolicked in their liquid Utopia.

Several houses could be seen scattered about the mountain on the far side of the valley. The guide said this was the village of Waha,[1] but as this was not a stage we did not descend. The

---

[1] Probably corresponding to Haka on Sir Charles Bell's map.

wind, which had been rising since we crossed the pass, now increased to gale force and brought with it snow and sleet. The volatile effects of beer had worn off and an uneasy silence was maintained, as we huddled forward on our horses' necks, hoping fervently that they would be able to keep their feet on the treacherous trail while we battled our way against the howling wind.

After several hours of this, as darkness came to blur the outlines of the mountains, the trail began to lead down sharply from the exposed heights to the comparative shelter of the valley. We had not spoken a word for hours because I knew that this was the best way of teaching the Tibetans a lesson which they would not forget; they who administered the law knew only too well what to expect from the law for their folly. I grunted to Dawa Dondrup to ride ahead and he pushed his weary horse to a reluctant trot. I noticed as we approached the end of the valley that several houses there were empty and wondered if we had reached a ghost village. But as Dawa Dondrup had not ridden back it followed that, like Noah's dove, he must have found a place to rest. In a few minutes we noticed some people inside a court-yard and turning in that direction swung stiffly from our horses.

As I entered the room, Loshay, Aku and Dawa Dondrup were rushing around—and ordering the various members of the family to do likewise—preparing me a worthy couch on which to recline beside the fire. I acknowledged such consideration with silence, and did not give the usual permission for them to sit down and drink tea. When Loshay started immediately to pre-pare a meal I gave orders for my saddle to be brought up from below. The Tibetans gave me a puzzled look as the saddles were kept in the stables, and then realization dawned—my whip was attached to my saddle. Sometime later I was awakened by Loshay shaking me gently with one hand and holding a heaped plate of scrambled eggs in the other. On the low table beside me was a pile of ash-baked scones and a pan of Indian tea. At first, in that drugged haze of bewilderment which follows on being wakened suddenly from a deep sleep, I thought it was early morning and time for departure, and then I noticed that I was

fully clothed, except for my riding-boots, just as I had come in. The others were watching me closely with all the exaggerated commiseration of friends at the sick-bed of a rich relative—wondering whether their present ministration would be rewarded after the recovery or their past lack of ministration rewarded at the decease. Memory came flooding back and with it a picture of my mother saying "Always give a child what you promise it, whether it be a bun or a beating." It was a philosophy she applied with vigour, and, in my case, apt. I was about to call for the whip when the significance of my riding-boots being off suddenly struck me—someone had unlaced them and also the legs of my riding-breeches while I was asleep, so that I could be comfortable. I looked at them as they sat around and, stifling a grin, lectured them on the folly and fruits of drunkenness. This time they had tasted of the folly, the next time they would taste of the fruits. In the meantime they could comfort themselves with the knowledge that they had been saved by a storm and a nap.

## 11th February

This village of Dzea was also too small to provide sufficient animals, and arrangements again had to be made for porters to carry the loads. I could get no information as to the distance of the next stage except for a vague assurance that it was "far", and so we were up before dawn and on our way as soon as it was light enough to see.

The trail was in a horrible condition, being only a faintly defined path winding in, over, through and out of boulders. At one time we would be hundreds of feet above the river, then shortly afterwards picking our way among the boulders at its side. The journey was tedious in the extreme; several times we had to dismount and help the horses over mounds of stones and boulders, until I began to wonder whether it would not be easier to carry the horse than vice versa. The valley would make an excellent place of poetically just banishment for platitudinous politicians.

# The Journey

It was past noon when, rounding a surrealist Stonehenge, we came upon a few houses whose members' subsistence must have been wrenched against fearful odds from the inexorable surroundings. This was Luz, indeed, peopled with a handful of Jacobs. If I asked for bread would they give me a stone? was my thought as I entered the low doorway leading to a smoke-filled room, in the largest "house" in the "village" of Zutik.

I ordered animals to be brought immediately and the loads sent ahead, since I intended leaving for the next stage as soon as I had eaten a hasty meal.

There was an immediate protest from everyone, including Dawa Dondrup and Aku who considered they were being considerably deprived of their legitimate—and other—tax-gathering by this haste.

The landlord pleaded his inability to supply animals and I pointed out that he could supply porters. He pleaded the extreme distance to the next village and I pointed out that it would be no nearer next day. He pleaded the impossibility of doing anything and I pointed out the door.

The trail grew a little better as we left Zutik behind a heterogeneous collection of horses, yaks, mules and porters. One porter I had sent ahead with only the light load of my sleeping-bag and strict injunctions to get to the next stage before nightfall. The rest of the caravan could follow at the normal pace. One or two open spaces allowed us to pass the straggling caravan and even to put the horses into a trot, but soon we were climbing again and a shifting gravel slope brought us back to a crawling pace once more. The afternoon wind was rising and chilling us to the bone.

We had been plodding upwards for some time, glancing apathetically from the moving dust of the trail to the moving foam of the river below, when, rounding a corner, the path dipped down steeply and suddenly for about fifty yards to pass under a huge overhanging rock, and then rose equally steeply and suddenly on the other side of the rock like the dip in a roller coaster. There was no room to dismount on the trail, which was less than two feet wide, and any attempt to do so would have

160

pitched both horse and rider into the river; at the same time there was not sufficient space between the trail and the over-hanging rock for a horse and rider sitting upright to pass underneath. We gazed at it for several minutes without speaking. There was nothing to say. We could not move backwards, we could not move sideways, we could not move upwards, we had to move forward. Loshay finally said over his shoulder that he was going to ride fast downwards and then swing backward to lie along the horse's back as we passed under the rock. It was an excellent idea to draw forth applause at a circus, but I could scarcely consider it thus objectively. However, Loshay was already away in a slithering run, reins loose and heels beating a tattoo against the horse's side. I tensed myself as I saw him hurtle towards the rock, expecting to see his head smash like an egg against it; but he swung expertly backwards at the last moment and the horse swept under and up the other side. I took another look at the rock and then the river and considered wistfully for a moment whether it would not be just as well to pitch myself in the river first as go in afterwards with a split head. I sighed as I acknowledged the proud necessity which drives a man to attempt the dangerous impossible rather than the safe probable, and kicked my reluctant steed into action. I had to give it its head as we plunged downwards at appalling speed. As the distance shortened and the angle of the slope grew more acute the opening between trail and rock seemed to disappear. It was difficult to remain poised on a saddle that was taking on more and more the characteristics of a school baluster. Suddenly, the rock appeared right in front of me and I threw myself backwards with the cantle of the saddle boring into my spine and felt the wind of the rock's passing brushing my face as I passed underneath. The sudden rise beyond was almost too much and I nearly slid off the horse's rump before I could regain my balance. By the time I had sufficiently recovered bodily and mental balance to look back, Dawa Dondrup had successfully followed with only Aku to come. We drew rein, as Aku was rather diffident at participating in fun and games at high altitudes and we wished to see him solve this problem. Alas, he,

too, was left without alternative and we could hear the slither and bump of his desperation. When he came to a halt behind Dawa Dondrup we saw that he had not been so successful in his timing: the rock had split his forehead, above the right eye, in a deep gash from which the blood was gushing. He held it together until we reached an open space and then I took my first-aid kit out of my saddle-bag and bound it up as well as I could with strips of Elastoplast. If he had looked piratical before, he looked positively evil now.

It was getting on well towards dusk and the horses were dragging along wearily before we sighted the first of the few houses of the village of Ngoyu, at a fork in the valley, which was our stage for the night. The houses in which we had been staying between spells of camping in the open had grown gradually more crude and dilapidated as we neared the borders. The inhabitants correspondingly so. Gone was the virile independence and swashbuckling assurance of the lawless, fearless Khamba, to be gradually replaced by the poverty-stricken obsequiousness of the Lhasa-governed Tibetan. The house outside which we now arrived was a new low in filth and grinding degradation. The largest of a few mud-and-clapboard structures, it had only a small four-foot high door as an entrance to a completely black, evil-smelling room containing the domestic and other animals. Having stumbled over grunting pigs, squawking hens, yapping mongrels, munching cows, and ploughed our way through their combined excreta, we entered the living-room of the house through a small aperture in the "wall" dividing the two rooms. This room was about twelve feet square but had little floor-space, since it was used also as a store-room for all manner of things from yokes to yak dung. There was no vent for the eye-torturing yak-dung smoke, and for some time I could only lie outstretched on the floor blinded by tears and racked by coughs as I sought to keep beneath the worst of that yellow cloud. When the fire settled down to a glowing red pile of hot ash I was able to sit up and take an interest in life once more.

Outside I could hear sounds of altercation and gathered that my companions were working off the effects of a tiring journey

on the unfortunate inhabitants. There were the sounds of blows
and apologies and hurried comings and goings. The misrule of
law was being administered. Behind a breath-sucking, tongue-
protruding landlord Loshay came in with his arms full of
saddles and bridles, cursing the smoke, the landlord and the
"prison", as he termed the house, impartially. I relaxed as I
absorbed the atmosphere and warmth and mused idly on a life
which could still provide colour and significance even when
executed in drab shades of grey. A vast universe, a tiny spinning
earth, a remote country, an unknown valley, a filthy hovel, a
few people, caught and crystallized for a moment in eternity on
the canvas of Divine inspiration. I was able to alleviate their lot
only a little with a few medicines and fewer words. Their dialect
was atrocious and not understood even by my Tibetan com-
panions. Squalor surrounded by splendour. Poverty in the
midst of plenty. Kings in exile.

## 12th February

We were now approaching what was reputed to be the most
difficult part of the whole journey. Off and on throughout our
trip we had heard of the Nakshu Dri-la, or Nakshu Dri Pass,
and the dangers involved in attempting to cross it. I decided to
treat it with the respect it appeared to deserve and so made no
fuss when told that we should make only a short stage today in
order to be fresh for the attempt on the pass tomorrow. We ate—
eggs!—leisurely, and left—comparatively quietly.

The trail was quite good and led upwards steadily without
attempting some Hannibal-baffling soar or plunge. As we
turned out of the valley on to the higher slopes snow began to
fall again and we met the full blast of the wind from the heights.
Once more I shrivelled up behind my zips and pondered on the
future possibilities of battery-heated clothing.

About four hours or so later after steady riding, we arrived at
the village of Naksho, a small place of about nine or ten wooden
houses. The wood for the houses must have been brought a
considerable distance for as far as I could see the valley was

# The Journey

bleak and bare, with a few trees scattered only on the far summits of the mountains.

Dawa Dondrup celebrated our arrival by hitting a villager with his whip before he had even dismounted. That would mean excellent service for the time being, at least. One of these nights we were going to find it decidedly uncomfortable when some village worm decided to turn. I sought to soften the indignity with a smile of sympathy, some photographs from an old newspaper, and a gift of dried fruits and walnuts. The photographs were appreciated most. I had often amused myself by calculating how far I could travel in Tibet with one load of *Picture Post*, *Life* or some other illustrated magazine. Naturally, the number of copies had to be increased to cover the very necessary censorship of certain matter which might have helped my travels but would have destroyed my reputation. Two or three photographs were often sufficient for a night's lodging in some house, instead of the bowl of rice which was customary.

The house in which we were to spend the day—and night!—had been recently built, but the method used lacked originality and initiative: the wooden planks had only been laid against the log supports, so that the wind found every corner and every opening in the building and chilled us to the marrow. The Tibetans heaped up a huge fire of logs until I thought that the house itself would go up in flames, but even this was insufficient to supply a modicum of heat in this raw, exposed Siberian-blast's playground and I had to have a large brazier filled with glowing charcoal beside me as well. It was cold. It was so cold that I actually had a struggle before baring my head of its fur hood to say a short grace before eating. I even attempted to handle my knife and fork—for the eggs, of course!—with my fur-lined gloves and worked out a successful compromise by eating with a fork in one hand and wearing a glove on the other.

In the afternoon the snow began to fall heavily and the villagers were dubious of our chances of crossing the pass. It was only because they were in no doubt of what would happen if they refused to help, that they remained no more than dubious.

## 13th February

When the snow fell to a certain depth it was impossible to cross the pass; it was past that depth now. When the wind blew in a certain direction it was impossible to cross the pass; it was blowing in that direction now. I had to impress upon them that when food supplies got to a certain level it was impossible to wait indefinitely until it was possible to cross the pass; my supplies were below that level now.

I went outside several times before darkness fell to watch the rate of fall, though, and was not too happy about it. I knew that the Tibetan would try to dodge "ulag", with its demand of food and animals, but that he was not afraid of hard work or a hard journey. It was folly to try to force them against their better judgment, but there was no means of knowing how long the pass would remain impassable and a delay of a few days here might mean that I would be held up by swollen rivers for several months and that I could not complete the journey at all. There was only one thing for it and that was to go ahead with a full caravan of yaks—if obtainable. Then if it continued to snow throughout the night they with their unerring instinct would be able to sense the trail and breast their way through with their great strength.

On inquiry I found that yaks were to be obtained, and so I ordered four extra to travel without loads in order to break the trail. These would leave with the loaded animals before dawn and we would follow on fresh riding-horses, as soon as we had eaten, in their trail.

The arrangements being completed, I climbed into my sleeping-bag and for the first time went to sleep with almost all my clothes on. How the Tibetans managed to sleep at all in that cold was a source of wonder to me.

## 13th February

It required a major effort to get up and face the future. The shivering villagers who were to accompany the caravan would tie on a load then hasten to the fire to warm their stiffened fingers. As soon as it became light enough to see a shadow ahead

# The Journey

they were off, the crunch of snow and the creak of loads on leather thongs fading into the distance.

We ate steadily and quickly to full capacity of stale bread, tsamba and dried meat, washing everything down with great quantities of scalding butter tea. A long, hard day stretched ahead and it might be twelve hours before we could eat again.

The snow had fallen steadily throughout the night and lay knee-deep on the ground. Our journey was made easier, as I had anticipated, by the broad swath beaten down by the plodding yak. The ascent out of the valley grew steeper and from several inches the snow increased in depth to several feet in parts. How the yaks had gone on was a mystery. We passed through a clump of silent, snow-draped pines and came out on to a large, shallow, saucer-shaped depression surrounded at its extremities by towering mountains. Everywhere was white and it became a relief to look at the darker grey of the sky. Several hundred yards ahead I could see the yaks like large black beads moving off the string of the trail behind them. As we gradually caught up with them the leading yak suddenly disappeared into a snowdrift. The whole caravan was held up until the men struggled past the heaving yak on the narrow trail to reach the leader and then proceeded to dig him out, grabbing his shaggy hair on either side, his horns and his tail, to lift him bodily on to his feet. He was then held, and the next one driven into the gap, to beat down the loose snow until the loaded animals could follow on. It was slow, freezing, tedious, back-breaking work at that altitude. Even with eleven yaks ahead breaking the trail our horses would suddenly stumble and disappear beneath us into drifts, throwing us headlong into the snow from which both horse and rider had to be dug out by the others.

The wind increased, driving the freshly falling snow into our faces and making the use of coloured glasses impossible. The monotonous blinding whiteness made our eyes ache intolerably. There was no sign of a trail anywhere in that huge, milk-white saucer; and after the yaks had failed to find the solid footing of the path beneath, one of the drivers went ahead to sound the

depth of the snow with one of the six-foot-long sticks which they were all carrying. He would plunge this stick into the snow to see if it was less deep than in surrounding parts, until he found a spot roughly in the direction in which we were going, and then he would drive one of the unloaded yaks forward over this part to make a path. As soon as the yak floundered to a standstill the other drivers would help to dig it out, and then the next yak could safely follow.

At times, as we reached a point where the probing stick found no resistance when plunged to the limit of its length, we had to double back on our tracks. Then the other drivers would catch hold of the leading man by the legs, while he wormed his way forward over the thin crust of the snow, plunging his stick around in a wide circle to find the solid trail beneath.Sometimes he would disappear head first through the snow and there would be a frantic spell when the others worked like madmen to get him out before he suffocated. Only a few could help as they had to confine their activities to the narrow, beaten trail, and we had to sit tense and watchful until each person or animal was dug out and we moved forward another few yards. It was exhausting work and it took us several hours to cross several hundred yards. On several occasions I was about to give the order to return to Naksho, but always the thought of my food and the importance of the journey made me hesitate until we moved forward a little once more.

Gradually we worked our zigzag way across the saucer and up the side towards the summit. The Tibetans were by this time stripped to their waists with only their thin cotton shirts for protection in that biting, chilling wind. I could feel my underwear clammy with sweat against my skin even although my beard was frozen to my face in a solid block of ice.

Two hundred yards below the summit of the pass, we were brought to a full stop. The ceaseless winds had carried the snow into huge drifts on the last slope and after sounding in every direction there seemed to be no way through. We held a council of war and, surprisingly enough, it was the villagers who wanted to make a last attempt at the summit before deciding to go back.

One powerfully built young fellow, who had led most of the way, volunteered to go ahead into the drift to try and find the path, if we would tie a rope to him and pull him out if he disappeared. It must have been murderously fatiguing work as he painfully laboured forward a few yards, then rested before going forward again. Time after time he would disappear and then one of the others would relieve him for a spell, but he always came back to take the lead as soon as he had recovered. Slowly the trail wound its costly way to those tantalizingly close prayer-flags marking the summit, until with an admiring shout we acknowledged the success of that magnificent effort.

Once this slight trail had been made the yaks were sent in to beat it down; but as each one disappeared because of its great weight we began to despair again of ever being able to make the distance. Every one of us laboured like a man possessed, and by coaxing, beating, pulling, yelling, managed to get one beast to the summit, where we left it to lie panting and exhausted while we returned for the next. Having now got all the yaks to the summit, where they stood heads-adroop into the wind, we sat down to have a rest and view the broader trail we had made. We would have to drive the yaks back down again to bring the loads up, as we had unloaded them for the attempt on the summit. When we had driven them back down again and loaded a few, we found that the trail could not take the weight of animals and loads; so once more we drove them upwards, while the men staggered wearily to the top with the loads, and then dropped them exhausted at an altitude above the eternal snowline.

The exertion of the past few hours had been so great that in spite of the wind and snow on the exposed summit men and animals lay around recovering their strength for some time afterwards. With my back resting against the pile of stones holding the prayer-flags in position, and shielded from the wind in front by a co-operative yak, I surveyed the prospect ahead with less and less enthusiasm. We dared not go back now that we had come so far on our way, and yet in front of us the mountains dropped away in a series of snow- and ice-fields. If the

valley behind us had looked like a saucer, the area ahead looked like exaggerated icing on a gigantic cake. Snow and ice dipped and rose and fell in fantastic patterns to lose themselves in the enshrouding snow, leaving the imagination to supply what lay beyond.

For some time, contrary to my expectations, the going was comparatively easy after the exertions of the recent climb and we dropped down sharply through knee-deep snow, leading our horses behind the yaks, until we had reached a large snow-covered ice-field. As soon as we ventured on to the ice our feet shot out beneath us and the animals slithered all over the place in the attempt to get a footing on the glassy surface. It was hopeless to try to negotiate it, and so once more we unloaded the pack animals, and with one man going ahead to break footholds on the surface we dragged the recumbent yaks and horses over one by one like sleds. The bewilderment of their expressions would have been ludicrous in other circumstances, but as it was we were hardly in the mood to appreciate humour.

Having successfully crossed this obstacle those of us who had horses decided to ride. I, for one, was completely exhausted and ached in every bone, and I had only done a fraction of the work accomplished by the Tibetans. The trail was now a narrow, treacherous ledge skirting the shoulder of the mountain above a sheer, unbroken, snowy slope which would have delighted the heart of a skier but which did other things to mine. To fall on that without skis would mean landing at the foot thousands of feet below as the centre of an outsize in snow-balls. I was not amused. Then my macabre speculations received a rude jolt. Loshay was riding just ahead of me and his horse slipped and fell. I watched with that fascinated, detached helplessness which one experiences when borne along by an inevitable chain of circumstances. Loshay was putting up a magnificent exhibition of horsemanship as he maintained his seat on the slipping, slithering horse which drew remorselessly nearer to mine as it slid down the slight incline of the trail. Suddenly with a wild lurch it cannoned into my terrified ani-

mal and I was putting on a repeat performance of Loshay's act. I decided that it was an impossible struggle and recklessly threw myself off the horse into the loose snow of the mountain slope rising almost sheer above us. I was certain to roll down but at least I had a slight chance of stopping on the ledge—if the horses did not kick me over in their frantic struggles. The miracle happened. Loshay must have seen me leave the horse for he landed beside me a split second later in a smother of snow, and the horses, relieved of their riders, ceased to struggle and lay still on the ledge. We lay buried in the snow beside them and had to wait in the ridiculously sprawled position in which we had landed until the laughing Tibetans, who seemed to think the whole performance was put on for their special benefit, had dug us out.

As soon as the horses were on their feet once more, shivering from fear and exhaustion, we proceeded to walk them forward. The trail was beginning to dip down steeply, anyway, and walking was much safer if considerably more tiring. It was bitterly cold and the wind was everywhere. Not a tree or a shrub or even a patch of earth showed to break the monotony of the journey or to lend hope for a halt. It must have been well on into the afternoon, although it was difficult to tell with the sky an invariable dull, leaden grey, and there was no sign of a possible camping-place. The occasional shouted remarks of the drivers had become less and less frequent and we had gone for some time in silence. There was still a long way to go, one of them replied in answer to my query.

Ordering the drivers to hold the animals to the side of the trail, I told Loshay, Aku and Dawa Dondrup that we would ride ahead to make the nearest village where we could obtain other men to come and help the drivers. It would mean that we should have to break the trail instead of letting the yaks do it for us; but there was no other course, as to plod along and take a chance on a camping-place before nightfall was to court certain death in that atmosphere and in our condition. The drivers wanted to stop in the first clearing and sleep beside the yaks throughout the night for warmth, but I was afraid that the

sleep might be a long one and our last. I was sorry for them, as they were fatigued to the point of dropping and staggered along dully behind the yaks, holding on to their tails to ease the effort of walking, but a night in the snows without food, fire or shelter would without the slightest doubt kill us all. I shook my head against their requests and led my horse to the front to break the trail as I was the freshest.

The descent was now so steep that we could not ride and had to lead and pull our horses along, lifting our legs high at each step as we battled our way through the snow. It was painfully slow, body-killing work and before long the breath was sobbing in my throat and my lungs felt torn raw with the effort.

We came to a flat snow-covered plain, and I ordered the others to mount and push the horses to their limit. Our whips rose and fell with pitiless regularity as we drove the animals forward into the snow and wind. The gruelling exhaustion of walking had given way to the freezing numbness of riding; the deadly cold began at the extremities and ate its way steadily inwards until it froze even the fears of frostbite. I lost all interest in everybody and everything. The Tibetans seemed to be different creatures moving in a different world. Nobody spoke. Only occasionally would one of the Tibetans let loose a string of oaths when his horse stumbled and either threw him or jolted him off balance and he had to climb back wearily into the saddle. And still the snow whispered its caressing requiem of death. It was everywhere. It began to take on living qualities of hellish enjoyment and hate. It was angry at our invasion of its domain. This was the Roof of the World where snow was eternal and unconquerable and we were interlopers and must die. I did not care whether I lived or died. I had long since lost all feeling. I had lost even the desire to pray. The heel which kicked my horse forward did not belong to me. Nothing belonged to me. Only hate. I hated the horse beneath me pulling savagely at the reins as it stumbled to its knees more and more often from exhaustion. I hated the darkening sky above me which threatened more snow and a night in its chilling embrace. I hated the trail which stretched endlessly before me, holding

tantalizingly to the heights and giving not the slightest indication of dropping down to a valley and shelter. Above all, I hated the snow as it lay around me everywhere. Even in the forest through which we were now passing it lay heavy and thick on the branches and ground, and the darkness of the trees did not relieve it of its terror, but rather enhanced its sinister menace. The fear of it was almost stifling at times. That the Tibetans felt the same was evident as they swore savagely and fearfully at the same interminable length of the trail and endless snow. We went forward.

It was dark when at last we began to drop and several cut trees gave promise that we were near some human habitation. The horses stumbled every few steps now and took longer to struggle to their feet, even with merciless blows. With a suddenness that was pathetically melodramatic a few black smudges loomed ahead of us, and we had arrived. No dogs barked. No frightened, obsequious villagers ran forward. No light showed. No voice answered our repeated yodel. The village was unoccupied.

It must have been the fact that I was able to appreciate the irony of the situation which brought me the consciousness that I was alive after all. At any rate, I slid off my horse and walked stiffly to the door of the nearest house and hammered on it with the butt-end of my whip. The mocking silence fanned the glow of defiance, which had almost died in the ashes of defeat, into a sudden flaring fury against forces which were trying to destroy us. Whirling round I ordered my companions to pick up the nearest log and batter the heavy door down. We would have warmth and shelter if I had to use the remaining houses for firewood.

Suddenly, Dawa Dondrup gave a cry and pointed to the dark shadow of the window in the next house. I looked at him curiously.

"There was a face there just now," he said, and strode towards the door. Reaching it he smashed a log against it and, sure enough, from within there came the sound of a quivering voice. A few minutes later the door opened and a remarkable

figure appeared. It was an old woman—that much I gathered from the drooping withered breasts—but of such an incredibly wrinkled, filthy and bedraggled appearance that it was hard to believe her a limb of homo sapiens. To add to the general weird effect she had a huge hanging goitre obscuring her neck. All this we could see in the ruddy glow of a small flickering fire. That was enough. She might look like some grotesque guardian of the Gates of Gehenna but we wanted a fire.

Her "house" was soot-encrusted, smoke-filled, with cockroaches as the most evident form of uninvited occupant. No doubt there were many others whose acquaintance we should make throughout the night. At the moment all that we wanted was warmth—that soothing, satisfying, relaxing sense of languor in the aura of which all suffering is modified. Food could come later, fire was imperative. While we unsaddled the horses and turned them loose in the stall the woman was told to get food and plenty of it. The fodder for the horses we would find ourselves. The activity involved would help to get the blood circulating again in our veins and lessen the danger of frostbite when we sat near the fire.

When we entered the hovel, the old woman had put about three small sticks on the fire, which must have been her conception of a blaze. With a roar of rage, Aku grabbed an armful of logs and heaved them on to the fire in the open fireplace and then proceeded to blow it up into a roaring furnace. The old woman wrung her hands and complained that her house would go up in flames. I thought that it would be a distinct asset to the community if it did. Which reminded me:

"Where are the rest of the villagers?" I asked her.

She looked at me blankly. I sighed. This was Tibet. As their own proverb said:

> *Every district its own dialect:*
> *Every lama his own doctrine.*

Loshay took up the theme with appropriate gestures. His effort was rewarded by the same uncomprehending stare. I felt cheered. Dawa Dondrup thought if he lifted his voice into a

roar and looked threatening it might do the trick. It failed. It was left to lisping, leering Aku to succeed with a combination of grunts and gestures.

The villagers only came to this village called Miji in summer. In winter they lived in a village called Riga a few hours further down the valley. The two villages were usually classed together as one and called Mijiriga. Yes, they had received the letter announcing our intended arrival, for a few men and animals had come here yesterday but, on seeing the weather, they had gone back again as they did not think we should attempt to cross the pass. She had heard us arrive but had been too frightened to answer our call.

"What had she to be afraid of?" asked Loshay brutally. "With an appearance like hers she'd be safe anywhere."

Aku and Dawa Dondrup thought this excruciatingly funny and gave it the treatment they considered it deserved.

In the meantime I had sat down gratefully on a pile of saddle-rugs and I gave myself up to the seductive pleasure of unthawing. Loshay had the small pan, which we carried in our saddle-bags for emergency, on the fire and in a few minutes my pleasure would be increased by that scalding, satisfying brew conceived to be the unequalled, unfailing remedy for just such a circumstance, butter tea. I watched the flames from the fire leap almost to the cross beams of the roof and was not in the slightest perturbed to see the sooty undersides begin to glow redly in the heat. I had known the extreme of cold and the extreme of heat seemed pleasant by contrast. At least I would go as far as I comfortably could.

The flames seemed to be of a peculiar variety of colours and I mentioned the fact to Loshay. He looked at me curiously for a moment and then asked if I felt any pain in my eyes. I blinked a few times and then said they felt sore, probably due to strain, but not painful. Why? Snow-blindness, he answered slowly, is never felt until one looks at a fire and then the agony is excruciating. I did not feel greatly worried as the only discomfort I had could be attributed to tiredness and to the stinging snow. However, in a little while the discomfort increased until I could

not bear the light of the fire on them. By this time the others were suffering as well and I felt the approach of fear. Had we overcome the worst obstacle so far, only to be met by a worse fate? It appeared to be so for when the yak-drivers arrived a few hours later they found us with tears streaming down our cheeks and between our fingers as we pressed the palms of our hands against our eyes. They had barely unloaded the animals and joined us at the fire to drink tea when they, too, began to complain. Soon two of them were rolling on the floor in their agony with their faces towards the wall, away from the torturing glare of the fire. I tried applying butter and cold tea compresses but nothing alleviated the blinding pain. We had all brought dark glasses but the continual work and snow had forced us to abandon them and now we were having to pay the price.

We ate our meal in a mist of tears and pain and retired as quickly as possible to a darkness shot with brilliant streaks of agony. Gradually it eased and I drifted off into an uneasy sleep. I wakened several times during the night and heard on each occasion the groans and restless movements of some of my companions. Tomorrow loomed dark and difficult.

## 14th February

I was awake before dawn and ordered a start immediately without waiting for tea or breakfast, since the place where we were to change our animals was supposed to be only an hour or two's ride down the valley. While the animals were being rounded up for the next stage and the pack-animals caught up with us we could be having breakfast there. There was none of the usual carefree noise and bustle of loading, and the two who had been suffering from snow-blindness last night were not in evidence. The remainder of us were suffering from painful, swollen eyes but there was nothing I could do about it and I had to give the ruthless order to depart and leave the two drivers behind. Only the strong survive in this country.

Snow and ice still lay everywhere but at least it was firm and there was none of the laborious ploughing forward of yesterday.

# The Journey

The horses were reluctant to move at first but a further taste of the whip sent them bounding ahead. I was sorry to drive them as they had done a wonderful job yesterday, but necessity was driving me with equal relentlessness. If the drivers succeeded in bringing the yaks as far as the next village I doubted whether any of them would be able to return.

The trail led through a sheltered forest where we were able to travel at a fast trot. Rounding a bend, we came upon the other, winter half of the village in a clearing in front of us. Only the same size as the summer village above, it was more solidly built and smoke curled pleasantly out of the windows and roofs. My escort was spoiling for battle because the villagers had not made preparations to receive us last night, and called for the headman before they had alighted from their horses.

However, he was so pleasant and anxious to please—and probably anxious to get rid of us!—that almost as soon as we had asked for anything it was there. The animals with their drivers (once more we had changed to horses and mules for fast travel) were ready and waiting for the yaks to arrive with the loads, so that they could load up and be away before we had finished eating. I ate several boiled eggs and recklessly expended some of my precious Indian tea. I felt that way. Loshay had recovered, the escort was in fine spirits, we had a fresh caravan and whatever the future held it was nothing like yesterday.

The sun was now shining, the sky was blue and—it seemed incredible—we were now dropping out of the snows into the green coniferous forests, where the snow lay only in the hollows and shade. There were still occasional stretches of snow and treacherous ice on the trail but these became fewer and fewer as we continued to wind down the valleys. At no time did we leave the forests, but the trees were sufficiently far apart to let the sun slant through pleasantly in an ever-changing variety of patterns. It felt good to be alive.

About two hours later we arrived at the village of Drowa Gompa, which turned out to be quite unworthy of its large lettering on the map, having only two wooden houses and a very small monastery, from which the village took its name. The monas-

tery was reputed to have formerly held about forty priests but at present it looked as if it could scarcely contain ten. Some of the muleteers were replaced here and I noticed three young muleteers not previously with us, one of them no older than thirteen years.

Leaving Drowa Gompa the trail wound through the forests, high above the river Po Tsangpo. After the efforts of yesterday, I was quite content to let the horse drift along at its own pace well behind the caravan. We would make our stage tonight without any undue haste or excitement. I spoke too soon. The voices of the Tibetans as they hazed their animals along had formed a harmonious background of sound to the steady clip-clop of the horses' hooves, so that I did not notice anything that might indicate trouble in the offing until I heard Aku shout at two of the drivers to stop arguing and get on. They continued to squabble for some reason, the gist of which I could only gather to be that the bigger fellow of the two had not wanted to come and was venting his spleen on the younger muleteer.

Some time later we suddenly missed him and Loshay asked idly where he had gone. The thirteen-year-old told him that he had run off into the forest to circle back to Drowa Gompa as he did not want to come. The effect on Loshay was electric. He whirled his horse on its haunches and sent it thundering back up the trail. As he hammered past me I could see that he was fighting mad and so I ordered Aku to follow to help in any emergency which might arise. We rode on, and it was about two hours later before they caught up with us, with a new rider behind Loshay on his horse.

On questioning them as to what had transpired it appeared that Loshay had caught up with the young fellow who was running up the trail back to the village, and riding him down at a gallop had caught up his long hair as he passed and dragged him until the horse stopped. Loshay had then pitched himself off his horse and still holding the fellow by the hair had laid into him with the whip. Throwing the whip aside, he had proceeded to give him a thrashing with his fists but had to stop, disgusted, when the powerfully built young fellow fell on his knees and

M                                   177

pleaded for mercy, saying that he had syphilis and could not walk and offering to prove it to Loshay. Loshay had thrown him aside contemptuously and gone on to the village to fetch another driver.

The trail now broadened out and we went on ahead of the caravan, the horses moving at a fast clip. There were several houses at intervals and we exchanged guides at each place without stopping for more than a few minutes while the man saddled up. For all that the trail was better than we had previously experienced, it was on one of those stretches that we almost met with tragedy. We were riding along swiftly when suddenly Loshay's horse stumbled and went right over on its neck. It was so sudden that Loshay was thrown clear of the horse and landed asprawl on the edge of the trail with his body over the drop. The mountain at this part fell right away down a boulder-strewn slope to the river a thousand feet below, and another five inches would have meant his death. As it was, he was badly bruised. The horse being all right, however, we carried on at the same pace and in the late afternoon arrived at the village of Kyigang.

The village was a community of about twenty small, wooden houses scattered over the slopes of the valley. As we approached the largest, one or two men came out and walked towards us slowly to lead our horses in. It was a mistake. They should at least have looked interested if not welcoming. The escort swung down from their horses and with wooden expressions went into the house to see if everything was in order before they returned any greetings. No one was left long in doubt. I had only led my horse to the nearest stable when the first man came flying out of the door holding his hands above his head. Another followed almost immediately. Then another. The escort was having a field day. I leaned against the horse to watch the door interestedly as vituperation and men continued to pour through. The whole village must have been inside, I thought. Probably playing cards or dice. They were now reaping the whirlwind with a vengeance. There was a rapid scramble to be the first to reach my horse, as the stable would put them beyond reach of the

irate justice within the house. Others not so fortunate had not only to go back into the house but had to run in with apologies hoping—futilely!—to avoid further punishment.

Yes—forgive us, kind sirs!—we received your letter. We sent it on to the next village. No, we did not make preparations for your arrival, magnanimous sirs, because we did not expect you. Yes—oh!—yes, we expected you from your letter but not so soon, honourable sirs. Oh!—we did not know what you desired as preparations, good sirs. Oh!—forgive us! Oh!—excuse us! Oh!—do not punish us! Oh!—

It lost its novelty and became monotonous. I went in. Really, the place was not worth the expenditure of energy in preparation. Even after it was swept out and rugs spread out on the worm-eaten floor it was still a hovel. Wooden planks had been carelessly placed against wooden supports for walls, and in the same way for the roof. Through the spaces the wind blew uninterruptedly. We tried to counteract the effect of the wind by building up a huge fire in the stone container which served as a fireplace but were conspicuously unsuccessful.

I had my usual meal of tsamba, dried meat and eggs, then climbed into my sleeping-bag out of the draught, and out of the night.

## 15th February

Another short stage today. We prepared very leisurely to leave Kyigang as no amount of hard riding could bring us beyond Tsachung, and got away some time after sunrise.

The horses we had been given were very poor and the one I rode had an awkward gait, jolting abominably. Again there were not sufficient animals to carry the loads, and men and women had to be supplied as porters.

We were now proceeding down a wide valley. The towering mountains which had shut us in for months were receding and I began to feel that the journey's end was near. The trail was broad and wandered easily through stately coniferous forests, with other varieties of trees beginning to show occasionally as

we began to drop into the cool, temperate zone from the alpine. The sound of the horses' steady plod was muffled in a thick carpet of pine needles. Away to our right the river swept majestically on a smooth bed to the sea.

Two or three hours later the trail led down to the river, to where a bamboo bridge perilously spanned the gap. This I had been told was the first of a series of five bridges which lay between us and Zayul on the Indo-Tibetan border. It was the best one. It boded ill for the future. All my life—if any remained to me after this trip!—my nightmares would contain bridges, and, unlike the Psalmist's my ideal rest could never contain still waters, as the thought of bridges must inevitably follow. If this was more solid than the one we had crossed several days before, yet it was much longer and swayed perilously above the now leaping waters even without weight upon it. I put my weight upon it. It seemed to pause in shock at such temerity, then shuddered in protest. I wrenched my eyes from their fascinated stare at the waters far below and, fixing them resolutely on the even farther side, walked. When we had all arrived safely we were too carelessly nonchalant, we talked too much and too loud, laughed too much and too loud. It had been dangerous.

The trail gradually became narrower and stonier and the forest crowded us in. A queer, misshapen dwarf pressed himself against a tree and gaped at us as we passed him on the way. Strange creepers appeared, curling round trees in deadly embrace and hanging ghostly fingers over the trail to caress us chillingly as we passed.

In the early afternoon we left the forests and entered the wide bowl of a spacious valley. In the distance some houses showed up behind cultivated fields. Tsachung. They were solidly built wooden houses on top of a stone foundation, the soundest I had seen since leaving Gartok. The escorts disagreed with the room which had been prepared for us, and with the mild application of a piece of wood to the back of the headman and his wife, managed to obtain a cleaner and cosier god-room instead. The heat from the charcoal fire soon offset the chilling

glare from the disapproving idols. There is little doubt that if the idols had had any power they would have used it to blast the infamous, unheeding humans from their presence but, like Baal's, their Energizing Power must have been asleep or on a holiday—or disinclined to battle. Whichever it was their ferocity was ineffective and pathetic. The man who has known God has no fear of gods, only a great pity for those who make them and worship the powers which inhabit them. Slaves to a damning delusion, exploited by ruthless masters.

We arrived well ahead of the porters and it would be some time before I could have a proper meal. I decided after several bowls of tea to use the time in another wash—my second since Gartok. Probably that is what is wrong with the people of the West, I thought, too much time on their hands before and after work and so they hasten to fill the vacuum with washing and titivating, and excuse the vanity by giving the process the dignity of science, hygiene. Certainly one should always remember the balancing factor of social responsibility, I hastened to add, though, as the odours of several weeks' journey wafted around my nostrils.

When I had washed my hands and face and settled down to read for a little, the first of the porters arrived and I was able to eat. They continued to straggle in till after dusk and I left the arrangements for the next day to Loshay. I had insisted on making Zayul tomorrow, regardless of distance, and finally had wrung a reluctant agreement from the headman of the village to make the attempt, so long as I did not insist on all the loads arriving on the same day. He would make arrangements for my bedding to be there and the rest to follow in two days. There were only two families in the village at present and porters would be difficult to obtain.

Instructing Loshay to lay out my best riding-clothes, some presents and ceremonial scarves, I went to bed early in order to be up well before dawn.

# *The Journey*

I gave orders to leave without eating and we would break-fast after sunrise on the trail somewhere. One guide riding and one pack animal would travel with us at a fast pace and the other loads would arrive the following day with porters.

The trail was again very rough and broken and, impatient though I was, I had to hold the horses down to a fast walk. On the few good stretches I drove them into a jolting canter. The trail was leading down almost all the time now and the mountains grew smaller, falling further and further back. The river poured along a rough, boulder-strewn bed which at times churned it into a foaming maelstrom.

Dropping from the high shelf above the river we came in sight of another. No! It could not be true. I thought bitterly of the impression I had been given of bridges in my educated past. No one had ever prepared me for this. It was a bridge in every sense of the term, a "structure raised across a river, &c." There was the river, there was the structure, and it was raised high enough. It was a bridge all right. But if ever I should disinte-grate morally and take to surrealism my first painting will be of a crazy spectral vinculum of rotting wood, lined with leering skulls, spanning over a foaming river of whipped rotten eggs. I would come here to paint it.

In the middle of the river were two immense boulders, almost identical in size, standing about fifty feet out of the river, twenty yards or so apart. Someone in a moment of extreme aberration had conceived that because the gods had un-doubtedly placed such boulders in such a position in the river it followed that the gods in their benevolence meant their humble servants to cross the river at this point. It is not re-corded whether the gods gave the instructions for the bridge to span the spaces which were left. Probably they did, on the principle that "whom they destroy they first make mad". Only a madman could have strung the two bamboo ropes from moun-tain to boulder, boulder to boulder, and boulder to mountain,

then placed the crazy platform of wood on top. And only mad-men would attempt to cross.

I decided it was better for the pack-animal to die first and with encouraging shouts of farewell stoned it on its journey. It seemed more inclined to face the stones and whips than the path ahead and I could not find it in my heart to reproach it, but "hope springs eternal in the human breast" and I would require my bedding on the other side when—or if!—I arrived. In any case the animal was much more fortunate than we who had not only to take ourselves over but lead a horse as well.

The Tibetans were now chanting prayers to their various deities and the sound seemed an appropriate requiem in that savage setting, with dirty prayer-flags flapping dismal farewell. My prayers, if less mechanical, became almost as repetitious as I swayed like some clowning Blondin in a stiff-legged jig of death. When I reached the first boulder sweat was pouring down my face and body and my legs were weak with strain. I wanted to sit down. I wanted to look back the way I had come. I wanted to give in. I dared not do any of these things. I stepped on solid ground and the air from my lungs whistled past a relaxing epiglottis.

We all crossed safely, and my normally irreverent escort gave vent to their gratitude in a paean of rowdy and raucous praise.

Our deliverance from the jaws of death had given me an appetite, or perhaps just made me more conscious of the diges-tive function, and I gave orders to dismount for something to eat at a house which suddenly thrust itself at us from amongst the trees. Only one family lived here—a man with his two wives—but we were able to get some eggs and milk so I scramb-led them without the usual unkind thoughts on the subject. As I ate I avidly read a newspaper, which had found its way here from India, although it contained mostly ancient news and film advertisements. I began to feel I was getting near civilization again and hurried through the meal.

The trail was now clearly defined, a smooth path leading through forests and clearings as it followed the river on one side or the other. The mountains were rounded, wooded and

friendly, gradually becoming smaller and more apologetic as they left their mighty prototypes behind them. The river passed through various boisterous phases to majestic calm. The bitter cold was gone and the air had an exciting flavour. I was slightly intoxicated with the green pulse of life all around me after the monotonous splendour of the heights and with the rising assurance that I was going to accomplish my purpose successfully, I kicked the horse's flanks impatiently to set a faster pace.

Passing through a dense wood where water dripped in the gloom from the hanging creepers, we began climbing a steep winding path. This would bring us, somewhere above, on to the last bridge, the guide informed us. It did. I must crave my readers' pardon. Bridges always seem to be cropping up at disconcertingly disproportionate intervals in this journey, but I submit that they loomed equally disconcertingly and disproportionately on the author's horizon, and if this record is to remain true to experience so must they remain. Some day I might be able to write a bridgeless record but so long as my destiny confines me to Tibet, the greatest watershed in the world, the possibility seems remote. Born within sight of the famous Forth Bridge and Kincardine Road Bridge, brought up in a village with a Skew Bridge at one end and a Barrel Bridge at the other, it would appear destined that bridges should crop up in my life as regularly as bad pennies, unwanted relatives and surgical operations in other people's. Yet I am afraid I shall never be able to "Win Friends and Influence People" for I must confess my inability to conform to the chapter in that famous book which advises compromise with the inevitable. A bridge should be a thing of beauty and a joy for ever! Conservatively speaking, it should be a thing of utility and satisfaction in its lifetime. The greatest magnanimity would have failed to view the structure before me with equanimity.

It was an iron bridge—at least, its name meant "Iron Bridge". The iron was conspicuous by its absence and the bridge almost equally so. The misnomer disturbed my aesthetic appreciation and I asked the guide why it should be thus named. (The delay also helped to soothe my nerves which were twanging like

harp-strings in anticipation.) He informed me with pride that *this* bridge was unlike the others because it had iron staples driven into the rock face on which the planks rested. I had to accept his word for it as all I could see was the planks—or, to be more correct, the spaces between the planks. The valley at this point took a sharp turn to the left between the steep sides of the mountain. The river had been fed considerably by several streams and now swirled, sullen and deep, in a wide sweep round the bend. On every side dense forests rose from the river to the tops of the mountains. In all that dark greenery the bald face of the mountain slope before us rose malevolent and ominous. It was of solid rock and dropped straight down from far above into the yellow waters three hundred feet beneath. It was into this rock that the iron was said to have been driven. Iron entered my own soul as I contemplated it. I had been so near to success and this was bitter irony. I could not see how far the bridge stretched, and the guide was merely vague and hopeful. The rickety platform inclined upwards for about twenty yards, then disappeared round a bulge in the mountain wall. The gap between the earth of the trail and the first of the rotting, at best, half-inch thick planks was spanned by three untrimmed logs whose only claim to security lay in the rough bark and jutting twigs, either of which might choose to leave the parent tree suddenly beneath our hesitant feet.

Do horses think? Have they emotions? Is their apparent phlegm only superficial? I do not know and I could not spare the time or interest to find out. Grasping the reins firmly in my right hand, but not too firmly in case I had to let go if the horse slipped, and with my left hand held out to maintain balance and obtain some cold assurance from the rock face, I launched out on the most courageous act of my life. The logs rolled slightly as they took the horse's misplaced weight, and I blenched. The planks sprung, slipped, and stood up on end. I trod with all the delicacy of an Agag and did not think my antics incongruous. I heard the horse slip and flattened myself hands aspread against the rock face, callously letting the reins go. It recovered itself, however, as only one of its legs went through the planks, and I

gingerly knelt to pick up the reins again. I wish I had four legs, I thought ridiculously, or eight would be better still—with suction-pads all over! Then changed my mind as I decided that it would merely serve to bring my eyes nearer the spaces in that springing wood through which the water was hypnotizing me. I rounded the bend. Another stretch lay ahead, longer this time. I do not know the length. It reached beyond the grave.

Well, the fact that I am writing this record is sufficient to show that I accomplished the crossing. So did the others. I shuddered afterwards when Loshay told me cheerfully that he had driven the pack-animal on to the bridge too quickly and that it was climbing behind me alone before I had even reached the bulge in the rock face. The humour of the Tibetan is delightful.

The trail ran straight into Zayul from here, and I despatched Dawa Dondrup ahead to announce our arrival. The Dzong Bön of Zayul would be the biggest official on the way, except for Dege Sey and Kungo Dzong in Gartok, and so a rigid observance of custom was necessary. Zayul is really the name for the area, the Tibetans calling the large village there simply Shiga Thang. No one seemed to know of it by the name given on the map, Rima, not even in the village itself. It was situated on a wide shelf in the valley above the confluence of the Rongo and Tsangpo rivers and was merely a collection of filthy little lean-to shacks. I had been told that there were several Tibetan officials here and had expected quite a decent-sized place, larger than Gartok, but instead I found this filthy, depressing village.

The whole population had turned out to watch my arrival and my horse was led between two lines of goitred, gaping villagers almost indistinguishable from each other under their coating of dirt, to a house only a little cleaner than the others. A Tibetan officer came forward to greet me with the information that he was responsible for attending to my needs.

I had a quick wash, put on a clean shirt, polished my riding-boots, and with Loshay and Dawa Dondrup following with the ceremonial scarves and presents went to pay my respects to the Dzong Bön. He seemed surprised to receive the scarf and presents and, had he only known it, he had every reason to be. How-

ever, I derived a great deal of amusement from his embarrassment at finding me aware of the courtesies demanded by a Tibetan etiquette so carelessly practised by himself, and comforted myself with the thought of coals of fire.

It was to be bread cast upon the waters instead, though, and almost immediately returned to me. Tomorrow was the first day of the Tibetan New Year would; I be his guest for the day? Thank you very much, I should be delighted. In the meantime would he excuse me as I had had a long day and wished to retire early? Yes, certainly, and might my sleep be peaceful.

## 17th February

I wakened at the sound of the door opening. I knew it could not be a thief because Loshay, Aku and Dawa Dondrup were all in the room with me and no thief in Zayul would be prepared to take on such odds. Besides, though the door had creaked open the sound was not suspiciously cautious. I watched for the shadow of whoever was coming in to be shown up against the various cracks of daylight showing through the wooden boards. It drifted to where Loshay lay on the floor on the far side of the room and I grinned. If the intruder was up to any monkey tricks he had kicked off with a wrong guess. Loshay slept with his sword in his hand. I debated within myself whether to cough, turn over or make some movement to warn the intruder that I was awake, then decided against it. I was curious, and I could always stop Loshay before he did too much damage.

There was silence for a few minutes and I wondered whether it was not after all a thief, rummaging carefully through Loshay's clothes. He almost deserved to get away with it for his sheer effrontery. And then I almost sat upright in my astonishment. It was not a man, but a woman who had entered the room, and I could hear her hold a whispered conversation with Loshay! After a time I gathered enough of the conversation to know that it was the landlord's daughter and that she was making arrangements for providing each of my companions

# The Journey

with female company for that night. I stretched, turned and coughed but the fact that I was awake did not seem to trouble them unduly. If I had inquired they would have replied with engaging grins: "It is Tibetan custom."

Not long after I got up and dressed leisurely in my now rather crushed foreign suit instead of the Tibetan gown and furs which I had been wearing. Before I had finished, the first of my New Year visitors arrived. The New Year is one time when the Tibetans really wash. There are individuals, and even communities, who have never known what it is to have water on the skin except by accident, but normally the Tibetans will have a thorough wash for the New Year celebrations. They do not object to water or being clean, they have no unhygienic and primitive code as many have suggested, but they know that to wash in the freezing cold and piercing winds of Tibet is to ask for split lips and skin and chapped hands. It is much more sensible to rub butter on the skin as protection from the cold, or mud as protection from the winds. It is remarkable how amenable one becomes to such sound reasoning when one has to break the ice on the stream to get water or when the water freezes on one's hands before it reaches the face. I once gave a bar of soap to some wandering nomads as an experiment and their reaction was prompt, resolute and effective. Men and women, who had never seen soap, stripped to the waist and proceeded to enjoy themselves in the icy water as Nero's Romans never did in their heated baths. They not only washed their own hair and bodies but helped each other as well.

The Tibetans of Zayul were no exception—in spite of yesterday's indications! They had washed and dressed up in all the silk and brocade finery they possessed for just such an occasion. Those who yesterday had stood in dirty mud-encrusted gowns with no shirts on their backs or boots on their feet now visited me in a constant stream in brocades, silks, broadcloths, embroidered boots, silver, gold and turquoise ornaments, jingling as they walked. It was the chief celebration of the New Year and they meant to enjoy every minute of it. Already many of them were drunk and the festivities had scarcely begun.

# 17th February

About ten o'clock the Dzong Bön sent some of his servants to escort me over to his house for the first meal of the day. He was not making the mistake of overlooking the finer points of Tibetan hospitality this time, and his secretary was on the veranda to greet me when I arrived. As we entered the house some servants brought forward an elaborately constructed edifice of multi-coloured butter on a base of rice and tsamba. It was a religious symbol of good luck offered to the household idols at this time: the custom is to take some of the rice and tsamba and throw it over one's shoulder. I declined, saying that I worshipped the living God and was forbidden to propitiate lesser deities, and the Dzong Bön and his secretary laughed good-naturedly.

In the morning sunlight, slanting through the open windows, I could see the room better than on the previous night when most of it had lain in shadow. Like Dege Sey's or any other Tibetan official's room, it contained the rug-covered dais, the cabinet with the gilded idols, the low tables, but on a less pretentious scale. The paper-covered, intricately-latticed windows were fastened to the roof by a hook. Both the Dzong Bön and his secretary were in stiff, yellow brocade which made a rich susurrus as they moved. After the formal exchange of courtesies, an excellent meal of tsamba, meat cooked in various ways, and sauces, eggs and vegetables, was served. My dexterity in moulding the tsamba with my fingers and handling the chopsticks to pick up the meat and other things was duly admired and with due modesty repudiated.

When we had finished eating I gave the usual traveller's account of conditions existing in other parts, finishing up with the account of my own trip from Kham as a subtle method of introducing the subject of my departure. I wanted to leave immediately and did not wish to be ensnared into remaining some time through a newly stimulated and over-exaggerated sense of courtesy on my host's part. It would require very diplomatic handling, as no one would wish to travel during the New Year celebrations and also I should be dependent upon the Dzong Bön to a great extent for co-operation in exchanging some of my

goods for Indian money. Always to be borne in mind was the fact that I expected to return this way as well, which called for peace and goodwill in relationships. After he had started to play mahjong with some of his officials, I tentatively broached the subject of my excusing myself, on the ground of having to prepare for my departure on the morrow. The issue was delicately poised, since he dared not risk a show-down in which he could be defeated in front of his officers, if I insisted in holding to the instructions in my letter of authority. He protested a liking for my company while I protested my regret at the urgency of the circumstances which tore me away from his, and we finally compromised on another meal in the evening when we should finally decide. In the meantime I would make what preparations I could.

Loshay, Aku and Dawa Dondrup had been busy and when I returned to my quarters there were already several prospective buyers. For the next hour or so we haggled away in true Eastern fashion over the price of articles. I decided to sell everything that was not absolutely necessary as I needed every rupee I could find, and so got rid of my saddles and saddle-rugs as well. I had been told by the Dzong Bön that it was possible to ride only a short way beyond Zayul, when the trail became so bad that horses could proceed no further.

In the evening I returned for another meal with the Dzong Bön and this time it was almost completely Chinese with rice and trimmings. Zayul was a rice-producing area for Tibet and so it was more easily obtainable than in other parts through which I had travelled. To maintain my early advantage, I blandly accepted the departure on the following day as agreed. He tried various apparently innocent suggestions to detain me but I was equally innocent in avoiding them, until I had his reluctant assurance that horses would be waiting for me in the morning. He sought to atone for his lack of courtesy on my arrival by magnanimously offering to escort me at my departure. I adequately acknowledged the honour.

When I returned to my own room I found it packed with Tibetans, almost all of them roaring drunk, and for the next

few hours had a hilarious time. The Tibetan when drunk is either an engaging friend or a deadly enemy. I preferred them in the former state, but my efforts to keep them thus were so successful that they swore they would not allow me to leave. I must wait for the horse-races, the rifle-shooting, and the usual fun and games—accompanied with digs in the ribs and knowing leers. I knew Tibet, I knew Tibetan custom, eh? Ha, ha, ha, ho, ho, ho. Aku and Dawa Dondrup lent their influence and persuasion to the argument, but I was determined to leave and said so as plainly as was both safe and possible in the circumstances.

Gradually they all left, shouting their good-nights and good wishes over and over again, shattering the night with their howls and yodels, until only the landlord's daughter was left with two or three other servants who continued to pour out tea and chang as the bowls were drained. I suddenly recalled the conversation in the early hours of the morning, and wondered if this girl, who looked no more than seventeen, had actually made the arrangements in which I had heard her taking part. Just as I was dropping off to sleep I heard stealthy footsteps outside followed by a whispered colloquy, and all my servants tiptoed away.

## 18th February

My loads had been considerably reduced by the things which I had sold, but they grew again as the Dzong Bön sent me the customary gifts of food, rice, flour and some Tibetan sweetmeats. Most of the carriers must have been suffering from a tremendous hang-over for they only came at irregular intervals until nearly mid-morning. All the loads had to be carried to the riverside, as the horses could only be obtained on the far side because of the unfordable and unbridged river. The loads being safely despatched at last, I went to call on the Dzong Bön. There was the usual drinking of tea and the usual talk, then he informed me apologetically that he would not be accompanying me but his secretary would. I could barely refrain from smiling,

it was so typical. He dared not trust the precarious dignity of his inconsequential position to the hands of the vulgar mob. He was effusive in his parting wishes.

I had told Loshay to hire riding-horses for us, to take us to the river about a half-mile away, as it would have been considered very bad form for my escort and myself to walk while the accompanying officials rode. On reaching the edge of the high shelf overlooking the river we dismounted and entered a little hut used for checking people and loads as they departed for, or arrived from, India. Here we drank several bowls of tea again, ate walnuts and sweetmeats, while we exchanged parting courtesies. Then we walked to the edge of the cliff.

I gazed long and earnestly at the method of crossing. Had I known then that I was going to write a book about my experiences, I would probably have done something else, so that some variety might have been introduced into my actions and journals; but I had no idea that the future would demand a variety of actions and emotions to titillate the literary appetite. I just looked. Lest the reader should think I am addicted to hyperbole, I will give an unadorned and simple description of the method used to cross the river. Should he still be incredulous then I refer him to the works of an authority on that particular area, Captain F. Kingdon-Ward, or that intrepid explorer-author-artist, John Hanbury-Tracy—although he would probably disagree with me on principle anyway. (The former has particular reason to remember this crossing as the lack of adequate facilities kept him stranded several weeks in Zayul during the 1950 earthquake!)

The "bridge" was a fibre rope about two inches in diameter, tied round a huge boulder and held down firmly by other boulders heaped on top, suspended over the river, and tied in the same fashion on the lower slope of the far side, about one hundred yards away. At its lowest sag the rope was probably about fifty feet above the swiftly flowing river. To cross, a grooved piece of wood was placed on top of the rope, another rope passed over it and under the person crossing, who sat in the loop of the rope with hands grasping the rope, just under

the wood. A villager went ahead to show me how it was done and I watched his downward plunge with fascination until the slack on the rope in the middle was passed and he slowed down on the swoop up the far side as it tautened with his weight. His momentum, rapid as it seemed, had not been sufficient and he had to pull himself up hand over hand over the last twenty yards, until he stepped on the ground and untied himself allowing the "seat" to be drawn back for the next man. This was the almost transfixed author.

I stepped between the ropes.

"You are ready," said the rope-tier, with the satisfaction peculiar to all executioners from the French Revolution onwards.

I was not; but I was in no position to argue. With memories of home and of the last man going over, I bade the Tibetans a fond and brittle farewell and hurled myself forward. There was a blurring flash as land and waters and heavens lost their contours and the wood screamed a demoniacal rattle in its slide down the rough coils of the rope. I could feel the heat from the friction on my hands. The far side leapt towards me and I had the sudden sickening thought that I had over-propelled myself and was now about to end my days as a mark on the mountain, when my speed noticeably slackened and I coasted to a stop about five yards from the far slope. The first man over helped me closer by throwing his weight on the taut rope. It felt good to stand on solid ground again. The popularity of "terra firma" as a phrase became understandable.

Soon all the loads and servants were across and we loaded them on to the animals brought there by the Dzong Bön's order. The next stage was reputed to be quite close: there was no need to hurry.

As we crossed a clearing shortly after leaving the river, a family in a small house waved to us. I took it to be the usual greeting and waved back, but Dawa Dondrup suddenly said that he recognized one of them and turned his horse in that direction. We were puzzled at this sudden recognition as he had never been this way before, but followed slowly after him to the

house, where he had dismounted and was talking to the people, a man and two women. As we approached they went inside hurriedly, followed by Dawa Dondrup, while we waited outside. We became impatient at his continued absence, went inside to see what was delaying him and found him talking to a pretty Tibetan girl in her colourful New Year's dress, with the man and woman nowhere in sight.

"Hi! What are you doing?" Loshay asked impatiently—although I should have said the situation was evident.

"This is a friend of mine from Chamdo." Dawa Dondrup answered hastily—too hastily, I thought.

"Ah," conceded Loshay, no doubt mollified by such a fortunate encounter, "that's different."

The scene was set for a nice performance, and I was resigning myself to a lengthy delay when the girl decided the comedy had gone far enough and refused to play.

"I don't know who you are," she declared hotly to Dawa Dondrup.

I was aghast. Such perfidy was almost Western in its cunning. The frank simplicity of the purely Tibetan approach was giving way before my eyes to one that was strangely familiar. I looked reproachfully at Dawa Dondrup, sorrowful at such deplorable lack of originality. He was becoming civilized.

The gleam in Loshay's eyes was neither reproach nor sorrow. It was sheer, unadulterated mischief. Dawa Dondrup, for some inexplicable reason, had overreached himself and provided him with a wonderful opportunity.

"You are to be compared to a dog," he said slowly and distinctly, "and a particularly low type of dog at that. You dare to thrust your company upon this young woman! You are without shame."

It was so apposite I could have cheered. All it required now was for Loshay to add: "Begone, sirrah! And never let me see you again," and for the girl to look into his eyes as the curtain came down.

She was doing it now! Yes, she was gazing into his eyes with all the frank adoration necessary in such circumstances. Dawa

# 18th February

Dondrup had been forgotten. Loshay had not been introduced, but that was mere quibbling over trifles. He was better-looking and better dressed and that was sufficient criterion for any woman. Further, had he not saved her fair name from being besmirched by that oaf's unwanted advances? Dawa Dondrup looked chagrined. Loshay looked triumphant. The young woman looked coy. I looked at the door. I must have been the least suggestive of the lot for no one paid any attention to me. I had to cough apologetically, loudly and artificially several times before they looked inquiringly at me.

"Eh, I think it's time to go," I tried to say firmly, although even to my ears it sounded lame and hopelessly inadequate in such promising circumstances.

Loshay looked as if he were about to say he didn't mind if we did, but thought better of it. After all, it was his scene and he was determined to take the curtain calls. He looked at her with the appropriate pain and shadow of a great sorrow in his eyes and turned hopelessly towards the door with bowed head and firm but reluctant footsteps.

It was perfect, and I gave it the ovation it deserved—when we had gone some distance from the house. Dawa Dondrup was mortified and defiant, still maintaining that he had met the girl in Chamdo; Loshay was almost delirious with mirth and mockery.

A few hours later, we arrived at the small village where we expected to stay the night. Most of the people crowding forward to watch our arrival were hopelessly drunk and merely blinked stupidly or giggled when we asked them where the headman's house was.

Dawa Dondrup was still feeling raw and this treatment did not help to soothe his wounded vanity; so that when I heard the sound of blows and groans I knew that he had reached the end of his patience if not of his search. Sure enough, on entering the house whence the sounds were emanating, I found him in a towering rage. It was out of all proportion to any lack of preparations there might have been on my behalf, and I told Loshay to stop it immediately. However, matters were more

serious than I had thought: the headman had apparently taken it upon himself to send on all our loads to the next village and we were left without food, bedding or baggage. Still, the man had blood streaming over his face from a dangerous head wound inflicted by a brutal baton of wood, and I called a halt to see what could be done. It was getting on well towards evening and obviously we could not travel much farther that night. It was with the greatest difficulty that we managed to round up a frightened villager to give us information as to where the next village lay and how far it was. When he said it was quite near, we did not know whether to accept this as truth or whether it was merely a ruse to get rid of us. We could not find out and had to accept his word, Loshay ingeniously deciding that the best way to prove it was to take him with us as a guide.

An hour later we arrived at the next village, a place called Sama, where preparations had been made for us in a small room about twelve feet by six. I have been in worse places with filthier people, but never with any of such low intelligence. The Tibetans as a rule may be gloriously filthy but they have remarkable intelligence considering their remoteness from other people.

I wandered into the kitchen to see how the food situation was progressing. It was the usual kitchen I have described elsewhere; but instead of the usual old man or woman in the corner chanting the endless "Om mani padme hum" prayer formula and awaiting a new body in the next incarnation, there was seated a grotesque cretin. At first glance I thought it to be some queer animal in the darkness just beyond the leaping firelight, but as my eyes became accustomed to the gloom I saw it to be human. In addition to the accumulated filth of a sub-human lifetime, the legs of the cretin were covered with a mass of revolting sores. As the landlady caught my pitying glance she came across and pleaded with me to do something for her imbecile offspring. But I could do nothing; even my first-aid kit was empty. The sores had been acquired as burns when the cretin had sat on the red-hot ash of the fireplace to get warm.

## 19th February

Zayul, Shigathang or Rima, as it is variously called, is the last official outpost on the Tibetan side of the Indo-Tibetan border. The last outpost on the Indian side is Walong. Somewhere between the two places lies the frontier. Coming from Tibet the last village is Sama and no other stage lies between until one reaches the Indian garrison of Walong. The distance is not far but the state of the trail is so bad that two days have to be taken to complete it.

I determined to get as far as I could and sleep in the open wherever we were by nightfall, and so ordered the horses to be used until it became impossible to go further. I almost regretted my decision immediately, for we had no sooner left the village than we had to pass through a boulder-strewn region where we mounted and dismounted with increasing exasperation. However, after we had negotiated this part, the trail improved and passed pleasantly through spacious woods.

After a few hours' riding we dropped down into a shallow valley, where there was a rickety wooden bridge. From above I could see figures moving about and by the amount of cut wood lying about took them to be workmen repairing the bridge. When we arrived we found this to be the case but received a shock at the sight of the workmen. Here were no tall, powerfully built Tibetans in voluminous gowns, but small wiry people with practically no clothes at all. I was curious, but my companions were thunderstruck and looked at them uneasily as if they were creatures from another planet. Indeed, with their thick dark hair piled on top of their heads in a large top-knot, their regular features and well-formed, compact bodies, naked except for an abbreviated loincloth through the folds of which was thrust a wicked-looking machete-like sword in bamboo scabbard, they looked what they were—a different race altogether. They were Mishmis, one of the head-hunting tribes of Upper Assam who inhabit the Indo-Tibetan borders to Burma. The Mishmi women were also small and beautifully formed

but spoiled the regularity of their features by inserting huge silver rings, or ornaments like small saucers, in their ears. They had short blouses, bare midriffs and long skirts reaching to below the knee. Both men and women smoked long-shafted pipes continuously.

After a first curious glance at us they went on with their work; I assumed that they had seen foreigners before, and that I had ceased to be a novelty as in my journey through Tibet. Some of their party were preparing a meal and I gave orders to my companions to do likewise. I was both hungry and interested in the Mishmis and a stop here would serve to satisfy both feelings.

Shortly after our leaving them at the bridge the trail became so bad that it was impossible for the horses to go further. The sheer slopes of the mountain fell away into the river and the trail was only a narrow path zigzagging across the face and down. At one point, where there was only room for one person to pass with difficulty, the mountain jutted out in a ragged, overhanging canopy above the trail and we had to stoop down and lean well over to one side in order to get past. Obviously, the horses could not do it, and we had come to the point where we had to trudge the rest of the way on foot. The distance to walk was not so great as I had been led to expect before the journey began and I now only required about ten porters, who should not be difficult to find.

Towards evening as I strode ahead to look out for a suitable camping-site, I noticed a line of people approaching across a wide clearing. When I drew closer I could see that the person in front was dressed in Western clothes, and I increased my pace in sudden interest. However, while he spoke some English, he was not a compatriot, being the head bearer of the leader of an expedition at present in Walong. To my eager inquiries he replied that Captain Kingdon-Ward, the famous botanist, was in Walong with an expedition and hoped to come up into these parts in his botanizing; he, the bearer, was going into Zayul for supplies of rice and tsamba and also with letters requesting permission to proceed further. I could not possibly

make Walong tonight even under forced march, but should camp and arrive the next morning.

Several hundred yards further on I reached a clearing in the jungle where two grass huts stood empty and inviting, and made camp for the night. Deciding that my arrival and meeting with foreigners merited a wash and a clean shirt, I had some water heated and washed my face and hair. The night was cold but, compared with the cold of the heights, pleasant. Still such unusual temperance of climate did not justify Loshay's actions. He, too, would have a wash. But instead of a moderate ablution in warm water to remove the top layer, he insisted on immersing his whole body in the icy waters of the river flowing from Tibet. I shuddered and steadfastly refused to look. It was the sort of imbecile action expected of a foreigner with perverted views on the responsibilities and demands of civilization, but Loshay was an unspoiled Tibetan child of nature. I had a sneaking suspicion that he must have heard it was the "done thing" among foreigners and was ordering his actions accordingly, as he prepared to enter foreign territory.

I was hungry and ordered my disgustingly clean servant to fry eight eggs. We had laid in a good supply at Zayul in anticipation and to have them still whole after two days was quite a triumph of organization. Before we left Sama in the morning I had had six boiled which, with this eight, made fourteen eggs in one day. Shall I write a paragraph on eggs as I did on bridges? No, if any reader wishes to know how I felt at having to face eggs in the morning, eggs at noon, and eggs at night, I suggest that he try it for some time in circumstances where the only other variety of food offered is raw meat—dried for one and two years in zero temperatures! It is a profound experience. *Verbum satis sapienti.*

## 20th February

I had the porters away at dawn without tea or breakfast, promising them a break on the trail. The path was now in good condition again, winding for the most part through tall grass

and thick undergrowth. Occasionally there were patches of
dripping, dank vegetation which indicated that we were now
in a different country with a different climate. I gathered later
from John Hanbury-Tracy that later on in the year in these
parts the leeches are something horrible. I can well believe it
for I remember squelching ankle-deep through mud with wet
creepers curling slimily above my head.

We climbed steadily for some time, then, topping a small
pass, dropped down the other side to a clear stream at the bot-
tom. The sun shone warmly, the stream gurgled pleasantly, the
grass spread invitingly, and so I called a halt for breakfast. Six
eggs with ash-scones, fried to soften them a little, tasted good
in such a setting when one was brimming over with health and
expectation. At two o'clock I arrived in Walong. There was a
clock in the C.O.'s office; so for the first time throughout the
journey I knew the time. Walong was an Indian garrison out-
post rather than an ordinary village, and the "houses" were
really dormitories or barracks laid out neatly and regularly.
Everything was spotlessly clean and the gardens between the
barracks were well kept and fresh. Soldiers moved about their
various tasks, stopping to glance at us curiously as we entered
the village.

I made my way to where some soldiers and civilians were
gathered on the wooden veranda outside a room and asked
for the head of the village or the C.O., whoever was in
charge. The work of Aku and Dawa Dondrup was finished.
No more arrogant commands. No more servile flatteries. No
more "lawful" beatings. We were in the sphere of the rule of
law.

The C.O., with his officers, was very pleasant and offered me
a chair and tea immediately, before beginning to question.
They were very surprised to hear that I had come all the way
from China through Tibet and were curious to hear about the
conditions there. I talked awhile with them and then asked the
whereabouts of Captain Kingdon-Ward. He was living in one
of the spare barrack-rooms near by with his wife, and the C.O.
would escort me there. He was sorry he could not offer me

hospitality as they were strictly rationed and transport of supplies was difficult, but he could provide me with an empty house. I assured him that that was all I required since I had servants and some food, though not a lot. However, as my supplies were low, would he please try to get me permission to travel as soon as possible. Certainly, he would wire to the Political Officer in Sadiya immediately and would I please wait in Walong until he had a reply? It should not take long, and he was sorry for the delay, but that was the law. I assured him that that was all right and asked if he would please escort me to meet Captain Kingdon-Ward, as it had been some time since I had spoken with a fellow-countryman.

First of all he showed me where I could stay during my wait in Walong and I gave the servants a few instructions, then we went over to one of the barrack-rooms where the C.O. knocked on the door. It opened and Kingdon-Ward looked inquiringly at the C.O.—and then he saw me.

"This is Mr. George Patterson," the C.O. formally introduced us, "Captain Kingdon-Ward."

"How do you do?" we Britished.

"Where in all the world did you come from?" queried Kingdon-Ward in amazement.

"China," I replied laconically, "through Tibet."

"By which route?"

"Gartok, Drayu Gompa, Zayul."

"Wait till my wife hears this," he chuckled, and shouted through the door to someone inside while we sat on chairs on the veranda.

A few minutes later his wife appeared, then suddenly stopped short on seeing me as we rose from the chairs.

"Well! John the Baptist, I presume?" she exploded in astonishment.

We roared with laughter. It was certainly apposite, for my hair lay on my shoulders, my beard was long and untrimmed and I was tanned deeply by sun, wind and snow. After a short conversation they invited me to have supper with them and I went off to wash and change. I had gone through all my spare

clothing and could only attend my first civilized engagement in silk Tibetan shirt and gown. My boots were clean.

## 21st February

As soon as it was decently possible I went to ask the C.O. if there had been any reply. No, there had not and it might take some time because the Political Officer would have to contact Delhi; however, he had stressed the need for haste in his report. I inquired also if it would be possible for me to send a wire to an acquaintance of mine in Calcutta since I required some money and wanted it to be in Sadiya for my arrival. He said it was not usual but in the circumstances he could send a message for me to Sadiya and they would forward it to Calcutta by the usual channels. With this I had to be content.

I then made my way towards the Kingdon-Wards' as I had arranged last night to go over my journey with them on the map. Kingdon-Ward was of the opinion that the route I had taken had never before been travelled by a white man as it was north of Baillie's route and south of the more travelled Gya Lam. He, himself, had planned such a trip but starting from Assam, and travelling north-east to China. When we had discussed the whole trip in detail we had lunch together and then I tried to recall what flowers, plants and trees I had come across for Kingdon-Ward's benefit. He was hoping during this expedition to find some of the rarer varieties of alpine flowers. I offered, when I sent my escorts back, to send letters by them to the many officials I had met en route to request their permission for the Kingdon-Wards to visit the area through which I had passed and to botanize there.

It was agreed that, while we awaited permission to travel our separate ways, it would be helpful on both sides to exchange supplies. I had some loads of tsamba, rice, flour and salt which I should not require on the remainder of the journey to Sadiya, but which they would need going north, and they had tinned food and other things which I certainly would require and they could spare. Mrs. Kingdon-Ward threw in several

blocks of Cadbury's milk chocolate which delighted me more than all the other food put together, necessary though I knew it to be. They also informed me that food would be impossible to obtain until I reached Sadiya; they had sought to conserve their supplies by buying on the way but had been completely unsuccessful. This made disconcerting news, for even with the food given by the Kingdon-Wards I was not after all going to have enough for the whole journey. They would have been only too pleased to give more, but I was reluctant to take more of their precious supplies knowing how uncertain travel can be, and the difficulty of obtaining food. After all, it is not everyone who can live on dried meat and eggs! The only solution was to attempt a fifteen-stage journey from Walong to Sadiya in shorter time by doing double stages where possible. I reckoned I had sufficient food for a week.

In the afternoon, having nothing to do, I went plant-hunting with them, and on our return I joined some soldiers in a game of football or what passed for football there. Afterwards I had dinner with the Kingdon-Wards and then retired to bed.

## 25th February

I ordered coolies for the Wednesday, expecting the arrival of the reply from Sadiya; but when lunch-time came and still no wireless message, I had to dismiss them. I had trimmed down my loads so that I should only require about half a dozen porters and also be able to cover long distances. I was not too happy at the idea of taking Mishmi porters as they were so small, and further, I gathered from the Kingdon-Wards that they would not go beyond one stage per day. The only other porters available were the few part-Tibetans, who were stronger than the Mishmis although reputedly less dependable. I decided to risk the latter as, having the language, I could always drive them further and handle them better. I disliked the idea of travelling with and being dependent on a caravan of porters, whose language I could not understand.

I wrote letters to Dege Sey, Pangdatshang and Geoff to be

carried back by my escort. Their work was now finished, the border having been reached, and I paid them off by giving as presents the articles I should no longer require. My saddle I gave to Aku and my riding-boots, mutilated beyond repair, I gave to Dawa Dondrup, who insisted that he could have them soled with Tibetan leather. I divided up the remaining ceremonial scarves between them as they could obtain quite a bit for them in Zayul. Geoff's horse, which I had had to leave behind in Zayul because it had been impossible to bring it over the river, I sent back to Geoff, through Dege Sey, giving Aku permission to ride him. With effusive thanks and compliments on both sides, we parted.

I drank innumerable cups of tea, and read, then had more tea. Late in the afternoon, one of the sergeants who spoke English called on me to ask me to join them in a game of football, which I did. I came back to more tea and found Loshay in conversation with a young Tibetan who had just arrived. Their talk was of blood, bone and butchery and I gathered that the Tibetan had been in some terrific fight in Sadiya with five Mishmis. He had been imprisoned and sent to the Tibetan border under escort for having cleft one of the Mishmis from shoulder to waist, disembowelled another and put the remainder to flight. The fight had been forced upon him, so the authorities had dealt with him leniently by dismissing him from the country. He was looking for a job and I had visions of adding another fighting-mad Tibetan to my entourage. I retired to my sleeping-bag with my stomach full of tomato soup and bread and my head full of gory details and dreams.

On Thursday the permission had still not arrived and I watched my food stocks diminishing with growing alarm. The longer I remained, the more difficult it was going to be to attempt the journey. I disliked the thought of living on the Kingdon-Wards and only agreed with reluctance to having dinner with them at night. Travel in the mountains makes hospitality expensive and appreciated. The C.O. was disturbed and apologetic but it was not his fault: he was only doing his duty.

## 25th February

On Friday morning, about ten o'clock, a reply arrived, with permission to travel. I at once set everything in motion to travel immediately; but after an exasperating wait for coolies, who never turned up, I had to postpone the journey again. This was something the C.O. could handle and I did not mince matters when I impressed upon him my intention of leaving on the morrow. If he could not provide coolies, I would use my own methods in finding them.

He found them. After an early breakfast I said good-bye to the Kingdon-Wards, who were leaving to spend the day at a nearby hot spring. The porters gradually drifted in and I finally got away by eleven o'clock. Within an hour I was held up. The mountain had slipped and carried away about fifty yards of trail. It must have been a new slip, for the C.O. would have told me had he known; and he would have had his men repairing it, because keeping the trail open for communications was his work. I had no intention of returning to Walong as the porters suggested, but swung myself recklessly on to the moving face and slithered my way across. Certainly the porters had loads, which made the crossing more difficult for them, but the loads were offset by their agility in the mountains, so I had no compunction in driving them on. At the most dangerous part Loshay and I stood ankle-deep in dirt to form a barricade, against which the porters could lean to prevent them falling down the mountainside into the river below.

This was the most difficult part. Afterwards, the path wound pleasantly between trees and across clearings, sometimes beside the river and sometimes above it. At one point we passed a huge boulder beside the trail with the name of a British regiment in English and a Chinese regiment in Chinese carved in the stone; this marked the boundary at one time after the Chinese had sought to infiltrate into India.

In the early afternoon, we arrived at a small clearing in which a few bamboo houses had been built. Several young Indians were sitting around talking or washing clothes. One of them addressed me in English and I found that he was a road surveyor and that he and the others were repairing the trail to

# The Journey

Walong. The place was called Sati. I had no intention of stopping there as we had only come a short way, and the English-speaking Indian had informed me that the next village was not too far away, but the porters were a hopeless crowd and pleaded that they could go no farther. I was annoyed, but there was nothing I could do about it. I knew beyond a shadow of a doubt that my food supplies could not possibly last until I reached Sadiya if I took the usual time over the trail, and at this rate it looked as if I were going to have to limit myself to the stages. I had to make Sadiya in a week or starve by the wayside. Before finally giving in to the demands of the porters, I agreed to stay in Sati that night if they would agree to doing the next three stages in two days. When I had promised extra payment as well, they agreed.

The hut in which I was to stay the night was a flimsy structure of interlaced bamboo, the sleeping-pallet and rickety table likewise. A decent gust of wind would have blown the whole village away, but as it happened to be in a sheltered clearing it was neither draughty nor cold. We were still about eight thousand feet above sea-level so the temperate weather was surprising. I had long since finished the last of my eggs, and for supper I had a royal feast of tsamba, tinned stew and chocolate. That night I lay back on my pallet, curiously patterned by the brilliant filtering moonlight, with an all-pervading content. I would make it all right; I could not fail now.

## 26th February

I had the porters up and away at dawn without breakfast. They were inclined to grumble but I promised them a break later in the morning. The trail led upwards through densely forested regions until it finally flattened out several hundred feet above the river. It had been maintained in a more or less passable condition by the soldiers, but this is only comparatively speaking. Mrs. Kingdon-Ward had ruined one pair of boots in fifteen days coming up and I was already well on the way to emulating her feat. The weather was now becoming much

warmer and I had to change into shirt and shorts for the first time in three years when we stopped for breakfast, and Loshay had to take off his Tibetan gown.

I was setting a cracking pace but had to stop continually to allow the porters to catch up. Loshay castigated them with every word in his extensive and expressive vocabulary, asking them sarcastically on one occasion whether they were Tibetans who ate food or animals who ate grass, but they remained sullenly unresponsive. I wished fervently that I could have laid hands on some of my Khamba Tibetans, who with their great strength could travel from dawn to dusk with huge loads, covering incredible distances, but the only Tibetans I saw were those travelling north carrying their own loads. We passed through the village of Widnung, eight miles from Sati, and I forced the porters to carry on for another few miles until we reached a large clearing in the thick tropical grass where I called a halt for the day. We would camp out beside the river for the night.

While porters cleared away the undergrowth and gathered wood for the fire I walked down to the river to sit on a stone and bathe my feet, but the water was too cold to be pleasant.

Loshay was in the process of preparing a meal, when two figures stepped silently out of the darkness into the light of the fire to be revealed as a Mishmi man and woman. It was quite cold and I signalled to them to sit beside me at the fire. They smiled, and then after a little while they addressed some remarks to one of the porters who could speak both Mishmi and Tibetan. The porter turned to me and interpreted that the Mishmis had brought some eggs: would I like to buy them? I agreed promptly without even troubling to haggle over the price, and obtained five eggs and a few vegetables, something like turnip. They would provide me with meals for the next two days.

During the night it rained, but as I was inside a waterproof sleeping-bag I had only to fasten the covers without having to get up. Loshay covered himself with two waterproofed slicker-capes which we used in riding through snow storms so he was

all right, but the porters were not so fortunate and had to get up to make a shelter with huge banana leaves.

## 27th February

I had breakfasted on two of the eggs obtained last night with ash-baked scones, and then we left. A few miles further on we passed through the empty "stage" of Minzang where there were a few of the same type of bamboo huts seen at Sati. Bamboo was plentiful so this type of hut was easy to build and maintain. The trail continued to follow the river, running due south, and became monotonous as it wound through forest and tall grass.

About the middle of the morning we stopped for a rest and I had some of the coffee made which had been given to me by the Kingdon-Wards. It was only a few miles to the next stage—seven from Minzang I had been told—a place called Chungwinti, and we arrived there at noon. There was a small company of soldiers billeted in the village, and also a schoolteacher who ran a native school. They were surprised at my arrival but the permits supplied from Walong soon set the officer's mind at rest and he placed a clean little room at my disposal. The porters hired at Walong did not go beyond Chungwinti, so they had to be paid off and new porters hired for the next stage. The officer in charge appreciated my dilemma in not being able to handle the Mishmis, but there was nothing he could do about it as there were no Tibetans for him to provide.

I was having a quiet read in my room in the afternoon when Loshay burst in to say that he had just seen some Tibetans arriving from Walong. They had made the journey from there in two days and were making for Sadiya at the same speed. There were nine of them, servants of a young Tibetan woman who was travelling to Sadiya, and they had only one or two light loads between them. He had tried to get them to act as porters for me, but they would only take the job if given permission by their mistress and if given a good price. I went outside to see them and they were quite willing to carry my loads, but the leader, a tall man with a large goitre, asked a ridiculous

sum. I was prepared to pay them well, especially if they reached Sadiya in eight days as they said they would, but not at the price quoted. My Scots caution came to the fore and I pretended indifference as to whether they took my loads or left them. I knew I should have to pay if they were stubborn, though, as it was the only way in which I could possibly reach Sadiya in time. My money would be of no use to me if I died of starvation before reaching Sadiya, which would be the case if I travelled with Mishmis.

While I was at supper I had a surprise visit from the officer-in-charge who came to announce that he had approached the Tibetan lady and, as she wished to leave some of her loads with him for safe keeping until her return, he had agreed to do so on the condition that she helped me in return. She was now outside waiting to talk the matter over with me. I hastily sent Loshay to invite her in. When she appeared in the doorway I got a shock. Even in the feeble light of the flickering butter lamp I could recognize her as the pretty young girl we had met at Zayul, Dawa Dondrup's "femme fatale". She was a bit startled on recognizing Loshay and me, but recovering her composure admirably she asked if she could help in any way as she had been told by the officer that I required porters. She had some business in Sadiya which had to be attended to quickly, and she would be travelling from dawn to dusk without using the recognized stages. If I did not mind sleeping out in the open she could offer her servants as porters, and a gift to each of them at the end of the journey would be sufficient payment. I assured her that this would suit me only too well since I too wished to be in Sadiya as quickly as possible; the quicker we arrived there the more I would be willing to give her servants for their services. Everything having been arranged satisfactorily she took a dignified departure, and I wondered whether I had not been mistaken after all in thinking she was the same person who had played such an amusing part at Dawa Dondrup's expense. Loshay, however, was positive she was the same person—and he should have known.

When they had gone we did a jubilant war-dance. My few

loads divided between nine hefty Tibetans should be nothing for them to carry, and we should make excellent speed from now on.

## 1st March

My stay in Chungwinti was memorable, for it was there the schoolteacher informed me that my diary was wrong and that somewhere along the way I had managed to lose a day.

The Tibetans called just as dawn was breaking, and it was a delight to see once again the loads being thrown around by these powerful fellows, and the pace at which they covered the trail. As we strode along in the crisp, early-morning air I rent it to shreds with bawling exuberance; the mountains were falling away, the forests were giving place to jungles and clearings and my legs were moving smoothly, I had a charming companion, and all was well with the world. The Tibetan girl, whose name was Ajayla, confirmed that she was the one we had seen in Zayul but still insisted that she had never known nor met Dawa Dondrup. We were left to walk together most of the time, as the observance of rank among the Tibetans did not permit the servants to mix with their superiors, unless they were requested to do so. The observance was usually relaxed somewhat during travel, though, and Ajayla did not demand the extreme forms of respect often shown and even gave cigarettes to Loshay and her head servant on occasions.

As the sun rose it became unbearably hot and soon the sweat was pouring down my face in streams. Ajayla and Loshay were in worse condition than I was, for they had been born and brought up in icy temperatures at fifteen thousand feet, but still we held to that mile-devouring pace. About midday we reached the usual stage of Munlang, stopping only for a short rest before moving on once more.

A few miles farther on some soldiers passed us coming up-trail and then, rounding a bend, I came face to face with a handsome, bearded Sikh in Army uniform. We stopped for a few words and he introduced himself as the Commanding

# 1st March

Officer of the Sadiya Battalion of the Assam Rifles on a tour of inspection. A few hundred yards behind him another line of porters indicated some other personage, who turned out to be a Road Inspector. I murmured a few polite words about the roads being in excellent condition considering the natural difficulties which had to be overcome, and then the jungle once again settled down to its perennial solitude. For the last few miles it had been busier than the streets back home.

Late in the afternoon we stopped at last beside a running stream, and I celebrated the distance we had overcome by opening a tin of salmon for supper and then finishing off with some chocolate. Before I had finished eating, night had fallen and the light from the fire was casting dancing shadows on the nearby trees. Soon the moon soared high overhead, surrounded by her scintillating court, to reign in luminous splendour.

We had built separate fires; Ajayla with her servants at one, and I with Loshay at the other. As I lay with my head pillowed on my clasped hands, gazing upwards, my thoughts encompassing and transcending the majesty of my surroundings, Ajayla came over and joined me at the fire. She offered me a cigarette which I refused, and I reciprocated by offering her some chocolate which she accepted. For a time no one spoke, all being content to sit in the friendly silence. From where I lay I could see Loshay's good-looking face, red in the fire-glow, as he squatted cross-legged gazing inscrutably into the heart of the fire. Opposite him and to my right Ajayla sat out of the fire-glow and in the shadow, but the moonlight making her face pale and hauntingly beautiful. It was one of life's moments.

Some time later Ajayla rose with a murmured, "Sleep in peace", and returned to her fire a few yards away, where she prepared herself for sleep. Loshay still sat immobile beside the fire, the leaping flames giving his eyes a wicked expression. As I stretched myself sleepily he turned his head slowly and looked in my direction:

"Is it you, or me?" he asked sardonically.

I gazed at him uncomprehendingly for a few minutes, then, as his meaning dawned upon me, I exploded into laughter.

# The Journey

"Of all the conceited people I have ever come across!" I got out weakly at last. "What makes you think it should be any of us? Merely because a young woman sits down beside a fire for a few minutes it means nothing."

He looked at me mockingly with a smile lifting the corner of his mouth, and disdained a reply.

With a few further remarks—that he was too presumptuous and that anyway she was too good-looking to be interested in him, as well as being of higher rank, while I was a foreigner and equally disinterested—I climbed into my sleeping-bag, grinning at the eloquent shrug of his shoulders.

## 2nd March

We were up long before dawn and away while it was still dark. This was travel as I had known it and not the short mid-day stroll of the Mishmis. The sun was well up before we stopped to eat beside a small river. Tibetan tea was on the menu but it was a mixed blessing in this climate. Our long hike had given us a monumental thirst, but as we poured the liquid in it seemed to seep right out again through every pore in our bodies.

Before noon we had put another stage behind us and were swinging along at a great pace. How the Tibetans did it with loads I do not know, but even with sweat pouring in streams from their brows and shoulders they never relaxed. The valley widened out and we were completely exposed to the blinding sun as we passed between the tall grass. We had been told that yesterday's and today's journeys were the worst of all on the route to Sadiya, but the Tibetans were determined to literally take it in their stride and do the three long stages from Chung-winti to Hayulyang in two days.

In the late afternoon, we topped a small rise and there was Hayulyang in front us. A soldier came smartly to attention as I approached the single-storied wooden huts which served as barracks, and gave orders to another soldier to fetch the officer-in-charge. While I waited I looked around. Hayulyang was an

army post like Walong but was larger because of several out-lying thatched houses scattered about the clearing. I could see some Mishmis and civilian Indians walking around.

When the officer arrived I went with him to his office and gave him the usual report while I drank the usual tea. There were no formalities to be gone through as I had been given my permits at Walong, and I required no porters for my baggage. I tried to get some food but was only successful in obtaining a few vegetables sufficient for one meal. A small mud-and-bamboo hut was placed at my disposal, and since this was the only one available I had to share it with my Tibetan companion, Ajayla. The servants would have to sleep around the fire.

While the servants were preparing a meal I chatted with an Agricultural Instructor and a schoolteacher, who had been sent there by the Indian Government to educate the Mishmis. It appeared that the Mishmis were not only unco-operative but also hostile to any innovation which they sought to introduce, and only wished to be left to roam the jungles and mountains as they had always done.

On this occasion the Tibetans had built only one large fire and had cooked the meals for Ajayla and me there. It was dark when we sat down to eat, and pleasant to stretch one's tired limbs in the warmth of the fire, although the night was not cold. The Tibetans sat around the fire in a wide circle, joking amongst themselves, while Ajayla and I ate our meals with our personal servants attending to us. The laughter and singing of the Tibetans began to draw some of the Mishmis near, and soon there was quite a crowd gathered in friendly fashion around the fire. Only one of the Mishmis understood a little Tibetan so the exchanges were conducted by signs and grimaces most of the time. I was a bit uneasy at first; I felt that the rollicking humour of the Tibetans might not be appreciated by the small, silent but dangerous Mishmis, especially when the Tibetans passed frank and bawdy remarks on the amount of body exposure per-mitted amongst the Mishmis of both sexes. However, the Mish-mis took it in good part, grinning and nodding cheerfully between puffs on their pipes. Even when some of the Tibetans

went over and sat beside some of the Mishmi women, there were only the usual giggling and sidelong glances to be found the world over in similar circumstances. Loshay was the only one for whom I was directly responsible, and he lay sprawled out on the ground between Ajayla and me, taking no part in the conversation but watching everything with a lazy grin. Occasionally he and Ajayla would converse idly and off-handedly for a few minutes. When I arose some time later to go to bed they were all still too comfortable around the leaping fire to move, and I left them to watch the fire go down.

## 3rd March

We were again away at dawn without breakfast and no one was around to see us go. An early mist hung in the air until sunrise, when it evaporated in a wonderful, receding blend of colour. We climbed up steeply over the shoulder of a hill on a good path and then dropped down to a beautiful clearing in the forest beside the river. Loshay and I had gone well ahead so we gathered wood and kindled a fire before the others arrived. The sun was warm, the river gurgled past, the smoke from the fire rose straight up, unknown birds poured forth a wonderful melody all around.

We had scarcely left our camping-spot when the trail began to get really bad, and shortly afterwards a roaring mountain torrent poured across it at right angles to lose itself in the river. There was no bridge so obviously we should have to wade over. We turned off the trail to the left and followed the course of the stream to where it entered the river, and we saw that it widened out considerably at this point, sufficiently at any rate to allow us to wade across. The force of the torrent was still strong, however, and we cut down some long sticks from the trees to serve as supports. With these some of the Tibetans went into the stream, their trousers rolled up to their thighs, and then, standing knee-deep in the water and grasping the sticks passed from hand to hand, they formed a human chain against which the others could lean while carrying the loads over. The crossing was still

difficult to negotiate, and the water rose in a drenching spray around us, so Ajayla was carried over to the other side on the back of one of the Tibetans.

The trail was lost on the far side amongst the stones and boulders, and our progress became tediously slow and difficult. For long periods we had to plough ankle-deep through the sand beside the river, then slide and slither on the small stones or climb over huge boulders. Wearing only shirt and shorts I was soon soaked through by the exertion.

About noon, we reached a small unoccupied village called Nara and decided to rest and eat. I had noticed on coming into the village that the water supply consisted of a series of split bamboo poles laid end to end from some hidden mountain stream, and that the water splashed from this novel chute on a ledge into a little pool. It looked just the place for a shower-bath, and when I had collected my soap and towel I made my way back again to wash off the accumulated sweat and dust. Some of the Tibetans had collected containers and were already drawing water for tea, while others were stripped and splashing water on each other with shouts of delight. I stripped and joined them—then saw with a shock that Ajayla was unconcernedly washing herself amongst them. I hesitated; then, knowing that any sign of embarrassment from me would only embarrass them who did not consider such a situation unusual in any way, joined them. The water was cold and refreshing, and after the initial preliminaries of being splashed from every direction by the joyous Tibetans, I soaped myself thoroughly all over for the first time for months—or was it years? The Tibetans borrowed my soap, working it into tremendous layers of lather and giving themselves incongruous shapes with it. Ajayla was particularly thrilled with my sponge, and only surrendered it to me to have her back scrubbed with it.

The trail improved considerably after Nara and wound through sun-speckled woods and open clearings. Sometimes we would pass through cultivated patches where curious Mishmis would stand and stare until we were out of sight, but usually we travelled alone and in silence except for an occasional burst of

song from one of the Tibetans. In the late afternoon we arrived at a place called Mochima, which consisted of one open-work bamboo hut, and one long bamboo outhouse occupied by several Mishmis. We appropriated the bamboo hut for ourselves, with Ajayla on one side on a bamboo pallet and myself on the other on my camp-bed. The Tibetans would sleep outside around the fire as usual.

We were making excellent time so I felt that I could afford a good meal, and had Loshay prepare rice, a tin of stew and some dried vegetables. He also kindled on the floor of the hut a small fire at which Ajayla and I could warm ourselves while waiting for the meal to be cooked, and we chatted contentedly and sporadically about this and that. When Loshay brought the food in, steaming and saliva-producing, I invited her to share it with me instead of waiting for her own colourless diet. I had a boundless compassion for anyone limited to tsamba and dried meat even though I knew that the Tibetans had been brought up on it as their national diet. Loshay's face was expressionless when she accepted, but during the meal when he thought he was not observed he would look at me knowingly or tilt a quizzical eyebrow towards Ajayla. I pretended not to notice his facial antics although on several occasions I almost choked on a mouthful of rice when he was nearly caught by Ajayla looking up unexpectedly.

We finished our meals at last with sighs suspiciously indicative of surfeit, and I gave Loshay strict instructions that all goods and chattels of every kind should be carefully checked and then stacked in a safe place. The proximity of the Mishmis I did not consider a danger to our lives, in spite of their reputation for head-hunting, because they seldom fight with a large company of Tibetans; but they will steal anything in the way of cutlery or pans that attracts them, no matter how small it may be. To ensure perfect safety, I had the things stacked beside me and told Loshay to sleep inside the hut across the doorway.

The food and the fire had combined to make us drowsy, the talk grew more and more desultory, and I went to bed. This was a simple matter: it only meant slipping between the folds of

## 4th March

my sleeping-bag on which I was already reclining, and slipping out of my clothes. Ajayla sat a little while beside the dying fire talking to Loshay, then she too climbed on to her pallet on the other side of the hut and settled herself to sleep. Loshay wound himself in his gown on the floor, across the threshold, and the night with its silence enfolded us. The fire gave out only a dull glow in the middle of the floor, and the moonlight patterned us all, through the interstices of the bamboo walls, in bizarre and beautiful fashion. The river murmured its sonorous way to the sea.

I was awakened suddenly by a sound of movement, and tensed inside my sleeping-bag, waiting for it to be repeated. For several minutes I lay in silence, breathing quietly and naturally as I sought to place the direction from which the sound had come, but all was still. Clouds must have covered the moon for all was pitch-dark now and no amount of straining into the dark could bring objects into focus. I lay awake for a long time, gradually letting the tenseness go out of my body as the sound, whatever it had been, was not repeated, and slowly drifted off to sleep again, assuming that some of the Mishmis had been snooping around but, finding that we were too well prepared, had given up in disgust.

## 4th March

As Loshay moved around getting the early-morning tea ready, I asked him if he had heard anything during the night, and if everything was all right. He looked at me, as if curiously puzzled at my sudden hyperconsciousness.

"What sort of sound?" he asked suspiciously.

"Like someone moving around," I replied confidently.

"You must have been dreaming," he scoffed. "Everything is just as I left it and nothing is missing."

"I tell you I was awakened by a sound of some kind," I insisted, "and I definitely heard the scuffle of a footstep."

He gave me a long look, and then suddenly grinned. "You probably did hear something, but it was not a Mishmi. You heard me moving."

# The Journey

I thought he was joking at my expense and impatiently waved aside his heavy attempt at humour, but he shrugged my petulance off with an even wider grin and a sidelong, suggestive glance towards the pallet on which Ajayla had been sleeping. I refused to believe him for some time but his amused carelessness and my own certainty that I had heard someone moving finally convinced me.

"You had the opportunity and would not take it," he protested, adding with disarming candour and a wicked grin: "It is Tibetan custom, as you know. I told you the other night and you would not believe me. You learn the language and you learn the customs but you pay no attention to them afterwards. It was the same when we were in Gartok." And he gave an exaggerated sigh at my stupidity.

I wondered how Ajayla would behave on her return to the hut, but surmised from previous experience that she would not be unduly perturbed. I was right. When she came in she asked demurely if I had slept well and sat chatting as usual beside me while Loshay and the others served us with food.

Once more on the trail, we continued to keep up the same stiff pace, and the Tibetans were now speaking of reaching Denning, the last stage before Sadiya, tomorrow; a distance of some thirty-five miles including a steep pass. I doubted it, putting it down to wishful thinking, but Loshay seemed to think that they would do it. Kingdon-Ward had told me that there was a telephone in the bungalow at Theronliang from which we could communicate the expected time of our arrival at Denning, where there was a motorable road to Sadiya. We were determined to reach Theronliang today at all costs; whether we could make the trip from there to Denning tomorrow was another matter for another day.

We stopped for a very hasty snack and some tea about the middle of the morning in a thick forest, and then swung on again through jungle and tall grass. About noon we passed over an iron suspension bridge, the first solid structure I had crossed for years, and by mid-afternoon we were in sight of Theronliang. It was a very pleasant place, situated on the side of a mountain

above the river, the houses whitewashed and gleaming in the afternoon sun. The Government Inspection bungalow was a solidly constructed affair of wood with a wide veranda, but was already occupied by a magistrate and an army officer who were on a tour of inspection in that area, so I arranged to eat and sleep on the veranda.

The magistrate was very helpful and had the message of my arrival sent to Denning and Sadiya, with instructions for transport to be provided for me on my arrival at Denning. He was dubious about our intention of arriving tomorrow, but I was now confident and told him that I intended to be in Sadiya tomorrow even if it meant walking half the night to do it. I had already promised the Tibetans that if they reached Denning tomorrow I would provide money for their transport to Sadiya, so that they would not have to walk the fifty miles between those two places.

While lying back in a chair on the veranda in the cool of the evening I read my first up-to-date newspaper for years. The magistrate had brought yesterday's paper with him from Sadiya and I read that once again the Labour Government had gained power, but by a very small majority this time. It was strange to read of that and other world events after the months of silence and peaceful remoteness in the mountains of Tibet. I was in a new world and already Tibet seemed far away and mysterious in its lofty solitude. Only one more climb remained and then the mountains would be behind me and the plains of India at my feet. I had almost arrived.

I gave orders to retire early since we should be getting up at two in the morning and, lying side by side with my Tibetan companions on the veranda, I watched the clouds sail across the face of the moon. China, Tibet—and now India. I had left Tibet because I had believed it to be God's will, but a sudden uneasiness assailed me now at being so far from the place where I had been so happy. The paper had shown once again a world gone crazy—a world in fear and unrest, bewildered and pitiful in its tinny trumpetings, its empty knowledge—a world of many voices, none of them without significance but all without direc-

tion and purpose. I had come from a country where the voice of God demanded to be heard by its very silence, but how would it fare again in the market-place of the world? In four years I had learned much of men and God and Satan in the solitudes. I sighed; for I knew that the most pleasant phase of my life had closed for ever.

## 5th March

The moon was still high overhead, and it seemed I had only dozed for a little while, when I heard the Tibetans move around preparing for departure. We had prepared food last night so that we could eat before leaving and then, if necessary, travel all day without food.

There was a faint light from the cloud-streaked moon by which we could follow the path, but it was difficult and dangerous at times. In order to save time we did not follow the broad winding trail to the summit of the pass, which jeeps had managed to negotiate during the war, but chose to climb straight up the mountain by the path used by the Mishmis. This cut several miles off the normal ten miles to the top of the pass, but it was a lung-racking climb for the load-carrying Tibetans. We followed closely in the steps of each other, in silence except for our laboured breathing. Time after time we had to climb some sheer slope, pulling ourselves upwards by holding on to branches and creepers. When we finally rested on top of the snow-dusted pass, six thousand feet high, the dawn broke and the skies flushed a glorious red.

In the village of Dreyi, a mile or so further on, the people were only just beginning to stir and gazed at our passing in sleepy-eyed amazement, no doubt wondering where we had come from at that early hour of the morning. It was exhilarating to swing downwards through the trees and watch the haze lift slowly from the plains at our feet. When we reckoned we had only about eight miles to go to reach Denning, we stopped to cook a meal. I had sent word to Denning to say that we would arrive about one o'clock and to have transport waiting for us

there at that time, and as it could not now be much more than seven o'clock we had plenty of time to eat.

Each day had become warmer as we neared the plains of India, and now it was steaming hot as soon as the sun rose. The Tibetans never faltered in their killing pace, though, and still held to it with sweat pouring from their bodies in streams. Without a load my clothes were wringing wet. The trail wound constantly through forest and jungle, dropping towards the flat, colourless plains lying at our feet like some gigantic brown map with white patches for the water.

We arrived in Denning about noon. I made my way directly to the Government Inspection bungalow and asked the caretaker there if he had received my telephone message from Theronliang and if the transport had arrived. He replied that he had received the message and had in turn telephoned to Sadiya, and that the transport would arrive about four o'clock. I was disappointed at not being able to leave immediately but I had already imbibed sufficient of the spirit of the East to resign myself to waiting. The caretaker also said that he had been instructed to provide me with anything I might require until the transport arrived, so I told him to provide me with a meal of some sort as the Tibetans with my loads had not yet arrived. In the meantime I washed, changed into a clean khaki suit kept for this occasion, and brushed out my shoulder-long hair and beard. It would not do to be too like the wild man from Borneo on my first contact with Indian officialdom. Thus refreshed I sat on the veranda and ate—eggs! Yes, the ubiquitous hen had triumphed even here! However, my dismay was mollified a little by the presence of real bread on the table with plenty of butter. From where I sat I could see most of the whitewashed, peaceful village on the gently sloping incline. Cattle browsed peacefully, children played in the shade of trees, women hung out clothes in a variety of colours beside the stream. The ordinary sounds of peaceful living drifted lazily on the breeze and washed over me in calm content.

About four o'clock there was the sound of a motor in the distance, and shortly afterwards a jeep, followed by an open

# The Journey

truck, drew up outside the bungalow and four well-dressed men alighted. They came up to the veranda where I was and we introduced ourselves all round; one of the four was the Assistant Political Officer from Tezu, a place on the way to Sadiya, and another was the Tibetan Intelligence Officer. They had all been out shooting in the jungle and so had not been able to get to Denning before four o'clock to pick me up. We had a short chat and then, as it was getting dark, we made ready to depart. I requested permission for the Tibetans to travel in the rear of the truck as I had promised, and Mr. Samdup, the Tibetan Intelligence Officer, and I got in front with the driver. The jeep with the other members of the shooting party was only going part of the way to Sadiya.

We had only gone a few miles when darkness set in completely and the light from the headlamps cut a wide swathe in front of us. The road was unmetalled but in good condition and we were able to travel at a fairly good speed. It wound most of the time between towering trees which seemed to object sullenly to the strange, noisy object passing through. We passed a spot where there was a large pile of fresh manure and Mr. Samdup pointed out that an elephant, or a herd of elephants, had passed that way recently.

I must have dozed a little with the warmth of the cabin and the hum of the engine, for I wakened with a start as the truck drew to a halt. I looked inquiringly at Mr. Samdup, thinking that something had gone wrong with the engine, but he was peering through the windows into the trees where lights could be seen moving about in the darkness. When the engine was switched off loud squeals and shouts rent the night in a bedlam of noise.

"Elephants," said Mr. Samdup, informatively. "Would you like to see them?"

I assented enthusiastically, and pulled Loshay out of the back of the truck to see them as well. When the lights of the truck were switched off we were in pitch darkness and could only find our way with difficulty by following the distant, flickering lights. As we stumbled closer to them, into ruts and

222

over logs, the noise increased in volume, loud trumpetings and crashing undergrowth drowning the shouts of the men. With a suddenness that was startling we were there. In a huge clearing in the jungle, lit only by spluttering wood-torches of the natives, several elephants had been tethered. Their little eyes gleaming redly in the fitful light, they were helpless to do more than trumpet madly for they were tied firmly by thick ropes on all their legs to convenient trees. Crowds of natives shouting at the top of their voices were pulling and tugging at the ropes, while others were on the backs of the elephants urging them into co-operation. A few of the elephants were disinterestedly and placidly standing by. Mr. Samdup explained that the quiet elephants were tame animals which were driven into the jungle as decoys for the wild ones, which were now in process of being broken in. The seven wild elephants were throwing themselves around in a blind and bitter rage, and I heaved a sigh of relief when the sound of their wrath was drowned at last by the sound of the truck's engine.

Shortly afterwards we arrived at a ferry and crossed the river in a thick blanket of darkness. While we were going over Mr. Samdup exchanged a few words with Ajayla, but for the most part she had remained aloof since arriving at Denning. A short journey on the other side of the river and then we were among houses and in Sadiya at last.

Mr. Samdup apologized for not being able to put me up in his own house but drove me to the Inspection bungalow where he made every arrangement to see that I was comfortable, and then promised to call on me first thing in the morning to escort me to the Political Officer. The bungalow was a large rambling building with several bedrooms and a dining-room. Although it was late Mr. Samdup had persuaded the caretaker to prepare something to eat, and after a quick wash and brush up Loshay and I sat down to an excellent meal of fish and chipped potatoes.

I fell asleep with confused thoughts of Geoff, alone in a dangerous situation in that remote valley, and where and how we would meet again if for any reason I could not return—of

# The Journey

Calcutta, elephants, fish and chips, and Ajayla going off into the darkness with Mr. Samdup.

## 6th March

I wakened to the sound of persistent knocking and for a few moments gazed around in puzzlement before I could remember where I was. I called out, and a servant brought in early-morning tea. Loshay raised himself in grinning content at this service which was usually his own.

I had scarcely finished my eggs and bacon, when Mr. Samdup called to say that the Political Officer would not be free until one o'clock: and would I like to see around the town? He had brought his jeep so that we could do it in comfort.

Sadiya was not a large place in terms of population, but it covered a wide area. It was beautifully laid out, with broad, tree-lined avenues and well-spaced houses. The only faults I could find with it were the heat to which it was exposed and the encroaching menace of the mighty Brahmaputra which swirled its way hungrily past only a few feet away from the bazaar, large sections of the sandy bank dropping into its restless waters even as I stood. We stopped on our way through the town at a modern girls' school where Mr. Samdup introduced me to the local Education Officer, a woman who had graduated from Edinburgh University in 1945, and who must have been in Edinburgh while I was there. We had a long chat over places we both knew.

In the afternoon I paid a visit to the Political Officer, a Mr. Sharma. After I had answered some questions about my journey I asked if he had received any telegrams or money for me, and I told him of the message which the C.O. at Walong had sent to Sadiya to be forwarded to Calcutta for me. He replied that he knew nothing about the message and that he had not received anything for me but my permit. This was rather a blow, as I had counted on the money being there for my arrival so that I could proceed immediately. Certainly, my immediate need for haste was past for I now had sufficient food, but I did not know

## 6th March

how long I might be detained in India before I could return. I still had about two hundred rupees in my possession but that would not be enough to take Loshay and me to Calcutta with our baggage. However, Mr. Samdup came valiantly to our rescue and offered to let me have three hundred rupees which I could repay by cheque when I arrived in Calcutta. On our return journey to the Inspection bungalow, he pointed out a house in which an American missionary and his wife lived, and I thought I would pay them a visit. Mr. Samdup knew them, but as he had some work to do he would not go in and we parted at the gate after I had promised to eat with him in the evening.

The missionaries were American Baptists, Sealander by name, and, of course, as is usually the case when strangers meet unexpectedly in strange places we discovered we had mutual acquaintances. Mr. Sealander had gone out on some business but I had tea with Mrs. Sealander and accepted an invitation to lunch the next day to meet Mr. Sealander, on his return.

In the evening Mr. Samdup came to escort me to his house on the banks of the Brahmaputra, and I had an excellent Chinese meal with him. He had inquired about planes and trains for Calcutta and advised the former as being by far the more convenient. There was no airfield at Sadiya though, and I should have to travel to a place called Dibrugarh, about sixty miles away by bus, truck or train, where there was an airfield with planes taking off for Calcutta. He offered to make all the necessary inquiries and arrangements for me in the morning. He was most helpful in every way.

Later on, the Tibetan Assistant Trade Agent, a Mr. Tenpa, called in to see me and I arranged to have a meal with him as well. My social engagements were beginning to pile up, but I reckoned that I should not be able to get away tomorrow and so should be free to accept some invitations.

## 7th March

I was reading on the veranda after breakfast when a jeep drew up outside the bungalow and a foreigner got out and went

## The Journey

inside. When I had finished reading I went into the dining-room to have some tea, and found him sitting there at a meal. We introduced ourselves; he was the manager of some local saw-mills, had just come into Sadiya to inquire about some petrol coupons, and was having a meal before starting on his way back. He asked me when I expected to leave for Calcutta, and when I said that I should like to leave as soon as possible he offered to give me a lift almost as far as Dibrugarh if I could be ready within an hour.

I jumped at such an offer as it relieved me of the uncertainties of travel by train or truck; and proceeded at once to decimate what remained of my baggage. Arctic sleeping-bag, pots and pans and various other odds and ends which would be useless in India and which could be replaced on my return journey, I laid aside to be given to Mr. Samdup, who could either use them or sell them as he wished. The remainder went easily into the rear of the jeep. Mr. Samdup arrived, as I was in the middle of re-packing, with the money he had promised, and I left him to deliver my excuses to the various people who had invited me for meals.

Sadiya lies on the northern side of the wide expanse of the Brahmaputra confluence, and this we crossed on a chugging ferry steamer. For a short distance on the southern side we travelled along a dusty, bumpy road but this soon gave way to a metalled surface on which we could make good speed. The road wound away into the hazy distance between mile after mile of tea plantations, monotonous in their regularity and colour. Occasionally we would pass through some small village where the dress of the inhabitants would show up startlingly white, like a Persil advertisement, against the surrounding green and brown. It was stiflingly hot and I was glad we were travelling in an open jeep and not in a closed car, which Loshay and I would have found unbearable after the high altitudes.

When we arrived at a place called Tinsukiah, the saw-mill manager had to turn off in a different direction, but before leaving he made arrangements at a local garage for a car to take me right away to Dibrugarh. In another hour or so I

arrived, dusty and dishevelled, in this large town of Upper Assam. It was too late to make inquiries at the Air Office so I cruised around until I found the Inspection bungalow, rendez-vous of all travellers, where after some difficulty I managed to get permission to stay the night in a corner of the dining-room. I had gone to Circuit House to see the District Commissioner, but as it was outside office hours, and he was inside the bath, he had found it inconvenient to do anything about giving advice to a stray traveller.

When the other guests in the Inspection bungalow had finished eating and retired for the night, I wound myself in my Tibetan gown for a blanket and went off to sleep in the corner. I was disturbed all through the night by hordes of voracious mosquitoes, and as I lunged at them viciously in the dark vowed never again to complain of cockroaches, lice, fleas and bugs in Tibet.

## 8th March

I was around at the Air Office almost as soon as it had opened to ask if there were any vacancies in the plane going to Calcutta that day. The clerk told me that there were no vacan-cies on the through flight to Calcutta but if I did not mind changing at Gauhati, about half-way to Calcutta, he could find two bookings for us on that plane. I agreed immediately to do this; my natural reluctance to wait anywhere had been con-siderably increased by my recent experience of the mosquitoes of Dibrugarh.

We returned quickly to the Inspection bungalow to collect our baggage, and presented ourselves at the Air Office at 10.30 a.m. as requested to leave for the airfield. Before leaving I sent a telegram to my friend in Calcutta to announce my intended arrival there that night.

Heat waves danced and made fantastic shapes out of the planes as they came in and took off from the airfield, and when we took off at 12 o'clock the heat inside the plane almost drove us into unconsciousness. I was so certain that I was going to

faint, that I could not interest myself in watching Loshay's reaction to being in an aeroplane for the first time. I did notice that he was tense as he looked out of the window at the rapidly receding earth, but that might have been due to the effects of heat, not excitement. His face was as inscrutable as ever in accordance with the law of the Khamba never to show fear.

There was not much to be seen, however, because of the heavy heat-haze, and soon no one was interested anyway as the plane bumped us all into air-sickness. The steward was kept running backwards and forwards with eau-de-cologne, smelling-salts and the brown paper bags which were the only interests left in life; and soon he, too, was overcome. I thought Loshay was going to be the only passenger to triumph in this battle with the forces of nature but he also reached out for the brown bag and slumped down in his seat in defeat. The tremendous heat had formed air pockets amongst which the plane was only a feather-weight plaything, and we gradually rose and suddenly dropped with nerve-racking regularity. I have never felt so ill in all my life—even in a ship in a storm. When we hit a sandstorm before reaching Gauhati and the racking spasms increased in intensity, I did my best to die. I could not even faint. I was condemned to live in this heaving, writhing, tingling torment. From somewhere I heard Loshay asking desperately how to open the window as he wished to jump out and die quickly and painlessly and not in this lingering agony. He could not get past my prostrate body to the door, however, and I could not move, so I unconsciously saved his life.

After an eternity we began to drop down, and at last the plane coasted to a standstill. We had arrived half-way at least, I thought dully. No! The pilot was announcing that owing to the tremendous sandstorm he had been unable to land at Gauhati, and after circling for some time he had had to make an emergency landing at another airfield because his petrol was running low; we would wait here until he got the all-clear from Gauhati to proceed. I lay slumped in my seat. I was so bad that I could not even obtain a twinge of amusement out of the tragic ap-

pearance of some of the—originally—beautifully made-up female passengers. *Sic transit gloria mundi.*

An hour later we were given the all-clear from Gauhati, and I gritted my teeth in fear and desperation. I would have given anything to be able to walk to Calcutta but that was impossible, so with a supreme effort I strapped myself in my seat again. However, the storm had passed and the journey to Gauhati was so smooth that my body began to take on a measure of normality once more, and when we touched down at Gauhati I suppose I was faint but pursuing. The storm seemed to have thrown everything out, for the time-tables of all other planes had been disrupted. This meant that there were vacancies obtainable in the same plane and that we need not change as anticipated.

At 5.30 we took off into a blood-red sunset on our last lap, and I noted with surprise that I must be recovering, to appreciate as I did the glory of the night. The endurance and resilience of the human body is the greatest glory of all creation, I thought. Made in the image and likeness of God. The Greeks gave to mankind an anthropomorphic emphasis in art, they glorified the human form in the Venus de Milo and Apollo Belvedere. But the glory of man does not lie in his shape, beautiful though it may be, but in his capacity. God, Who cannot be contained in a Universe, can be contained in a humble and contrite heart. "Astronomically speaking, what is mere man?" asked the cynic. "Man *is* the astronomer," came back the simple, but shattering, reply.

Two hours later we were circling above the myriad lights which was Calcutta. Loshay's nose was flattened beyond its Mongoloid normal against the window-pane as he watched in fascination the flood-lit runway rise out of the surrounding darkness. The wheels caressed the tarmac, the roar of the engines died away as they were cut off, and we had arrived.

I had hoped that there would be someone at the airfield to meet me but no one came forward as we alighted from the plane, so I consoled myself with the thought that he would probably be at the Air Office in Calcutta itself. I was not greatly

perturbed for I had my friend's address and knew that I could always be directed there.

The journey from Dum Dum airfield into Calcutta was a fascinating experience. Gradually the darkness of the country-side, lit only by flickering oil-lamps in the few huts and road-shops which we passed, gave way to brilliant, electrically lit city. Buses, rickshaws, trams, bullock-carts, horse-drawn carriages and hooting taxis jammed the main thoroughfares into the city, and hurrying, jostling crowds of people thronged the pavements. It was bewildering and slightly intoxicating after the solitude of the past years.

There was no one waiting for me at the Air Office, either, so I called a taxi and gave the driver my friend's address as my destination. We turned into Chowringee, the main thorough-fare of Calcutta, with the joyous abandon and reckless disregard for life and property peculiar to the Sikh taxi-drivers of that city. Loshay sat silent in speechless amazement. He had seen electric lights in China but he had never seen the flickering neon artistry or the eye-torturing blaze of the lights of a great city. Under the thousand-bulb brilliance of the Metro Cinema entrance, hundreds of people, jammed shoulder to shoulder, sought to push their way to an evening's entertainment with an eagerness and enthusiasm worthy of souls in search of God; but I was sorrowfully conscious that the real reason was probably to escape from Him. This was civilization. This seething, aimless mass of humanity, purposeful only in its quest for food and pleasure, was about to swallow me up again for a little while. Would its clamorous, empty voices succeed in drowning the clarion-clear "still, small voice" which I had known and loved so well in the solitudes? Some lines from *The Wanderer*, by John Masefield, rose up before me as I turned my eyes away from the bright lights towards the darkness of the open Maidan:

*Therefore, go forth, companion: when you find*
*No Highway more, no track, all being blind,*
*The way to go shall glimmer in the mind.*
*Though you have conquered Earth and charted Sea*

# 8th March

*And planned the courses of all stars that be,*
*Adventure on, more wonders are in Thee.*
*Adventure on, for from the littlest clue*
*Has come whatever worth man ever knew;*
*The next to lighten all men may be you . . . .*

# Postscript

I was delayed in India and consequently unable to get back to Bo before the Chinese Communists attacked Tibet. Geoffrey Bull was captured in Tibet during that advance and was held prisoner there, and then in a series of prisons in China, for three years and two months. He experienced the usual Marxist indoctrination, endless interrogations and solitary confinement, etc., used in the aptly termed "brain-washing" and "brain-changing" of the Chinese Communists. He arrived in Hong Kong on 19th December 1953, tattered but triumphant, with his spirit unconquered as he writes in his first letter in four years to me:

"Dear George,

"Four years' greetings! I can just hear your Gaelic voice saying to me, 'David Livingstone, I presume?'!

"Well, brother, I have been a long time walking into the morning but I have wrestled until the breaking of the day, and what does it matter if we limp into the dawning provided our name is Israel? . . . Spiritually it was an immense trial, physically I've come through reasonably well. We must think of the past and think of the future, we must search out all in our work not after CHRIST, then go on again towards the mark. I have known triumph and failure—sorrow and joy—have passed through every mood of disappointment and elation—passed through death, I guess, all but the stopping of my heart beat, and passed through life as I have never known it before—passed through it all, George—but God forbid that I should glory save in the cross of Christ Jesus my Lord. I have been brought through with my armour hacked to shreds, but, brother, I am standing, that's just about all I know. . . . In my prison room I prayed that if it took twenty years to make me the man God wanted me to be then to keep me till that day, but in three years and two months He has let me go. I need to seek His will and enablement for that new service. I composed many poems but had no pencil so I forget much, but some were very precious to me—a verse comes to me now:

> *The discipline of sons precedes*
> *The joy and power of heirs mature;*
> *Faint not, my soul, the hurt recedes,*
> *The Father and His love endure. . . ."*

231

# Index

1. The author on
arrival in India

2. The author in Kham
Tibetan dress with his
Tibetan teacher

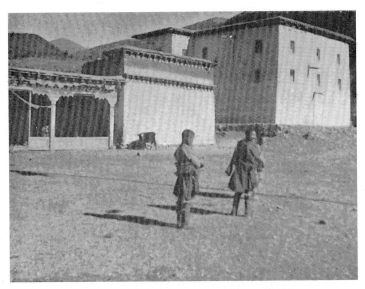

3. Pangdatshang's house in Bo, with a family temple on the extreme left. The wooden channels projecting from the wall of the house on the right are part of the primitive plumbing system and carry away the waste water

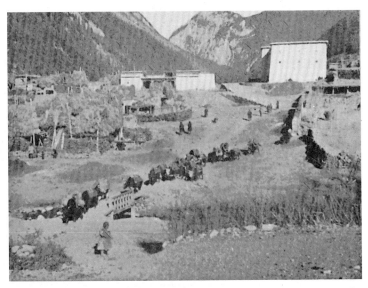

4. Caravan of Yaks leaving Bo. Pangdatshang's house is in the background on the right

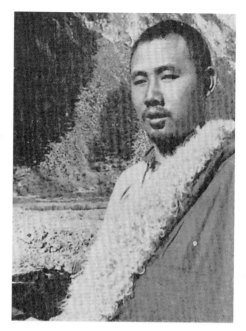

5. Linka Gyabön, bandit chief friend of
the author. His horse was the rival in the
race run on the course shown in Plate 13

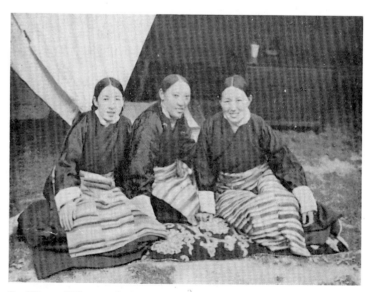

6. Three Tibetan ladies. The one in the middle is Pangda
Topgyay's wife. Her kindness and generosity were proverbial

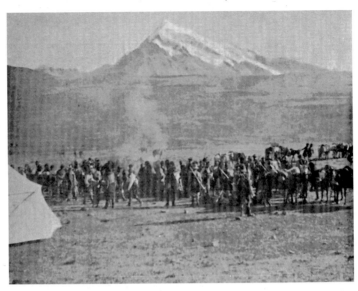

7. The caravan halts for the day on an empty, high plateau under the snow-peaked mountains. Note the guns and god-boxes slung across the shoulders of the Khambas

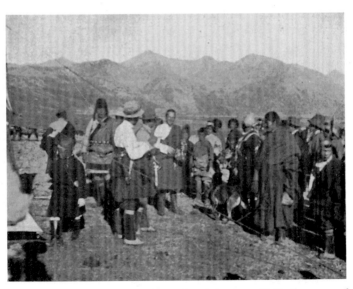

8. Another caravan stop. The author is in the middle foreground

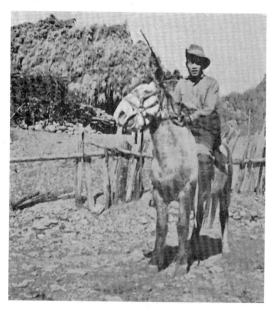

9. Loshay on his horse

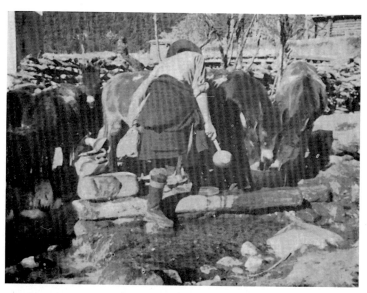

10. Caravan mules being watered and fed at the end of the day's
stage

11. Nomad Khambas in a Tibetan dance. The
bottle on the table contains 'a-rak' (brandy) and
the kettle on the ground 'chang' (beer)

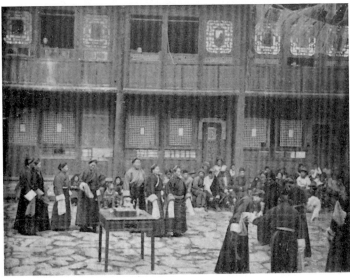

12. Khamba women performing a traditional dance in a Tibetan
caravanserai. Note the fluttering prayer flags in the top right-
hand corner of the picture

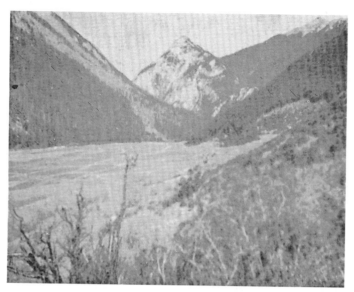

13. View of the northern end of the Bo Valley where the horse race was run (see page 26)

14. Typical Tibetan village about 13,000 feet above sea level

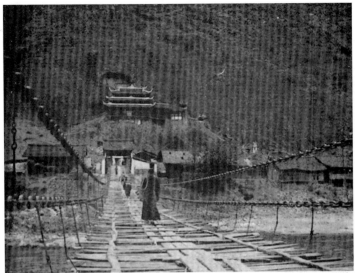

15. The last 'solid' bridge on the way to Tibet from China. While negotiating this bridge in pitch darkness, Geoff's horse went through between the planks and held up the whole caravan on the swaying bridge while it was lifted bodily to its feet again and led across

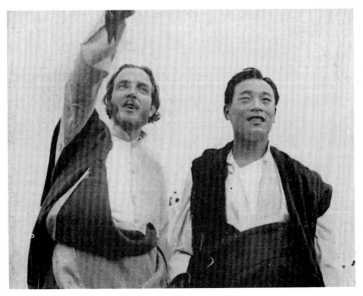

16. The author and Loshay on arrival in Calcutta

## MORE TITLES ON TIBET
## FROM PILGRIMS PUBLISHING

www.pilgrimsbooks.com

*For Catalog and more Information Mail or Fax to:*

## PILGRIMS BOOK HOUSE

Mail Order, P. O. Box 3872, Kathmandu, Nepal
Tel: 977-1-4700919  Fax: 977-1-4700943
E-mail: mailorder@pilgrims.wlink.com.np